DAVID BEST

Department of Philosophy, University College of Swansea

London GEORGE ALLEN & UNWIN Boston Sydney © David Best, 1985. This book is copyright under the Berne Convention. No reproduction without permission. All rights reserved.

George Allen & Unwin (Publishers) Ltd, 40 Museum Street, London WC1A 1LU, UK

George Allen & Unwin (Publishers) Ltd, Park Lane, Hemel Hempstead, Herts HP2 4TE, UK

Allen & Unwin, Inc., Fifty Cross Street, Winchester, Mass. O1890, USA

George Allen & Unwin Australia Pty Ltd, 8 Napier Street, North Sydney, NSW 2060, Australia

First published in 1985

British Library Cataloguing in Publication Data

Best, David Feeling and reason in the arts. 1. Education – Philosophy 2. Arts 370'.1 LB880.B471 ISBN 0-04-370156-6 ISBN 0-04-370157-4 Pbk

Library of Congress Cataloging in Publication Data

Best, David. Feeling and reason in the arts. Bibliography: p. Includes index. 1. Aesthetics. 2. Creation (Literary, artistic, etc.) 3. Arts – Study and teaching. I. Title BH39.B42 1985 700'.1 84-18493 ISBN 0-04-370156-6 (alk. paper) ISBN 0-04-370157-4 (pbk.: alk. paper)

Set in 10 on 12 point Garamond by Red Lion Setters and printed in Great Britain by Billing and Sons Ltd, London and Worcester

Contents

Acknowledgements		<i>page</i> vi
Intr	oduction	viii
1	Response	1
2	Reason	12
3	Questions	34
4	Differences	48
5	Free Expression	63
6	Creativity	74
7	Feeling	89
8	Creator and Spectator	111
9	Two Attitudes	130
10	The Particularity of Feeling	138
11	The Aesthetic and the Artistic	152
12	Art and Life	168
References		194
Index		197

Acknowledgements

It is impossible to name all the people who have been kind enough, by their questions and comments, to contribute in some way to the writing of this book. I should like to offer my warmest thanks to all those, in various countries, who have done me the honour of inviting me to speak at conferences, universities and various kinds of college, as a consequence of which many stimulating points have arisen in discussion. I have also been privileged to be invited to contribute to seminars and in-service courses for teachers whose perceptive comments I greatly value.

I am very grateful to Mrs Valerie Gabe for her remarkable care, accuracy and patience with the typing, and for her generous help in many other ways.

My greatest debt is to Dr David Cockburn, of the Philosophy Department of St David's University College, Lampeter, who generously gave his time to subject to rigorous critical examination earlier drafts of the book, who discussed with me at length some of the complex problems which arose, and who made numerous very valuable, incisive suggestions for improvement.

Introduction

It is hoped that this book will be of interest and value to those in the arts and the arts in education, and also that it will be a useful introduction to the philosophy of the arts. I am especially concerned to offer the strongest possible support for the arts, and the arts in education, in these times of economic stringency, when they tend to be under threat. Thus it is of the first importance that the arguments offered for the value of the arts should be as sound as possible in order to provide them with that solid support.

A central concern of the book can be simply stated: if artistic judgements cannot be rationally justified there can be no place for the arts in education. Yet, since the arts and artistic judgements are often expressions of individual feeling and value, this seems to create a problem about how they can be justified, in which case there is also a problem about how the arts can be justified in education.

It will be very clear how crucial this issue is in view of the current, entirely justifiable, demand that all aspects of education should be assessable and accountable. But it should be emphasized that even for anyone not directly concerned with education, the fundamental questions which centre on this problem are unavoidable if one wishes to reflect seriously on the nature of the arts, and their relation to society.

Chapter 4, and the second part of Chapter 7, concerned with the artist's intention and the spectator's response, could be omitted if they are found to be too difficult, although I hope they will be comprehensible to some extent even to those without a philosophical background. However, the argument of the rest of the book can be followed without having understood these sections.

Chapter 2 is a considerably revised version of a paper which was originally published in the British Journal of Aesthetics; Chapters 5 and 6 are revised versions of papers which were published in the British Journal of Educational Studies; some of Chapter 7 is taken from a paper published in the Journal of Aesthetic Education; Chapters 10 and 11 are revised versions of papers published in Philosophy. The following publishers are thanked for their permission to reprint or revise material that previously appeared in their journals: Basil Blackwell Ltd (British Journal of Educational Studies); Oxford University Press (British Journal of Aesthetics); Cambridge University Press (Philosophy).

1

Response

What is the underlying explanation of or justification for artistic experience? Where do we find the foundations of the arts?

Part of the enterprise of this book is to resist the misguided preoccupation of much modern philosophy with a prevalent conception of the character and scope of rationality. I shall argue that the traditional tendency in philosophy is to intellectualize in the wrong direction. With respect to the arts, a sometimes damaging consequence of this misconception is a depreciation of the importance either of reason or of feeling. Yet, for instance, although I criticize the subjectivist, this is not because he is wrong to insist on the central place of feeling in the arts, but because he misconstrues its character. A more adequate conception reveals that, if anything, feeling is even more important than he had realized, although in a different way.

Central to my argument is an emphasis on the natural ways of acting and responding which underlie the concept and conventions of art. The emphasis is necessary in order to resist the misapprehensions (a) that to argue for justification in this sphere is to argue that responses to the arts are ultimately justified by reason, and (b) that one reasons one's way to feeling about the arts. There is *some* truth in those misapprehensions, as we shall see, but in this chapter I shall argue that, in a more fundamental sense, on the contrary, it is the *natural* response and behaviour which gives sense to the reasons. At a more sophisticated stage there is an intricate interdependence between natural response and reason in that reasons can confer new possibilities of feeling, and whole dimensions of feeling are possible only for those with rational understanding. Thus to contend that the immediate, natural response is primary is certainly not to depreciate the place of reason, but rather to provide an account of what ultimately gives sense to reason.

It might seem, at first sight, that to argue that it is the natural response, rather than rationality, which is fundamental is to concede to subjectivism. But the point I am making applies to rationality in general, and not only to that in the arts. Where the arts are said to be subjective, this is usually assumed to be by contrast with disciplines such as the sciences where judgements are rationally justifiable. That is, if it is the dependence of what we call 'reason' in the arts on this fundamental natural response which is the source of 'subjectivism', then that is not what I am repudiating, since such dependence is the substratum of all reasoning.

Perhaps I can approach the point in this way. Language is the precondition of rationality, in that only creatures capable of using language could be capable of giving and understanding reasons (see Bennett, 1964). Yet language itself could not have been constructed as a result of reasons. It is often assumed that man invented language in order to communicate, yet this assumption is unintelligible since in order to create language there would already have to be a language in which its ideas could be formulated. In this respect language is significantly different from a game. Wittgenstein (1958, §7 et seq) uses the term 'languagegame' to refer to the various related areas of discourse which together constitute a whole language, yet although the term is useful in some respects it may also be misleading. It is possible to invent an entirely new game and even, if one will allow Esperanto in this sense to be a language, a new language. But even if a language could be invented, it would make no sense to suppose that language could be invented since it would have to be presupposed to formulate the ideas and structure of the new one. Similarly, Wittgenstein's insistence that language is spoken according to certain rules may also give a misleading impression, since one could learn to use language by following certain rules, as one could not learn to play chess from a rule book, since the rules have to be formulated in language. The rules of grammar and logic are not prior to but codify or describe in summary form the ways in which language is used. That is, it is not that linguistic usage depends upon the rules of grammar and logic, but the converse, that the rules depend upon the linguistic usage, which is why grammatical rules and the logic of language are not exact. Thus what gives sense to the notion of a reason is the usage; there can be no external rational justification of the usage.

What justifies our having a concept of art, and the concept we have? The traditional quest of the philosopher is to find those bedrock propositions which are unquestionably true and on which the edifice of knowledge and rationality can be securely built. Yet, although my brief sketch

Response

here is obviously inadequate as a discussion of one of the most complex issues in philosophy, it is sufficient, I hope, to indicate that this is a self-defeating quest, in that of any bedrock proposition it can be asked how *it* can be justified.

To illustrate the point by reference to language again, it is for this reason that in his later philosophy Wittgenstein presents a very different approach, and suggests that language is a development from, sometimes replacing, various ways in which human beings instinctively act and respond. Language itself is a network of forms of behaviour, but it is underlain by pre-linguistic behaviour. It is important to recognize (a) that the natural responses and ways of behaving are the roots of the arts, language and rationality, (b) but also that the arts, language and rationality give an enormous range of extended possibilities of feeling, responding and behaving. The latter point will be discussed at greater length in later chapters. Here I want to concentrate on the former.

The change from non-linguistic to linguistic behaviour consists in the learning of different behaviour. For example, verbal expressions of pain replace the primitive reactions of crying out, rubbing the injury, and so on, and they are just as immediate; they are not based on any reasoning. The same is true of our responses to other people in pain. We simply respond immediately, whether verbally or not, without making what would anyway be unintelligible hypotheses or assumptions as to what might be occurring in their private minds. It is in this way that verbal expressions of pain depend upon and are extensions of natural behaviour and responses. At this level we cannot intelligibly speak of knowledge and justification, but simply of ways of behaving and responding.

There are two levels of response and behaviour which I shall refer to as 'natural'. At the deeper level are the responses which are instinctive, and to which appeal must be made for any learning to be possible. A clear illustration is the philosophical problem of induction, that is, the problem of what justifies our confidence that when in the past one event has been regularly correlated with another, such a correlation will continue in the future. The expectation that such correlations will continue is, of course, fundamental to all the sciences, yet the problem, which has puzzled many philosophers, is that of finding or providing a rational justification for induction. For instance, the sun has risen every morning of recorded history, but how does that justify our confidence that it will rise tomorrow? There is nothing illogical or contradictory about saying that however frequently it has risen in the past it may not rise tomorrow. Of course, it may be possible to give cosmological or other reasons, citing

other correlations, which justify our confidence that the sun will rise tomorrow, but clearly these are equally inductively derived. That is, particular inductive statements may be justified by reference to others. but what justifies our confidence in any such statements? The oddity of the question becomes apparent when we notice that any 'justification' of the statement that induction can, or cannot, be relied upon would itself require an appeal to induction. In short, it makes no sense to suppose that there can be an underlying reason which justifies our confidence in induction. Yet this does not imply, as some philosophers have concluded, that our confidence in induction is irrational, and that no inductive statement can be justified. What it shows is that the reasons given within the practice of induction, to justify particular inductive judgements, cannot themselves be justified in some more fundamental, external sense. The standards of what counts as a valid inductive reason are not justifiable in that sense, but are rooted in the instinctive expectation, revealed in immediate ways of acting and responding, that things will continue in the future as they have in the past. Unless there were something which humans just do, some innate, instinctive response, there would be nothing to which learning could appeal, nothing on which a reason could get a grip. A good inductive reason is one which cites a frequent correlation, and it counts as good only by implicit reference to our innate expectation that such regularities will continue.

At the other level are those responses and actions which are learned in the sense not so much of being the result of explicit teaching as of being assimilated by growing up in and emulating the practices of a social environment. Examples are learning to wave goodbye, smiling as a greeting, nodding in agreement or approval, and various other gestures and facial expressions which a child assimilates as the norms of behaviour. These underlie language as they are underlain by the instinctive responses which are the roots of reason, knowledge and understanding.

The distinction can be illustrated by means of an example. An experiment was carried out in which a psychologist claimed to have taught rats how to discriminate colours. The rats were released at one end of a cage, and there was food at the other end. The floor between them was covered in coloured squares whose positions were periodically changed, and every time a rat crossed or touched a red square it received an electric shock. It learned to avoid the red squares. But did it, as was claimed, learn to discriminate red? Clearly not, since unless it could *already* see colours (or some other factor which differentiated the squares) it could not have learned which squares to avoid. The possibility of learning depended

Response

upon an innate capacity to see differences; without such a natural ability the learning would have had nothing on which to obtain a grip, as it were.

In general, the possibility of learning by conditioned response depends on unhesitating behavioural response to regularities, in this case electric shocks correlated with going on to red squares. That behavioural response could not itself be learned, but is the precondition of learning.

With respect to the arts, the instinctive response on which the possibility of learning and of grasping the concepts of the arts depends would be, for instance, swaying to rhythm, reacting to sounds, colours and shapes. Without such innate propensities there would be nothing to which learning at the higher level could appeal. Although the distinction between the levels is important, I shall use the term 'natural' to refer to the responses and behaviour of both since it is sometimes difficult to distinguish them, and since what is of greatest significance to my thesis is to recognize that such non-rational ways of behaving and responding are the roots of the concept of art; that they give sense to the reasons used in discussion of the arts.

Traditionally, philosophers have sought the foundations which it was supposed there must be to justify our concepts. Wittgenstein rejects this foundationist picture, that is, the notion that our concepts need or can coherently have underlying *justifications*. Instead, he points to the way in which concept-formation is a development from instinctive behaviour and response, and then from being brought up in the ways of behaving and responding of a particular community.

Consequently, so far from man's being able to create language, there is an important sense in which language and the arts create man. For the forms of behaviour and response and the linguistic and artistic forms which develop from them give man his conception of life – a conception which is expressed not just in forms of words, but ultimately in ways of living.

There are various loosely related sets of human activities, and one should look not for an underlying justification of each, but rather at what *counts* as justification *within* each. There is no intelligible room for a question of whether it is rational to engage in them. (This position will be qualified in Chapter 12, since the arts and the rest of life and language are interdependent, and I do not wish to suggest that what is expressed in the arts cannot be criticized or justified, for instance, in terms of the validity of what it says about life.)

At this fundamental level, we learn to create and respond to the arts in the same way. A child grows up in an environment where there are responses to the arts in which he learns to join. It would make no sense to speak of reasons for responses at this level. By analogy, one learns to play chess according to certain rules, and certain moves *within* the game may be illegitimate, but it would make no sense to suggest that the rules themselves could be illegitimate, since illegitimacy is determined by failure to conform with the rules. An activity may be legal or illegal, but it would make no sense to ask whether a law were legal.

A child simply learns to behave and respond in ways which constitute the beginnings of a grasp of what is involved in engaging in artistic activities. That the possibility of reasoning depends upon this more fundamental level of simply learning how to respond can be shown by means of an example. Imagine someone who came from a country where there was no activity of drama, or anything like it, watching Shakespeare's *King Lear* several times. He comes to realize that the actors do not really die, and that members of the audience know this. Yet the latter, every night, are profoundly moved emotionally by what they see. And what they see is, according to his conception, someone who just pretends, every night, to die – and they *know* he is merely pretending. Hence, he concludes, their emotional response is simply irrational, for how could they, if they were rational, be moved by a situation which they know to be false?

It is important to notice that it would be impossible to give the foreigner a rational justification for why people respond in this way. Indeed, as we shall see in Chapter 12, there are philosophers who, even from within our society, similarly over-intellectualize the arts, or, perhaps, intellectualize inappropriately, and who conclude that being moved by a character in a novel or a play is irrational. The foreigner may be told and may accept that most people in our society respond in similar ways to situations which they know to be not real life ones, taking place, moreover, in the obviously 'artificial' environment of a stage, in a theatre. But he could not engage in such an activity, and respond appropriately himself, and the crucial point here is to recognize that this inability to respond would not reflect a failure of *rationality* on his part. The reasons we offer to him cannot connect with anything which would allow him to respond.

Admittedly this is a rather odd example. For instance, I said that the foreigner knows what pretending is – yet this has *some* relation to the convention of drama. Moreover, it may be hard to imagine a society in which there are no activities at all which bear any relation to the ways in which children act out situations in our society.

Response

The roots of concepts and the reasons which express them are, then, ways of acting and responding which have been absorbed as the norms of the way of life of a society. Training may be involved here, but such training needs something on which to work, in that a child must already share attitudes and responses with us if the training is to be possible at all. There are many related activities which are part of the roots of the concept of art, such as 'make-believe', imagining being Red Indians or nurses, forms of representation in painting and drawing, nursery rhymes, being told stories, responding to and making rhythm, clapping games, responding to simple tunes. (That *training* is involved at *this* level does not, of course, imply that it is appropriate at other levels of education. But, as we have seen, a precondition of being able to engage in rational discourse is to have grasped, without rational justification, what counts as rationality.)

Margaret Wootton, in an unpublished work, has written of her experience of teaching several years ago in Kenya:

The students were shown a number of pictures, the idea being to get them talking. As the lesson progressed it became clear that they had never seen a representational painting before and were quite unable to pick out what was in the picture or see any resemblance between the pictures and the people, landscapes and objects that had been painted. There was no tradition of painting and drawing in the tribe in this way – they had painted masks and their own faces, and had a strong tradition of wood-carving.

Unless someone could grasp what it is to respond to something as a sketch of a person, it would be of no use attempting to give him reasons for seeing a resemblance, and *therefore* for responding to it as a representation. He would be unable to comprehend how pencil lines on a piece of paper could possibly be *like* a human being, and reasons could make no appeal to what comes within his understanding. The reasons given for the attribution of resemblance are *internal to*, and cannot be used to explain, representation.

A similar example is the imaginary one of a people who find black-andwhite photographs grotesque. By contrast with us, they see the miniature, black and white images as a repugnantly distorted representation of human beings. No reasons, *external* to the concept, could be given to show them that such judgements are inappropriate, and that a photograph can be an accurate representation of a human being. There could be no separate, external step of reasoning. To grasp the kind of resemblance or representation involved here, which could give the possibility of appropriate judgements, would be to grasp the concept of photography.

This raises a serious objection to the prevalent assumption that artistic meaning can be explained by a general theory of symbolism. For while of course there can be symbolism in art, it cannot be what explains or gives meaning to the arts, in some sense which is *external* to them, since an understanding of the arts is a precondition of recognizing the symbolism. Any such attempt to provide an external explanation of the creation of the arts is misguided, since it has to presuppose in the explanation what it purports to explain. When an art form is in existence, symbolic meanings can be expressed in it, but it would make no sense to suppose that the arts were created in order to express symbolic meanings.

Understanding the arts, in the sense of being able to engage in them, presupposes roots in non-rational feelings, responses, or attitudes. Understanding the arts, in the sense of being able to articulate artistic experience, presupposes, at least to some extent, understanding in the former sense.

That artistic understanding is rooted in natural response does not imply that there are no criteria for the appropriateness of responses to particular works of art: that is to say, it does not imply that there are no limits to the kinds of feeling or attitude which an individual may appropriately have. Strawson (1968, pp. 71-96) writes of the reactive attitude which we normally have to other human beings. This attitude consists in the ways we act and respond to other people, for example, in our moral expectations, in holding them responsible for their actions as well as feeling responsible to them, in our natural responses of sympathy, and so on, by contrast to our attitude to animals or inanimate objects. Although this is the norm, it could change to a detached attitude, if, for instance, someone were to become insane. In certain cases of insanity, indeed, the person could no longer be an object of the normal reactive attitude appropriate to a human being, and would be regarded as a subject for treatment. There is a role for choice of attitude, but it is a limited possibility. One could not simply adopt a reactive attitude to such an insane person, although there are exceptional circumstances in which one may adopt a detached attitude to normal people. One might, for instance, see people as rather like helpless machines, scurrying about aimlessly on predetermined tracks, and one might imagine a rather horrifying play or film presenting such a perspective on human concerns and activities. But this attitude could not be adopted permanently and for all people. It is significant that such a play or film would be disturbing, for such a response would be a consequence of the fact that these are normal human beings. That is, such a response would be parasitic upon the normal reactive attitude. There are criteria

Response

for the appropriateness of attitudes and, except in unusual circumstances, the suggestion that one might adopt the detached attitude to normal people would make no sense. The reactive attitude is an essential part of understanding other people and living in a society, and it gives sense to the notion of reasons in relation to them. Swift, in A Modest Proposal, suggests that the two problems of over-population and insufficient food could be solved by the simple expedient of eating young children. As Swift expected, his readers were revolted by this proposal. What underlies this sense of revulsion is the reactive attitude, since people were being asked to treat as food members of their own species. No *reasons* could be given for this sense of revulsion, since it is at an instinctive level. It is rather that any reasons we might give for the way people should be treated would derive their substance from such a natural response. One might say, for instance, that a certain way of treating people was appalling because it amounted to treating them as cattle. Similarly, a reason for opposing the institution of marriage, or at least a certain attitude to marriage, might be that it perpetuates the notion that, as a wife, a woman is still to some extent regarded as an object, as the property of her husband. The force of both, as reasons, derives from an implicit appeal to the natural reactive attitude to other human beings.

It may be worth emphasizing again that the reactive attitude is ultimate, in that it is not underlain by reason or hypothesis. For instance, responding sympathetically to other people is part of this attitude. Thus that someone winces or cries out in an appropriate situation is not evidence from which I infer, from a general theory about human beings, that he is in pain and deserving of sympathy. It is difficult to give any sense to the notion of one's having formed such a theory, or to understand what could justify it. My attitude, expressed in my response, is ultimate. While, in a sense, I have a reason for responding to him as I do, it is not an *underlying* reason, which *justifies* my response. My response is not based on a theory about the kind of entity I am confronted with, it is based on nothing. Or, to put the point another way, it is not that my attitude is based on a belief, but that the meaning of a belief that he is suffering is given by the attitude to him *as* a human being. Thus, my belief, in a particular case, that someone is suffering is based upon the fact that it is a *fellow human being* who is wincing and crying out, and I simply *have*, instinctively, a reactive attitude to fellow human beings. Learning how to respond to others is based upon an implicit appeal to this attitude. Roughly, it is not that the response is based on a reason, but that the reason is given its meaning by the natural response to other human

beings. This point, which is central to my thesis, may be difficult to grasp at first. It will become clearer as the book progresses.

Similarly, a child is not given reasons to justify his responses to the arts, he learns to share and engage in artistic and related activities. This learning is achieved, at the early stages, not so much by explicit teaching as by being initiated into the activities and responses of the arts.

There is a complex relation between feeling and reason, in general and in the arts. My arguing, in Chapters 2 and 3, that there is a prevalent neglect of the importance of reasoning does not imply a depreciation of the substantive issue of feeling; my arguing here that understanding the arts depends ultimately upon non-rational attitudes and responses does not imply a depreciation of reasoning. The natural responses give sense to reasons, yet reasons can open vast ranges of feeling which could not be experienced without them.

It is worth mentioning, too, how important it is to keep alive a natural response to art as one develops rational understanding. This is related to the importance of intuition, and by no means only in the arts. Some people are said to 'have a feeling for' a subject. Part of what that means is that they can make what are often fruitful conjectural leaps, ahead of the evidence or reasoning. Of course such leaps have to be substantiated, in general, by evidence or reasoning, to be regarded as reliable – in that sense intuition depends upon continued tuition. Nevertheless, without such intuitive leaps, no progress could be made – the scientist, for instance, would have no idea in which *direction* his search for evidence should proceed. In the arts, as in every other sphere, the feel for the subject should be cultivated, not weakened, as one extends enormously the scope of one's rational understanding.

I wrote above that one's responses to the arts are both natural and learned. This will sound odd, or even contradictory, only to those who assume that there is a sharper distinction between the two terms than can coherently be drawn. What could be more natural than to respond emotionally to powerful music, to a superbly performed play, or to a vividly written novel or poem? A particularly clear illustration is the way in which children respond to the reading of a story. Yet learning is necessary for all such responses. An animal, for instance, could not respond in that way; neither could the people in the society with no concept of representational art respond, for example, to a drawing of a sad or agonized face.

Response

It should be remembered, too, that I am using the term 'natural' in a broader sense than as equivalent to 'innate'. In some cases it is difficult to distinguish between what is entirely instinctive and what has been learned even, for instance, with animals in the wild. The distinction is not relevant to my principal interests, which are with what are the roots of reason and understanding in the arts.

Summary

In this chapter I have tried to make the point which can hardly be overemphasized, that the root of artistic understanding is our natural response to and engagement in the arts and related activities. Although reasoning is of crucial though often neglected importance, it should not be misunderstood as providing an underlying justification for artistic appreciation. It is rather that the natural responses to and activities of the arts give sense to the reasons. A child learns how to respond to the arts before he could possibly grasp any purported rational principle of justification of such response. Moreover, no explanation of any such principle would be comprehensible to anyone who had not already some experience of responding to the arts. Thus we shall be looking in the wrong direction if we try to discover what is fundamental to artistic experience in this sense. Moreover, as in other areas of philosophical inquiry, to make this assumption about the character of what is fundamental is likely to lead to a distorted conception of artistic understanding. The roots of artistic, as of any form of understanding, are to be found not in an underlying rational principle but in what is much simpler, namely, in what is involved in a child's learning, in the natural ways of responding which are the preconditions of learning. In this sense, it is irrational to be too rational, for artistic meanings and responses are not derived from an underlying rational principle; indeed, on the contrary, if any principle can be formulated it would be answerable to the natural ways in which people respond to the arts. This is why it is to rationalize in the wrong direction to examine the roots in order to try to find a principle. If there should be such a principle, it will be found at the top of the tree, supported and nourished by the roots of natural responses.

Introduction

My insistence in Chapter 1 that there can be no principle which underlies and justifies our responses to and engagement with the arts should not be construed as denying the possibility of justifying artistic judgements. On the contrary, rational justification in this sphere is both possible and necessary – most obviously, perhaps, for the educational credentials of the arts. That it makes no sense to suppose that there can be a rational justification for the natural responses which are the roots of the concept of art does not in the least imply that there cannot be rational justification of judgements made *within* the concept of art which has grown from those roots.

There is a prevalent tendency among those concerned with the arts, and perhaps especially with the arts in education, to overlook or even to repudiate the place of reason. While the role of feeling is generally assumed to be obvious, the notion of reason in this sphere is often regarded with suspicion. Hence it is commonly said that the arts are a matter of feeling rather than reason. The subjectivist is right to insist that feeling is central to the arts, but he is in serious error to assume that therefore artistic appreciation is unreasoned, a matter of irrational or nonrational feelings or attitudes, and thus that reasoning is irrelevant or even inhibiting. Of course, an inappropriate emphasis on reasoning *can* prevent a full understanding of the arts, but equally an inappropriate emphasis on feeling can prevent such understanding.

Reason is equally important to questions of appreciation, meaning, interpretation, judgement and evaluation, so I shall not differentiate between them. For economy, my argument will be directed primarily to appreciation, although it applies equally to the creator and the spectator.

There is a common confusion, usually revealing a misconception about philosophy of mind, that whereas reasons may be appropriate to appreciation, the creation of art is purely subjective, in the sense that there is no place for reason.

Since the role of reason in the arts is sometimes regarded as questionable, I shall compare it with the sciences, where the role and importance of reasoning are usually unquestioned. Although of course there are considerable differences between the two areas, there are also similarities in the nature of reasoning.

For expository purposes I shall often consider the case of exchanges of opinion, but it should be remembered that at least equally important is the thinking about a work of art which involves reasoning one's way to an opinion about it.

Education

It is worth emphasizing that the question of educational consequences is not separate from or peripheral to the central philosophical issue. One does not, as it were, do the philosophy and then consider the educational implications. The question whether reason has a place in the arts *is* the question whether it is intelligible to speak of knowledge in the arts, and as Plato insisted, the question of whether knowledge is possible *is* the question of whether there can be learning and teaching.

It may also be worth mentioning that I certainly do not wish to limit education to what goes on in schools, colleges and universities. There is a great deal to be learned from the arts during the whole of one's life. Nevertheless, unless artistic experience is answerable to reason in some sense, there can be no justification for including the arts in our educational institutions. Arts educators are often their own worst enemies, in that they tend to accept or even proclaim subjectivist assumptions – probably because they see no alternative. Yet that is to concede that there is no role for reason, and therefore that judgements are not justifiable. Accountability, for instance, depends not only upon the quality of the work, but upon the reasons which can be offered for the inclusion of that kind of activity in the curriculum. It is only if rational justification is possible within an activity that the activity can be justified educationally.

Subjectivism

The subjectivist correctly insists on the importance of individuality and freedom; on the wide differences of opinion there may be about the same work of art; on the centrality of feeling and creativity. He cannot see how these can be compatible with an insistence that reasons are equally important. Yet there could be no such thing as learning without objective criteria for progress and evaluation, including self-evaluation. Thus the dilemma for a subjectivist teacher is that as a teacher it is incumbent on him to encourage progress so that each individual student can develop his or her artistic potential, yet as a subjectivist he cannot attach any sense to this notion. For a consequence of subjectivism is that artistic meaning or value depends solely upon what each individual feels about it, in which case no sense can be given to understanding or meaning.

Subjectivists often fail to recognize this consequence. For instance, the principal of a well-known dance academy once wrote: 'Dance is such a subjective matter that there is nothing that can or should be said about it.' One wonders how he can reconcile this with accepting his salary, since it amounts to denying that he and his staff can teach anything to their students. Some years ago an American dance professor, recognizing that an implication of her professed subjectivism is that anyone's opinion is as good as anyone else's, was unable to object when some of her students, as their dance performance, sat on the studio floor eating crisps. Despite her commendable honesty, she lost her job. Such explicit recognition of the consequences of subjectivism is rare. Usually the subjectivist is in the odd position of denying a platitude, for he is well aware that the arts have meaning, and that some works and performances are better than others. Despite what he may say, he reveals this in what he does, for example, in the way he responds to different works of art, and in those he wants to see or hear again.

There is a line of thought which appears to support subjectivism, and which may cloud the issues. It may be stated as follows: 'The impression I have of art must come through my senses, therefore it is my impression and no one else's, and therefore it must be subjective.' But a similar argument would apply to such unquestioned cases of objectivity as mathematical propositions and statements about physical objects. It is by means of my own faculties that I see that 2 + 2 = 4, and that the table is brown. Nevertheless, such statements are not subjective. That my impression of art is my impression, in that it depends upon my senses, does not in the least imply that artistic judgements are subjective. The

fact that it is my judgement, based on my impression, obviously does not imply that it cannot be correct or incorrect, as the 2 + 2 = 4 example clearly illustrates.

A closely related argument, which also appears to support subjectivism and which will be discussed in Chapter 3, is that an artistic judgement, like a moral and philosophical judgement but by contrast with what might be called 'judgements of fact', requires one's *own* assessment, rather than accepting what even experts say. However, this significant aspect of artistic judgements is by no means inimical to reasoning. On the contrary, the ability to reflect on artistic meaning and value, and to formulate one's own opinion, requires reason.

The term 'subjective' is notoriously slippery, and the subjectivity of the arts is often defended with such fervour that it may be worth stating certain theses for which I am *not* arguing. In opposing the subjective with the possibility of giving reasons I am not denying the importance of individuality and personal involvement, nor am I suggesting that there is a single standard which every rational being must accept. I suspect that much of the initial opposition to the notion of reason in the arts may evaporate when the sense of 'subjective' which I am opposing is fully recognized. There is no incompatibility between an insistence on the importance of reason, and those important aspects of artistic experience on which the subjectivist rightly insists.

Scientism and Subjectivism

A principal source of misconception on this issue is an inappropriate comparison with what is regarded as a paradigm of rationality. Thus a theme of this chapter might be 'Scientism and subjectivism: two sides of the same distorted coin'. For what often impels people to subjectivism about the arts is the common assumption that the sciences are paradigm examples of rationality, coupled with the recognition that artistic judgements are obviously not open to scientific verification. Part of this misconception is what might be termed 'the argument from disagreement', whose tenor is that artistic appreciation must be subjective because, unlike the sciences, there are characteristically such wide and even rationally irreconcilable differences of critical opinion about the same work of art. Such a notion, as we shall see, reveals an underlying and still common misunderstanding of the character of scientific inquiry and understanding.

A thoroughgoing example of the common assumption that the sciences are the paradigm of rationality, and that only scientific verification can justify our claims to knowledge, is contained in an article on dance. The authors (Spencer and White, 1972, p. 5) write:

Numerous claims for dance have been made, yet . . . little published research is available to give substance to the claims. The position taken in this paper is that dance is a form of behaviour, and as such, is open to scientific examination. That is, if something exists, it exists in quantity. The major method by which knowledge is developed in the behavioural sciences as well as in the physical sciences is by empirical investigation. Dance as a body of knowledge can be furthered in the same way.

Yet none of these branches of science can discover anything in a dancer's movements to support artistic or aesthetic judgements. So the argument might continue: 'Since all human behaviour is scientifically examinable, yet the aesthetic quality of movements cannot be discovered scientifically, such aesthetic quality is clearly not *in* the behaviour, in which case, if any sense at all can be made of the notion of aesthetic quality, it must be a subjective matter. Thus it follows that aesthetic and artistic appreciation cannot be rationally substantiated.' Such an argument is often applied, *mutatis mutandis*, to the other arts.

This explains my contention that subjectivism about the arts is the other side of the same coin as scientism. For the subjectivist accepts that judgements of artistic appreciation are not supportable by reasons since they cannot be supported by the kind of reasoning which is employed in the sciences, an important characteristic of which, he also assumes, is that definitive conclusions are reached. That is, the subjectivist accepts the doctrine of scientism that the only rational verification is scientific. Small wonder that critical appreciation of the arts has been characterized as the natural home of rapturous and soporific effusion.

There is a powerful temptation to assume that since no scientific analysis can locate an aesthetic or artistic element, then it cannot be actually in the physical movements of the dancer, and therefore it must be subjective, in the sense that it is merely projected into the movement by the spectator. This common kind of assumption is aptly captured by Hume when he writes: 'Beauty is no quality in things themselves; it exists merely in the mind which contemplates them' (in MacIntyre, 1965, p. 278). Ducasse writes (1929, p. 177): 'The feeling is apprehended as if it were a quality of the object'; Perry (1926, p. 31): 'It seems necessary at some point to admit that the qualities of feeling may be

"referred" where they do not belong ... '; and Reid (1931, p. 60): '... the value embodied in the perceived object or body is not literally situated in the body. The joy expressed in music is not literally in the succession of sounds.' It is clear that these last three writers make the assumption that artistic value must be subjective because it is not possible to discover it by the methods of the physical sciences. It is an understandable but misconceived assumption. Central to it is the notion which appears in the article on dance, quoted above, that if something exists it must exist in quantity. The confusion here was exposed in a cartoon depicting a couple of lovers embracing in the moonlight, with the young man exclaiming ruefully: 'I can't tell you how much I love you – I forgot my calculator.'

The point is that even if it be true that, in a sense, behaviour is open to scientific explanation, it would not follow from that, nor is it true, that all explanation or justification is of a scientific kind. The young man in the cartoon could prove how much he loved the young lady, but not by scientific methods. Epstein, asked whether he believed that absolutely everything could be expressed scientifically, replied: 'Yes, it would be possible but it would make no sense. It would be a description without meaning – as if you described a Beethoven symphony as a variation of wave pressure.' It would have been clearer, perhaps, if he had replied: 'No.'

Assessment without Measurement

There are important practical consequences of this issue, for instance, for accountability in education. Assessment tends often to be equated with quantification, and where an activity cannot be quantified it is too easily assumed that it cannot be assessed. Yet, to take an obvious case, the validity of a reasoned argument can be assessed, although it obviously cannot be measured. A student's progress in producing valid reasons to support his case can be assessed, but not by measurement. Moreover, anyone who wished to dispute my contention that assessment cannot be equated with measurement could do so only by reasoned argument. Hence even the attempt would be self-defeating – since he would have to appeal to our *non*-quantifiable assessment of the validity of his reasons which are intended to show that there cannot be non-quantifiable assessment. He would be pulling the rug from under his own feet even to *try* to dispute the case.

Only *some* kinds of assessment are quantifications. For example, one may assess a move in chess as a good one, yet clearly no sense could be

made of quantifying it. Moreover, the most important assessments we make in life, such as those involved in understanding other people, are not quantifications. How, for instance, would one set about measuring facial expressions in order to assess their meaning? We can recognize that people are sad, sensitive, or troubled, and we are constantly making such assessments of the character, mood and responsiveness of other people. One can be right or wrong, one can learn to improve one's ability to judge other people, or another person, but the notion of measurement here is completely out of place.

Similarly only some kinds of progress can be quantified. A good teacher can assess a child's developing maturity, sensitivity to a subject and sense of responsibility, but it would make no sense to suggest that these crucial aspects of a child's educational progress could be measured. Part of the temptation to equate assessment with quantification is that the latter is so much easier and less personally demanding than judgement. Simone Weil writes (1962, p. 18): 'For men burdened with a fatigue that makes any effort of attention painful, it is a relief to contemplate the unproblematic clarity of figures.'

However tempting it may be, it is a serious misconception. The most important areas of education require sensitive, informed judgement, and thus there is no substitute for high quality teachers.

Reasons for Interpretation

In order to bring out a central feature of my case for the rationality of the arts, it is worth considering another argument which is assumed to show the inevitability of subjectivism.

It is sometimes claimed that whereas there are recognized methods of resolving scientific disagreements, there are no such methods of resolving conflicts of critical opinion about a work of art, for a scientific statement, unlike a critical judgement in the arts, can be verified by empirical tests and observation.

The apparent force of this objection derives from its conflating what are in fact two distinct assertions. The first amounts to a confusion of standards, since to assert that artistic judgements cannot be verified by the empirical tests and observations characteristic of the sciences amounts merely to asserting that artistic appreciation is not science. That is trivially obvious. The point at issue is not whether artistic judgements are scientifically verifiable, but whether they are verifiable.

The second assertion implicit in the objection is clearly false, for there obviously are recognized methods of resolving differences of critical opinion, as anyone who engages seriously in the arts knows very well. For example, a critical opinion of a literary work may fail on the grounds either of internal inconsistency or of having less adequate support from the text than another critical opinion.

What appears to give substance to the initial contention is the elision of an assertion which is trivially true but irrelevant, namely, that artistic judgements cannot be verified scientifically, with an assertion which is substantial but false, namely, that there are no methods of resolving conflicts of critical opinion.

It has already been remarked that there tends to be too narrow a conception of the character of reasoning. There are different kinds of reasoning, such as the deductive, which is characteristic of mathematics and syllogistic logic, and the inductive, which is characteristic of the sciences. But reasoning can also be used to give an interpretation or picture of a phenomenon or situation, and this kind of reasoning is central not only to the arts, but also to scientific and other forms of knowledge. As an illustration, consider one of the figures sometimes used in the psychology of perception, which at first, however hard one scrutinizes it, appears to be just a meaningless jumble of lines, but in which, when it is pointed out, one can clearly distinguish a face. The reasons offered in support of the judgement that there is a face there would consist in drawing attention to the relevant features in the drawing. Moreover, it is significant for some of our later discussion of the possibility of coming to see or understand a phenomenon or situation under a certain interpretation, description, or concept, that once one has seen the face it may be hard to imagine how it was not immediately apparent, and one may be unable to see the figure in any other way subsequently.

However, the situation is often more complex than this, in that there may be a variety of possible interpretations. Clearly, so far from undermining the role of reason, one has to appeal to reason to decide which is the most convincing. Sometimes even this cannot be achieved, since two interpretations may be equally possible. For example, consider the figure overleaf which can be seen as a duck or as a rabbit.

Each of two people, one contending that it is a duck, the other that it is a rabbit, could support his contention by citing, as reasons, features of the figure – for example, 'There are its ears'. However, there is not the arbitrary, unlimited possibility implied by subjectivism. The figure cannot be seen as a clock, for instance.

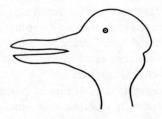

While it is true that, in one sense, reasoning cannot improve eyesight and hearing, it can open up possibilities of perception which would otherwise remain closed. One's attention may be drawn to the significance of previously unrecognized subtleties of a poem or novel which suffuse the whole work with a new meaning, yet, from a purely physical point of view, one sees nothing which one did not see before.

Although a work of art may be open to various interpretations, this lends no support to subjectivism, since beyond certain limits a judgement could not count as an interpretation at all, *because* it could not be supported by reasons. That is, there may be in some cases an indefinite, but there cannot be an unlimited, scope for intelligible interpretation; the very sense of 'interpretation' requires limits. There has been a variety of interpretations of Shakespeare's *King Lear*, but a conception of the play as a comedy, in normal circumstances anyway, could not intelligibly be regarded as an interpretation. Within the limits, of course, there is scope for argument and decision about whether a particular interpretation is valid or invalid.

Although there are different traditions and concepts of art, this does not imply that each is equally available to us, in the sense that we could choose which to adopt. Neither does it imply that one is limited to understanding only the arts of one's own culture. This is an issue which will be discussed in Chapter 4. At this juncture I mention it in order to bring out, with respect to the kind of reasoning we are now considering, an important distinction between conceptualization and interpretation.

The conceptual, which is the more fundamental, gives sense to reality, and it sets the limits for intelligible interpretation. To bring out what I mean I shall refer briefly to two common kinds of thesis which I shall call realism and relativism. Although, for simplicity, I shall discuss the issue in terms of language, it should be emphasized again that the contribution of the arts, and other activities, to conceptual understanding cannot be coherently distinguished from that of language. The realist supposes that

there are facts about the world which are independent of, and determine, the concepts expressed in language. There are trees, rivers, clouds, births and deaths, to which we attach names and descriptions in order to communicate about them. For the realist, the structure of language mirrors, or ought to mirror, accurately the pre-existent, pre-conceptualized phenomena. However, as we have seen in Chapter 1, it is incoherent to suppose that man could invent language, since it would have to be presupposed for the invention to be possible. Moreover, no sense can be given to the notion of recognizing divisions in a 'real' world independent of human classification, since the recognition would itself require classification. For example, to recognize that something is a tree is already to employ a classification. The problem is not quasi-empirical; it is not that however hard we try we cannot reach this 'real' world, but that nothing could possibly count as reaching it. Which is to say that the notion of a reality which is independent of language makes no sense. It would have to be understood to carry out the check, and understanding is given by concepts; thus to verify the correlation of concepts with 'reality' would require one's having unconceptualized concepts which, of course, is senseless.

The crucial point is that it is unintelligible to suggest that language could be true or false. Although propositions expressed *in* language can be true or false, it would make no sense to suppose that concepts can be true or false, since they are the standards of truth or falsity. The standard metre in Paris determines what counts as a metre, and the accuracy of metre rules could be checked against it. But it would make no sense to question the accuracy of the standard. Similarly, the concepts implicit in language and the arts determine what counts as truth and falsity, hence they also determine the *possible* constitution of reality. Consequently, if there were two different societies with different languages, it would be a senseless question to ask which was the more accurate one. Such a question would be rather like asking whether the rules of chess were more accurate than the rules of football. Analogously, an action can be legal or illegal, but it would be senseless to ask whether laws are legal, since laws determine what counts as legality.

The relativist recognizes that the concepts which determine what counts as reality are implicit in language, and since there are different languages, he contends that reality is relative. Yet, although there is something in this contention, it may be equally misleading if construed as implying that the different conceptual schemes are all equally available to us. For in that case reality would be what one chooses it to be. For the

realist, reality is independent of any possible conception, while the relativist regards language as a pair of coloured spectacles which can be changed at will to see a different reality.

Both the realist and the relativist are mistaken, although each is indicating a valid aspect of the problem which is overlooked by the other. The realist is right to insist that reality is not what we choose it to be, but he is wrong to assume that this is because reality is independent of concepts. The relativist is right to insist that reality is given by concepts, which may be different with different languages, but he is wrong to assume that they are all equally available to us. The important point for my argument is that it is not a matter of choosing to see reality in certain ways, but rather of learning a language, and the natural responses and actions which give sense to it. The conceptual network embodied in language presents reality to us, in its terms. Thus the relativist stands the position on its head. It is not that one sees reality according to one's interests and purposes, but that to a very large extent the concepts one has acquired in learning a language determine the interests and purposes it is possible to have. The qualification is necessary (a) because there are, of course, pre-linguistic purposes and intentions of the kind a very young child may have, and (b) because, more importantly, there is not a sharp distinction between them since, as was emphasized in Chapter 1, language is rooted in such natural interests and purposes expressed, for instance, in instinctive behaviour. Moreover, as we shall see in Chapter 4, the initial limits of intelligibility given with a language can be developed and extended according to people's interests and purposes.

Similarly, the network of concepts which one acquires in learning language and the arts constitutes the limits of the intelligibility of reasons, values and knowledge. *Within* these limits an indefinite number of interpretations of a work of art may be possible. A distinction of two levels can be seen here, the reasons for interpretation deriving their sense from the underlying concepts. The notion of interpretation implies agreement about *what* is being interpreted. That there may be differences of interpretation of a play or novel presupposes agreement at least that it *is* a play or novel. It follows from the meaning of 'interpretation' that disagreement is possible, and disagreement makes sense only by reference, if only implicit, to a shared conception. One can disagree only if there is something to disagree *about*, and if one can recognize conflicting reasons *as* reasons. For example, the possibility of different interpretations of a play presupposes agreement, to some extent at least, about what happens in it. There are various interpretations of the character of lago's actions in

Shakespeare's *Othello*, and these are based on and given their sense by the unquestioned fact of the virulent force of his determination to destroy Othello.

Nevertheless, to anticipate the argument of Chapter 4, this is not to imply that understanding is irrevocably confined to the conceptual limits which one has acquired in growing up in a culture. Other conceptions are available to the extent that one can learn other languages, arts, attitudes and ways of acting and responding. For the purposes of the present discussion of the character and scope of reason, it should be recognized that reason can be employed at both levels, in that it may achieve comprehension not only of different interpretations, but also of different concepts. Although. as we have seen, it would make no sense to suggest that the concepts given with language and the arts could be adopted at will, they can be changed or enlarged where there is some overlap with other concepts which may initially be beyond one's comprehension. For instance, different languages overlap to some extent, or there would be no justification for referring to each as a language. In this respect, the way in which relativism is often formulated gives the misleading impression that each language is entirely discrete. Yet even widely separated cultures have some point of contact which can offer a starting point for reasons which may achieve greater understanding of another culture. For instance, the arts are often and characteristically concerned with issues such as man's attempts to come to terms with death and suffering, which may provide starting points for such reasons.

The fundamental issue of the relation between concepts and reality is of considerable significance for the arts, and education generally. Some psychologists suggest that in order to perceive what the world is really like, it is necessary for all concepts to be eliminated. Thus Witkin (1980, pp. 90-1) writes of 'direct realism' or 'direct apprehension' which, he claims, can be achieved by taking away 'everything that memory adds' in order to see what is there *in itself*. The aim of this thesis, couched in realist terms which are initially plausible, is, commendably, to encourage fresh visions of reality. But, as we have seen, it is senseless to suppose that these could be achieved by *eliminating* all concepts. Fresh vision requires not the absence of concepts but a fresh concept. The point can be brought out by revealing the incoherence which centres on this tempting use of 'direct'. Our perception of reality *is* normally direct. If I am looking at a chess-board, in normal light, what could be more direct? The sense of direct used by those who argue in this way renders senseless any possibility

of understanding or referring to what is supposed to be perceived 'directly'. Someone from a society with no knowledge of chess or any similar game cannot directly apprehend the reality of a game of chess, however hard he looks at it, because he does not have the requisite concepts. Perhaps he can directly apprehend oddly shaped pieces of wood on a black and white squared board, and this may tempt one to think that at least he can see the reality of size, shape and colour without concepts. Yet concepts are necessary for that too, and it is worth remembering that they may be different in different languages. To bring out the point in a different way, someone who suffers a total loss of memory does not, as a consequence, understand reality *directly*. On the contrary, he understands nothing. For example, he could no longer directly see a tree, since he no longer knows what a tree is. Similarly, someone with no conception of a rabbit could not directly apprehend that interpretation of the figure, no matter how carefully he scrutinized it.

Reason, Concept and Interpretation

Near the island of Skomer, which is a sea-bird sanctuary in Pembrokeshire, the West Wales Naturalists' Trust has provided the 'Lockley Lodge Interpretative Centre' in order to help visitors to recognize the birds they will see and hear. This illustrates the close analogy there can be between interpretation and conceptualization as far as the role of reason is concerned. The Centre tries to help visitors to classify or conceptualize correctly what they see and hear, but the ways in which reasons can be given to achieve this are so similar to, as to be natural to refer to them as, interpretation. Of course, there are also significant differences. Whereas answerability to reason is always appropriate in the case of interpretation, this is certainly not always true in cases of applying a concept since, as we have seen, any reason necessarily presupposes a ground in a concept which gives it sense. More obviously, when I refer to a tree, a chair, the sky, and so on, I not only do not but could not give reasons for that application of the concept, and neither (to put the same point another way) am I interpreting anything. I simply see a tree. And if I were asked why I refer to it as a tree, the only answer would be that I have learned the English language. Given that, and in straightforward cases, there is no room for the further question of why I call it a tree. If, in normal light and when I was standing in front of it, someone were to say 'I realize that you know the language, but why do you call that a tree?', his question would

make no sense. By contrast, such a question about an interpretation would always make sense even if, in an obvious case, it might be surprising. Nevertheless, that there is not always a clear distinction between conceptualization and interpretation is illustrated by this example, since, in the Centre's terms, to interpret correctly what one sees and hears is to be able to recognize this as, for instance, a razorbill rather than a guillemot; it is to be able to bring what one sees under the correct description or concept.

A precisely similar situation frequently arises in the sciences in order to give sense to what is perceived, in that discovery is not a matter simply of accurate sensory perception. The greatest problem for a scientist is often not to conduct experiments and make observations, but to interpret his results. As we have seen, everything we call 'observation' involves conceptualization, but interpretation of the results is often required. Bronowski (1973, p. 82) with respect to the problems of understanding the electron, and the rival interpretations of two opposing factions at the University of Göttingen, writes:

The quip among professors was (because of the way university time-tables were laid out) that on Mondays, Wednesdays and Fridays the electron would behave like a particle; on Tuesdays, Thursdays and Saturdays it would behave like a wave...That was what the speculation and argument was about. And that requires, not calculation, but insight, imagination: if you like, metaphysics.

He goes on to say:

... new ideas in physics amount to a different view of reality. The world is not a fixed, solid array of objects, for it cannot be fully separated from our perception of it. It shifts under our gaze, it interacts with us, and the knowledge that it yields has to be interpreted by us.

Giving reasons for interpretations, whether of a work of art or of a scientific observation, is very like giving reasons for judging something to be of a certain kind, and it may be difficult to decide whether a particular case of disagreement or change would be better described as the same facts interpreted differently, or different facts because of a different conception. Kuhn (1975, p. 56), discussing the discovery of oxygen, writes: 'that a major theoretical revision was needed to see what Lavoisier saw must be the principal reason why Priestley [who had first encountered the phenomenon] was, to the end of his long life *unable* to see it'. And, with respect to

X-rays, which had created an unexpected glow on a screen, he writes (p. 58): 'At least one other investigator had seen that glow and, to his subsequent chagrin, discovered *nothing at all*' (my italics).

A particularly pointed illustration of the dependence of scientific fact upon underlying theory or interpretation was given in the following remarks by the mathematician and astronomer Bondi (1972, p. 226).

I regard the very use of the word 'fact' as misleading, because 'fact' is an emotive word which suggests something hard and firm. What we have in science is always a jumble of observation, understanding of the equipment with which the observation was carried out, interpretation and analysis. We can never clear one from another. Certain experiments that were interpreted in a particular way in their day we now interpret quite differently – but they might well have been claimed as 'facts' in those days...It's important to realize that in science it isn't a question of who is right and who is wrong; it is much more a question of who is useful, who is stimulating, who has helped things forward.

It is sometimes assumed that quantification provides a standard of certainty which transcends the dependence of human judgement on concepts and interpretation, yet the aphorism 'Lies, damned lies, and statistics' reminds us that figures by themselves are meaningless. To be meaningful they have to be interpreted.

It is also sometimes assumed that reason is exclusively or peculiarly the province of mathematics and the sciences, by contrast with imagination and creativity which are peculiarly the province of the arts. Yet both reason and imagination are necessary in all areas of knowledge and inquiry. *Reasons* may give understanding of different interpretations in the sciences and in the arts and, as some of the examples cited above clearly illustrate, in both it requires *imagination* to grasp their significance. It was a recognition of this point which induced Einstein to remark that in science imagination is more important than knowledge.

There is, then, a parallel between the two areas in that the sense of what is perceived, and of the interpretation of what is perceived, is derived from concepts given by scientific theory or artistic tradition respectively. The point can be illuminated by considering examples of the ways in which radical changes or differences affect the character of what is perceived in each case. Consider, for instance, the enormous effort of conceptual imagination required to grasp what Galileo said about the earth's revolving round the sun, after centuries of acceptance of the earth as the

centre of the universe. This conception was deeply embedded, and was expressed in linguistic expressions still employed, such as talk of the sun's rising and setting. To change it necessitated a considerable readjustment not only of scientific, but also of religious and other interlocking patterns of thought. Yet it required such a fundamental readjustment of underlying theory in order to be able to see the universe in Galilean terms. The observed facts were determined by those conceptions.

It may be said that at least we can be absolutely certain now that Galileo was right since numerous observations, for instance by cosmonauts, have shown that it is an indisputable fact that the earth revolves round the sun. While I do not wish to be taken as denying that the earth revolves round the sun, this way of thinking misses the point I am making. For, before Galileo and Copernicus, it was equally indisputable that the sun revolved round the earth, and any serious denial of this 'fact' was literally inconceivable. Scientists could no more consider an alternative than I can see through someone else's eyes. Similarly, we are now operating within a different set of theories and concepts which do not allow us to conceive of the possibility of a comparably immense change of view in the future. As J. B. S. Haldane once observed, 'the universe is not only queerer than we suppose, but queerer than we *can* suppose'.

The analogue in the arts is clearly exemplified by the difficulty for their contemporaries of comprehending the artistic innovators. Examples abound: Giotto, Turner, the Impressionists, Picasso; James Joyce, Samuel Beckett; serial music, the revolution in modern dance initiated by Martha Graham.

The necessity of grasping the relevant artistic tradition in order to be able to make valid or intelligible artistic judgements can be illustrated by the following two anecdotes. Ravi Shankar, the eminent Indian sitar player, during a concert in Britain was rapturously applauded. He thanked the audience and assured them that they should certainly enjoy the rest of his concert, since so far he had merely been tuning up.

While in Canada some years ago I was given another illustration of the point. A party of Eskimos, attending a performance of *Othello*, were appalled to see what they took to be the killing of people on the stage. They had to be reassured by being taken backstage after the performance to see the actors still alive. The Eskimos had assumed that new actors would be required for each performance.

Reasons: Lateral and Non-Verbal

To give reasons, in the sense under discussion, is to offer a picture of, a certain perspective on, a work of art. The justification of a judgement consists in citing features of a work, under a description which invokes the criteria of the art form. Clearly, unless one had seen the irony in a Jane Austen novel one could not give reasons in support of the judgement that it is ironic. Such justification consists not in probing deeper for a rational principle, but in a lateral appeal to the concept of art, and perhaps more widely to the network of related concepts which constitute a culture. The picture of the rational justification involved is more that of a net than that of the chain characteristic of deductive reasoning. For instance, reasons given in support of judgements of critical appreciation of Jane Austen's Persuasion might cite the development of Anne Elliott's character; whether and what she learned from her experiences; the extent to which she deceived herself early in the novel; the extent to which she overcame this later: and whether Jane Austen's irony is effective. All these aspects implicitly draw on concepts from life outside the arts. For instance, the judgement that character development is or is not convincing depends upon our understanding of people in life generally.

To come to see irony where one had not recognized it before is an obvious example of a way in which reasoning can bring a work of art under a new light. Another example is hearing a description of the composer's intentions, or the circumstances in which a piece of music was written, or even simply its title. The *Symphonie Fantastique* by Berlioz is an example, as are tone poems and impressionist music.

Reasons in the arts may not be exclusively verbal. One's interpretation and evaluation of a work may be given in various other ways, and expecially through the particular artistic medium, perhaps by comparisons and contrasts. For example, a musician might help us to understand an interpretation of a piece by playing certain passages with particular emphases, or with subtleties of phrasing, which cast a different light on the piece as a whole. One has often seen, in television's *Master Class*, a sensitive musician demonstrate, by playing with such emphases, his interpretation of a passage of music, and how important that interpretation was to his conception of the whole work. A painter might show how a different use of colour might bring about a significant effect on a painting. Indeed, there are various non-verbal ways in which understanding can be shown and achieved in life generally. For example, in support of a judgement expressing condemnation of war and jingoism one

Reason

might simply point to the corpses on a battlefield, or to photographs or paintings of scenes of consequences of war. This would be at least the equivalent, in certain circumstances, of offering a verbal judgement and supporting it with verbal reasons, and it might well be more powerful.

There are numerous examples of non-verbal, or not exclusively verbal, reasons which can contribute to or reveal artistic understanding. A point made by Chekhov to an actor playing the part of Astrov, in *Uncle Vanya*, effectively illustrates the point (Stanislavsky, 1961, p. 259):

During the intervals Anton Pavlovich dropped in on me and spoke with admiration, but afterwards he made one observation concerning Astrov's departure.

'But he whistles, listen... Whistles! Uncle Vanya is weeping, but Astrov whistles!' After that I could not make him explain any further.

How is that, I asked myself, sadness, despair and - jolly whistling?

But Chekhov's remark came to life of itself at one of the later performances. I just began to whistle, taking him at his word, to see what would happen. And straightaway I felt it was true! Just right! Uncle Vanya is dejected and full of gloom, but Astrov whistles. Why? Well because he has lost faith in people and life to such an extent that his disbelief in them has reached the point of cynicism. People can no longer cause him pain in any way.

There are those who are dubious about the notion of non-verbal reasons. This seems to me to be a further manifestation of the tendency to impose distortingly narrow limits on the possibility of reasoning. Sometimes, for instance, non-verbal reasoning can achieve more than could be achieved by verbal reasoning. To take a clear example, consider Samuel Beckett's play Act Without Words, in which, as the title implies, the only character never speaks. A certain view of, or judgement on, life is expressed in the play, and it might be said that it would be possible for the character to express, even if in a severely etiolated sense, the same judgement verbally, and support it with verbal reasons. Yet in its present form the play expresses that judgement on or view of life, and offers reasons for accepting its validity, in a richer sense without words - so much so, indeed, that there would be considerable point in insisting that this sense could never be adequately conveyed in words. Similarly, some of Goya's and many of Francis Bacon's paintings express a judgement on life, and offer support for it. One could cite similar examples from dance.

The important point is that a principal function of a reason, in any sphere, and whether verbal or not, is to give *understanding*. Of course this

is not to say that *everything* which produces understanding could count as a reason. As we have seen, there are limits to the intelligibility of the notion of a reason, and it must connect with, or appeal to, what already comes within the understanding of the person to whom the reason is given. The notion of a reason, too, involves validity or invalidity – the possibility of being right or wrong.

Nevertheless, if there are those who remain uneasy about the notion of non-verbal reasons it is not important for my argument. I have given reasons for supporting it, but what is most important, as my examples above reveal, is that there are various non-verbal ways of achieving, giving and revealing understanding.

Reason and Propositions

Metaphor, analogy, allusion and many other ways of presenting or drawing attention to a certain perspective or judgement on a work of art are also examples of reasons, or giving understanding, in this sense. This makes clear my rejection of the widely accepted assumption that reason is tied to the notion of knowledge as necessarily propositional. This way of construing the character of knowledge and reasoning is, for example, associated with the philosopher of education Hirst (1974; see esp. chs 3 and 6). I shall not consider this approach in detail, since I am more concerned to propose a thesis than to criticize others. I raise the issue in case it is not already clear that in arguing for the importance of reason in the arts. I am certainly not supporting, indeed I am repudiating, a propositional approach. For example, the poets of the First World War, such as Owen, Sassoon and Rosenberg, both expressed a judgement and supported it with reasons which consisted in offering a vivid vision of what war amounts to. In support of one's judgement about war one could now cite their poetry. This is clearly not propositional, but a judgement of the truth of war is expressed and rationally justified. Moreover, it should be emphasized again how important is the possibility of reasoning one's own way to a judgement.

According to Hirst, the domain of knowledge is centrally 'the domain of true propositions or statements' (1974, p. 85). This contention may be initially plausible for the sciences, although, as I have already indicated, further consideration reveals its inadequacy even here. But it does not seem to me even initially plausible for the arts. It has been said that the arts are forms of love, not of knowledge. While one sympathizes with the

Reason

spirit of this, it is misleading to say that we cannot legitimately talk of knowledge with respect to the arts, and worse to imply that knowledge precludes love. It is, unfortunately, all too often true that the methods of teaching what are popularly regarded as the central forms of knowledge *do* preclude love – but that is an indictment of the education system. Mathematics and the sciences, as well as the arts, should be forms of knowledge and of love. To regard the two terms as exclusive is as mistaken here as it is with respect to love of other people. So far from its being the case that love is inimical to knowledge, it is difficult to see how one could love another person without knowing him quite well.

The danger is that to continue to equate knowledge and rationality with the ability to produce true propositions will help to perpetuate the damaging misconception that where the arts are concerned we cannot legitimately speak of knowledge and rationality. For recognizing (a) that what one says in appreciation of a work of art may not be propositional, and (b) that appreciation of a work may not be revealed exclusively in what one says, those involved in the arts often feel impelled ipso facto to accept that the arts cannot be cognitive and rational. Thus, in offering a proposed rationale for the arts, at least one philosopher of education has argued that they are 'pre-cognitive', and 'pre-epistemological'; that the notion of truth-conditions cannot be applied here because a work of art cannot be said to be true or false. There are those of us who would argue that the notion of 'truth-conditions' in general is at least questionable, but I cannot digress to discuss that issue. More relevantly, this is a clear illustration of the narrow conception of truth, knowledge and rationality which is still so common. For of course some works of art can and do express profound truths, and some are false. If this notion of truth cannot be fitted into the rigid categories of 'truth-conditions', so much the worse for those categories.

In a similar vein Witkin (1980, p. 89) writes: 'The arts stand in relation to the intelligence of feeling much as the sciences do in relation to logical reasoning.' This whole approach, common though it is, involves throwing out the baby with the bath water. Knowledge, understanding and reason are central to artistic appreciation, and are necessary for the educational credentials of the arts, but that does not entail the ability to produce true propositions. Indeed, as we have seen, this conception is inadequate even for the rationality involved in scientific and other forms of knowledge often regarded as unquestionably propositional.

In short, the source of the misconception that the arts are a matter of feeling, not of reason and knowledge, is the unquestioning acceptance of

narrow a conception of reason and knowledge. As Wilson (1977, p. 133) puts it (and his use of inverted commas is significant):

It does not follow that these insights afforded by poetry are unavailable to 'reason' when this word is used in its broad definition... And it is, of course, *this* 'reason' we exercise when we assess and make judgements on our human condition, or specifically on education and its aims; and it is to the judgement of *this* 'reason' that the paradigm knowledge so prized as an arbiter by Hirst...must finally submit.

The Limits of Reason

There is a deep philosophical preconception that the question 'Why?', asking for a reason, is always appropriate, and that to decline or to be unable to offer a reason, reveals a lack of rationality. Yet there are situations in which to be *able* to provide reasons might be regarded as inappropriate and even repugnant. To refer again to the example used in Chapter 1, Swift, in *A Modest Proposal*, suggests that the two problems of overpopulation and shortage of food could easily be solved by the simple expedient of eating young children. One's natural reaction to this, as Swift anticipated, is repugnance. It is not just that one does not feel the need or may be unable to argue rationally against it, but rather that to reason about it is *already* an indication of a moral position which one cannot seriously entertain. That is, sometimes the fact that a position is not open to rational questioning is a mark of its centrality to a culture. Any alternative is, in the literal, rather than the currently debased sense of the term, unthinkable.

More important for my thesis, to argue for the central place of reason in the arts is not to argue that the request for a reason is always appropriate. The notion of explaining and justifying our artistic judgements is familiar enough and, as I have indicated, it takes a variety of forms. One might, for example, refer to striking progressions, or rhythmic variety, or subtlety of harmony, or sensitivity of playing, in music; one might refer to the structure of a novel, or the perceptiveness of character-portrayal; one might refer to the composition or use of colour in a painting. But what if, after being given such reasons in considerable detail, someone were to say that he could not see why that made it such a good work of art? One would have no idea what to say, and one would have to conclude that he just did not understand this art form. One's reasons cannot be understood unless one can find something which *be* recognizes as a reason, or unless

Reason

one can find something incompatible in his position. Even then one is not necessarily helpless – although in fact there may be little point in continuing. One may need to reach to the foundations, by trying to bring him to respond to and understand the art form or approach to art *as a whole*.

Again, the difficulty is, in principle, no different from other areas. If someone simply cannot see why deductive reasoning leads to a certain conclusion in logic, or why an addition in arithmetic gives a certain answer, or why a certain conclusion is drawn from a scientific experiment, and if his request for a reason is not of the kind which could be answered by offering him further explanation from *within* the activity, then one must either give up, or attempt to introduce him to the *activity*, for no reason will count as a reason for him until he grasps and responds appropriately to it; there is no sense to the notion of an *external* justification.

Conclusion

A major source of subjectivist assumptions about artistic appreciation is a fundamental misconception about the nature of knowledge and reasoning. This is the distorted coin of which scientism and subjectivism are the opposite sides. A more adequate conception reveals the misapprehension inherent in the argument from disagreement, in that the possibility of differences of opinion and interpretation lends no support to subjectivism in the sense in which it is opposed to rationality and knowledge, whether in the arts or the sciences. Artistic appreciation, like understanding in any sphere, allows for the indefinite but not unlimited possibility of interpretation, and of an extension of the concepts which give sense to interpretation and judgement. In short, knowledge of any kind rests on concepts and human judgement. That assessment in the arts is necessarily a matter of judgement concedes nothing to subjectivism, since such judgement derives its sense from the shared arts, language, attitudes and activities of a culture. The assessment may itself be assessed, of course, but that is not to say that judgements can never be completely sound. What often underlies the feeling that judgements can never be quite reliable is a craving for an incoherent ideal of knowledge as something absolutely fixed and certain, beyond the possibility of change and revision.

Summary

- That no rational principle justifies the activity of artistic appreciation should not be confused with the misconception that artistic judgements cannot be rationally justified.
- (2) By no means the only legitimate or most important kinds of reason are the inductive and deductive which are characteristic of science and mathematics.
- (3) An important kind of reason is that which brings a phenomenon or situation under a certain description or interpretation.
- (4) Concepts or interpretation are presupposed to give sense to what is perceived.
- (5) Interpretation, whether in the arts or the sciences, is answerable to reason.
- (6) The possibility of disagreements is not only compatible with but presupposes rationality.
- (7) Knowledge, or understanding, is not exclusively propositional.
- (8) Assessment in the arts, as in many spheres, is necessarily a matter of judgement. It is a confusion to assume that only quantification, and not judgement, can give genuinely objective assessment, since the meaning of the quantification requires judgement. There can be no educational justification or accountability for an activity for which no coherent account can be given of the answerability to reason of assessment and progress.

Questions

Succeeding chapters will consider in more detail issues which arise from Chapters 1 and 2. However, it is worth discussing immediately some of the questions which are most likely to arise, and which can be dealt with relatively briefly.

Value

I have emphasized that artistic appreciation is a fully rational activity in that the judgements involved are supportable by reasons. The objection is sometimes raised that even though judgements of meaning and interpretation may be open to rational discussion, these are irrelevant to the central issue, since the *real* problem of artistic appreciation is that of value-judgements.

It is clearly implausible to contend that interpretation is irrelevant to evaluation since it is impossible to evaluate a work unless one understands it. For instance, one's evaluation may change if one comes to recognize that it has ironic or other subtleties which one had previously failed to appreciate. Moreover, some evaluative judgements are obviously incompatible with certain interpretations.

More important, as I intimated in Chapter 2, evaluative judgements cannot be differentiated in this respect since they are also open to rational justification. It should be noticed that the non-rational responses or attitudes which underlie reasoning involve evaluations. Responses of wonder, delight, excitement and disappointment, for instance, are clearly evaluations of their objects, and these responses and evaluations may change on reflection, or as a result of recognizing the cogency of reasons for a different point of view. Thus arts education, for instance, is inevitably

concerned with the education of value-judgements; with what counts as good within the particular art form. Suprisingly often one encounters scepticism about the rationality of a certain area of discourse or activity on the grounds that values are involved in it. Yet to be inducted into *any* subject, discipline, or area of knowledge *is* to learn to grasp its criteria of value. One has, for instance, to learn what counts as good, better, or worse reasoning or evidence, and clearly to judge evidence as good and reasoning as weak *is* to evaluate. Thus one could not be said to understand a subject unless one had learned to evaluate by its criteria. Moreover, as Holland (1980, p. 24) puts it:

Those for example who profess enthusiasm for everything in music from Bach to boogie must actually be indifferent to music or interested in it solely as a diversion, otherwise it would matter to them what kind of music they heard... How much a person cares about a pursuit, whether it means much or little to him is attested by the liveliness of his appreciation of the distinction between the superior and the inferior in that *genre*, between the genuine and the faked, the impeccable and the slipshod.

Discussing the long history of philosophers, expecially of the empiricist tradition, who have persistently misconstrued value-judgements as mere subjectivist feelings or intuitions, in sharp contrast to those areas of knowledge which supposedly deal in value-aseptic logic and facts, Bambrough (1979, p. 106) writes:

Value, far from being contrasted with fact and logic as swamp with firm ground, or little sister with big twin brothers, is more fundamental than either...Neither logic nor history nor physics nor philosophy nor any other sphere in which this is *preferred* to that, where one view may and must be compared in *soundness* with another, where reasons may be adjudged good or bad, strong or weak, can be a point of vantage from which a philosopher may look down on the concept of value, unless we talk of looking down to mark the necessary but rare recognition that here if anywhere is the bedrock in search of which so many philosophers have scanned the sky.

It is surprising how persistent is the assumption that evaluation is purely subjective. For instance, people sometimes say: 'Oh, that's just a value-judgement', as if nothing more can be said since, it is assumed, value-judgements are unsupportably subjective. Yet of course one can and frequently does offer reasons in support of one's value-judgements,

Questions

and not only in the arts. One may be mistaken, there may be disagreements, but such possibilities presuppose rationality.

This assumption is part of the prevalent notion that artistic appreciation is, or is primarily, an expression of personal likes and dislikes. One is reminded of the 'Boo-Hurrah' theory of ethics, that is, the notion that moral judgements amount merely to non-rational boos or hurrahs of approval or disapproval.

Despite the prevalence of this assumption, it is difficult to give any sense to the notion that evaluative judgements are, or can be reduced to, mere personal preferences, or subjective likes and dislikes. Much of the argument of this book is devoted to exposing that fallacy and related ones, but there are immediately obvious objections which can be raised against it. For example, a consequence would be that it would be impossible to distinguish between evaluative judgements and likes and dislikes, whereas this is a distinction which obviously can be made. On such a view, the sentence 'He is a superb operatic tenor, but I dislike operatic tenors' would be self-contradictory, or it would have to be denied that 'superb' is an evaluative term, which is implausible. Similarly, we can and often do distinguish between liking and artistically evaluating films and television programmes. Someone might like Dallas, while recognizing that it has no artistic value whatsoever. Conversely, someone may recognize that Shakespeare's plays are great art, while not particularly liking them.

A largely contributory factor to this misconception is the assumption that when reasoning is appropriate it is always possible to reach definitive conclusions. Yet, as we saw in Chapter 2, that assumption is equally mistaken in other disciplines, such as the sciences. That reasons can be adduced in support of evaluative judgements does not imply that where there are disagreements it is necessarily the case that they can be resolved by rational argument.

It should be emphasized again that there could be no place in education for artistic appreciation if it consisted merely in statements expressing non-rational personal preferences.

This point should not be misunderstood. It clearly is an important aim of arts education to encourage a genuine love of the arts, a desire to engage in them, and a recognition of how much is to be gained from involvement with them. It is an aim of education to encourage students' likes and dislikes to coincide as far as possible with their evaluative judgements.

Beauty

It is frequently assumed that artistic appreciation is centrally or even exclusively concerned with questions of beauty. Thus it is sometimes objected that although reasons are important for interpretation, it is not clear how they can apply to such explicitly evaluative judgements as 'This is a beautiful painting'.

The question of value has been considered above. There are two further issues here. First, it seems to me equally strange to claim that reasons cannot be given for one's judgement that something is beautiful. Even in the case of natural phenomena such as sunsets and landscapes, one could give reasons to support one's judgement. That someone may not accept them, or may fail to recognize their point, tells as little against the possibility of rational support in this area as it does, for instance, in the sciences. As we saw in Chapter 2, reasons may be given which may allow someone to see a situation or a work of art under a different aspect, so that he sees beauty where he did not see it previously.

Secondly, this assumption may to some extent reflect the conflation of the aesthetic and the artistic which will be considered in Chapter 11. Moreover, although it is true that judgements of beauty have traditionally been assumed to be central to artistic appreciation, and thus have been central to philosophical debate, this assumption seems to me obviously mistaken, and it is surprising that it continues to be so prevalent. Terms such as 'beauty' appear very little in informed discussion of the arts, for instance, by knowledgeable critics. If someone were to express his opinion of music, concerts, plays, paintings, dance performances, and literary works such as poems and, say, the novels of Dostoevsky and George Eliot in terms of 'They are (or are not) beautiful', or some similar comment, and if these were the only kinds of comment he made, that would be a good ground for denying, or at least entertaining grave scepticism about, his capacity for artistic appreciation.

In my view it is doubtful whether there are any terms which are typical or characteristic of artistic appreciation, and I shall offer a reason for this in Chapter 11. However, I would suggest that terms such as 'sensitive', 'imaginative', 'carefully observed', 'lively' and 'perceptive insights' are far more often used.

Questions

Art and Science

To repeat, since the issue is important and has been misunderstood, I am certainly not arguing that scientific methods are parallel to, or can be used in, the support given to artistic judgements, but that judgements in the two areas are open to rational justification. The difficulty of grasping the point may stem from the common assumption that the scientific is the paradigm, the standard, by which other claims to rationality are assessed. Yet what this amounts to is a confusion of standards. As an illustration, consider the contention, from the recent history of philosophy, that not even scientific propositions for which there is the soundest possible empirical evidence can be regarded as certain since they do not have the infallibility of the deductive knowledge of, say, mathematics. Thus, for instance, on this view, although the sun may have risen every morning of recorded history, this cannot justify my claim to know that it will rise tomorrow, since it is *logically* possible that it will not. But questions of logical possibility are irrelevant. My claim is justified by the fact that there is sound empirical evidence - that is what justification amounts to in this context. It would be a similar confusion to deny that I can know that a window will break if I hit it hard with a hammer, on the grounds that there is no logical contradiction involved in asserting that it will not break. I know for certain that it will break, because windows always do break in such circumstances, and logical possibilities are irrelevant.

It is a confusion of standards to regard the deductive as *the* paradigm to which any scientific claim must attain if it is to be regarded as knowledge. It is equally a confusion of standards to regard the scientific as the paradigm to which moral, religious and artistic judgements must attain if they are to be genuinely rational.

To say that scientific judgements cannot be certain because they do not have the deductive certainty of mathematics and the syllogism is merely to say that induction is not deduction – or that science is not mathematics. Similarly to say that artistic judgements are not rationally supportable because they are not scientifically supportable is merely to say that the arts are not science. That is a truism. What is important is to recognize that there are kinds of rational justification *other* than the scientific.

Nevertheless, since I do argue that judgements in both spheres are rationally justifiable, it is incumbent upon me to show the relevant similarities between them. Doubts are sometimes expressed about whether

there is such a parallel. For example, if we compare the possibility of proof in the two areas, it may seem that there is a significant difference. Consider the following:

- (a) Philip believes that Rembrandt's portraits have no artistic merit.
- (b) Philip believes that water freezes at 100°C.

There may seem to be a contrast between the two cases in that whereas in (b) a proof of the mistaken belief can be achieved by a simple empirical test or observation, there is no parallel in the case of (a). Yet (b) is not the straightforward case of an empirically verifiable proposition which it initially appears to be, for it would make no sense to say that Philip *understands* the Centigrade system and still needs empirical evidence to convince him that water does not freeze at 100°C. The very *sense* of the Centigrade scale is given by 0° freezing and 100° boiling. Philip's mistake is conceptual, not empirical – rather as it would be if he wanted to measure a foot to confirm that it was twelve inches long. He does not understand the Centigrade system.

Similarly, it would make no sense to say that Philip understands Western art and yet can seriously assert that Rembrandt's portraits have no artistic merit. Whether or not he dislikes them, if he is unable to recognize in them *any* artistic merit, even of technique, for instance, that would be a good ground for saying, analogously, that he simply has no understanding of what *constitutes* good painting.

The cases are parallel, in that in both Philip's failure is one of conceptual grasp, and the proof in each case will consist in helping him to grasp the concept.

It has also been objected that whereas no one could deny that 2 + 2 = 4, this contrasts with the differences of opinion which so often arise about the meaning and value of a work of art. This marks a significant distinction between the two cases, the objection continues, with respect to the possibility of giving reasons in justification. But the example fails to provide a parity of cases, since a simple case from one area is compared with a complex case from the other. A legitimate comparison with 2 + 2 = 4' might be '*King Lear* is a tragedy'. No one could understand the play, and the concepts of tragedy and comedy, and still believe that *King Lear* might be a comedy, any more than he could understand numbers and believe that 2 + 2 = 5. Parity of cases reveals parity of answerability to rational justification.

The cases cited above are those in which disagreement immediately

Questions

reveals a failure of understanding. Most cases in science and art are not like this. In science the more usual cases are those in which someone understands the relevant concepts and can be offered empirical proof. Similarly, in the arts someone who understands the relevant concepts could, for example, be shown, where he had previously failed to recognize it, that certain passages in Chaucer or Jane Austen are ironic; or he could be given reasons for recognizing the underlying melancholy in a Shakespearian comedy such as *Twelfth Night*.

Truth

Another serious misconception is expressed in the objection that a significant difference between them is that the sciences are concerned with the truth, whereas the arts are much more a matter of imagination.

It may already be clear from what has been said about interpretation that the objection implies a naïve and ultimately incoherent or at least irrelevant notion of truth, since scientific truth is given by theoretical interpretation, an understanding of which requires imagination. Scientific discovery, the search for truth, as we have seen, is not simply a matter of accurate sensory perception but also requires imagination. It is a fallacy to assume that truth and imagination are distinct and perhaps incompatible notions since it may require imagination, in any sphere, to reach the truth.

There are two principal points to be made with respect to the arts. (a) Even if the value of the arts were to lie not in the truths they express but rather in presenting imaginary situations, there are criteria for the effectiveness with which they succeed in achieving this, and these criteria can be adduced as reasons in support of judgements. (b) More important, it is often a mark of the greatness of a work of art precisely that it *does* reveal profound truths about the human condition. To take a clear case, an allegorical work such as St-Exupéry's *Le Petit Prince* reveals truths about humanity through wholly imaginary situations.

Reading Meanings In

Another persistent misconception is that, unlike the sciences, any values and meanings attributed to the arts are merely read in. This is simply another version of the misconception inherent in the notion that beauty

is in the eye of the beholder, that is, that the characteristics cited as reasons for artistic judgements are mere subjective projections of the spectator. Again, a consequence of such an assumption would be that the notions of valid interpretation, and thus of artistic meaning, would make no sense. Yet, on the contrary, it is precisely the mark of a valid interpretation that it is not read in, but is supported by features of the work. To the extent that it is read in it is invalid. To be valid, a judgement has, for instance, to be supported by the text. Thus there is an exact parallel with the sciences where a valid conclusion has to be supported by the evidence.

Of course, such reading in occurs, in both disciplines, perhaps as a consequence of trying to fit recalcitrant evidence to a theory in the sciences, or of approaching a work of art with certain predispositions. Yet this is equally distorting in, and contrary to the character of, both disciplines, and in both it is important to learn to avoid any such tendency. Education in artistic appreciation consists in learning to recognize and eradicate readings in, and in developing the ability to discern increasingly perceptive interpretations and evaluations of, the works of art themselves.

The same misapprehension often arises over the notion of feeling in the arts. For example, Reid (1931, p. 79) writes of the feelings expressed in art that they ' ... belong, analytically and abstractly regarded, to the side of the subject and not the object'. It may immediately strike some as undeniable that at least with respect to feelings subjectivity has to be conceded, since a painting, for instance, cannot feel sad. I shall consider this issue in later chapters, but such a reaction ignores a central problem of aesthetics which is parallel to some of the issues discussed above. There is an important distinction which tends to be overlooked. The feelings expressed in Picasso's Guernica, in the poetry of Gerard Manley Hopkins, in Beethoven's Ninth Symphony, and numerous other works, are qualities of the works. These qualities may not coincide with how one may happen to feel in response to them. One may recognize that a work expresses sadness while having a quite different response to it. It is important to distinguish between what one may just happen to feel in response to a work of art, and the feelings which are expressed in it.

While it is, of course, true that only animate beings can *have* feelings, it is equally true that a work of art can *be* sad, or can express sadness, and the quality of sadness is as much a quality of the work as it is a quality of a person when he is sad.

Questions

A further very important factor here is the frequent conflation of two senses in which feelings can be said to be subjective. As a consequence, a point about feelings which is trivially true is conflated with a point about feelings which is radically mistaken, and thus the *latter* is assumed to be obviously true. (a) In the first sense, to say that a feeling is subjective is to say that it is felt by someone, and it is, of course, trivially true that only people (and animals) can have feelings. (b) In the second sense, to say that something is subjective is to deny that there can be any limits, and thus to say that feelings are subjective is to deny that there can be any sense in the notion of *appropriateness* of feelings. While (a) is obviously true, (b) is radically mistaken, for there are as obviously appropriate feelings in response to a work of art as there are to situations in life. For example, in normal circumstances. we should be at a loss what to make of someone who, when offered an ordinary toasted crumpet, responded with extreme fear. Such a response would be so inappropriate as to raise questions about his mental state. However, the important point I want to bring out is the danger of sliding between, or conflating, (a) and (b), so that a platitude is confused with a falsehood. This conflation of two senses of 'subjective' partly explains how one of the most fundamentally damaging misconceptions about artistic judgements, namely, that because they may be partly expressions of feeling the notion of appropriateness and answerability to reason is out of place, can appear to be obviously true.

Artistic judgements are often partly an expression of one's feeling about a work, but one can give reasons for the feeling by reference to features of the work.

Judgement

A similar confusion can arise from taking human judgements to be necessarily subjective. A prominent figure in educational drama, when asked whether he had really meant that all judgements by drama teachers were subjective, expressed surprise and replied: 'What other kind of judgements could there be?' To which the obvious reply was: 'Objective judgements.'

Of course, like the parallel case of 'feeling' discussed above, he may have been using 'subjective' to be entailed by 'judgement'. That is unexceptionable except that it may tend to obscure an important distinction between those judgements which are unduly influenced, for instance, by prejudice or predisposition, and those which are based on the

evidence, or on qualities of the object or situation. An example will illustrate the confusion which can arise. I once heard a young teacher, in support of his contention that all human judgement is subjective, cite the assessment of trainees on teaching practice in school, which, he said, is always 'disgracefully subjective'. The use of the pejorative, of course, reveals the confusion since it clearly implies that such judgements should, and therefore could, be objective.

We do not always know which kind of judgement we are making. One might, for instance, make what one fully believed to be an objective appraisal of music, drama, or dance only to realize later that one had been unduly influenced by a mood, prejudice, or other misleading predisposition. Such a possibility does not in the least, as we have seen before, invalidate the distinction. Indeed, we should be keenly and increasingly aware of it if we wish to extend our capacity for artistic appreciation. The reasons given in support of judgements should be based on the qualities of the work.

Sometimes what underlies the tendency to insist that all judgements must be subjective is the notion that judgements are made by human beings, and thus they depend upon our constitution and cannot be guaranteed infallible. Enough has been said about this notion in Chapter 2. There seems to be, underlying it, a craving for an unintelligible ideal of knowledge as beyond human conception. It should be recognized that according to this usage scientific and mathematical judgements are equally subjective.

There are, of course, important differences between mathematical or scientific judgements and artistic judgements. One important difference is that personal involvement is implied in the arts, whereas in the sciences it is more normal to accept conclusions reached by others. In relation to cars and electrical appliances, for instance, we just use conclusions without knowing how they were reached. In the arts, by contrast, it is doubtful whether one can be said even to understand a judgement which one has not reasoned through for oneself. Also by contrast, an artistic judgement commits one much more personally, in that the making of it implies one's own first-hand experience of the work. If I were to say 'George Eliot's Middlemarch is a fine novel, but I have never read it', there is an oddity about my remark which is not present if I were to say 'A Rolls Royce is a fine motor car, but I have never driven one'. One could, with propriety, say 'I am told that it is a fine novel', but that is not the same thing, and concedes my point. This characteristic, that artistic judgements cannot be made at second-hand, misleads some into assuming that they are subjective

Questions

in the sense that *all* that is expressed in them is a personal commitment or attitude. It is true that an artistic judgement may partly express the feeling or attitude of the speaker, but the subjectivist exaggerates this to the point of *equating* an artistic judgement with an attitude or feeling, which is usually construed as a mere personal preference. But this is to ignore the equally important *content* of that judgement, namely, the question of its truth or falsity, or whether it can be rationally supported. That is, while an artistic judgement expresses a personal attitude to a personal experience, there are *reasons* for it. The subjectivist does not so much put the cart before the horse as ignore the horse altogether. For he ignores that on which the personal attitude or commitment is based.

That artistic judgements may be partly expressions of feeling, involving personal commitment, does not, then, imply that artistic appreciation is a matter of personal preference, prejudice, or predilection. The judgement expressing the feeling and commitment is answerable to reason, in the sense that one could give reasons for it, and it could in principle be changed by more cogent reasons or reflection. In spheres such as morality and the arts, where feeling and personal involvement are so central, it is if anything even more important than in other spheres, though possibly more difficult, to make judgements which are rationally supportable. Moreover, it is of the first importance that education in the arts and morality should extend students' capacity for making and recognizing the validity of such judgements. Only in that way can one escape the restrictions of predispositions, and enlarge one's horizons.

Reason and Individuality

A related tendency is to assume that the individuality which is such an important characteristic of involvement with the arts commits one to subjectivism and is thus incompatible with the answerability to reason of artistic judgements. Yet so far from there being any incompatibility between the two notions, the possibility of artistic individuality presupposes the shared criteria of an art form which allows for the adducing of reasons. This issue will be discussed in later chapters, but it is worth mentioning now because it is so often assumed that individuality implies subjectivism.

For clarity, it is worth discussing the question in terms of the parallel, if not equivalent, issue of objectivity. In relation to moral judgements Bambrough (1979, pp. 32-3) writes:

To suggest that there is a *right* answer to a moral problem is at once to be accused of or credited with a belief in moral absolutes. But it is no more necessary to believe in moral absolutes in order to believe in moral objectivity than it is to believe in the existence of absolute space or absolute time in order to believe in the objectivity of temporal and spatial relations and of judgements about them... The fact that a tailor needs to make a different suit for each of us, and that no non-trivial specification of what a suit has to be like in order to fit its wearer will be without exceptions, does not mean that there are no rights and wrongs about the question whether your suit or mine is a good fit. On the contrary: it is precisely because he seeks to provide for each of us a suit that will have the *right* fit that the tailor must take account of our individualities of build. In pursuit of the objectively correct solution of his practical problem he must be decisively influenced by the relativity of the fit of clothes to wearer.

Similar examples may be indefinitely multiplied. Children of different ages require different amounts and kinds of food; different patients in different conditions need different drugs and operations; the farmer does not treat all his cows or all his fields alike. Circumstances objectively alter cases.

The same consideration applies to the arts. For example, the good teacher, at any level, will be concerned with what is right for each student and with the development of each student's individual abilities. Yet, so far from there being any incompatibility between them, the possibility of individual expression and interpretation requires a grasp of the criteria of an art form which gives sense to the notion of reasons given within it. Again, in principle, the situation is the same in other disciplines. Scientific progress, for instance, requires individual freedom for innovation, but that is possible and makes sense only by reference to the canons of what counts as sound and unsound evidence.

The anxiety sometimes arises that the notion of answerability to reason in the arts implies artistic authoritarianism. For example, doubts of this kind are sometimes expressed in questions such as: 'If the creation and appreciation of the arts are answerable to reason, that implies that there is a correct interpretation or evaluation of, and a correct way to create, a work of art, in which case who decides what is correct?' There are two important misconceptions in the first part of the question. Enough has been said to dispel the fallacy that rationality implies a single correct interpretation or evaluation. Answerability to reason does not mean definitive answers of that kind. Changes of conception have occurred even in the most soundly established scientific theories. Moreover, secondly, the notion of a difference of opinion, so far from supporting subjectivism, is

Questions

unintelligible on a subjectivist basis. If you and I disagree, there is a position which one of us asserts and the other denies, and an implicit *agreement* between us about what objectively counts as a reason of the kind which would settle the issue, or at least offer support to one or the other. Without such a background of agreed grounds of rationality no sense could be made of the notion of disagreement. On a subjectivist basis a 'disagreement' would amount merely to personal likes and dislikes passing each other by. Disagreements are characteristic of the sciences not despite but because of their being rational disciplines. The objective criteria of the subject gives sense to what counts as support for the contending positions, and therefore to the notion of disagreement.

The second part of the question, 'Who decides what is correct?', reveals a common misconception, which can be exposed by asking the parallel question 'Who decides that 2 + 2 = 4?'. In this case the incoherence of the question is obvious. We do not accept the latter because of some authoritarian edict, and no one *compels* scientists to accept a particular conclusion for which there is overwhelming evidence. To decline to accept such a conclusion, at least provisionally and in the absence of sound countervailing reasons or evidence, is a manifestation not of individuality but of a failure to have understood the scientific discipline. Similarly, to decline to accept an interpretation of a novel or play for which the textual evidence is overwhelming and in the absence of countervailing reasons is a manifestation not of unfettered individuality but of a failure to more determined individuality but of a failure to more determined and in the absence of countervailing reasons is a manifestation not of unfettered individuality but of a failure to understand the work and the relevant concept of art. The question of obeying or disobeying an authority does not come into it.

In fact, so far from conducing to authoritarianism, a genuine commitment to rationality precludes it, *because* a judgement has to be answerable not to edict but to reasons. Moreover, one's judgement may have to be modified or rejected in the light of sound reasons for a better interpretation or evaluation. Thus a commitment to rationality implies the repudiation of dogmatism, and any attempt to impose interpretation or evaluation by the exercise of authority. If anything, the danger of authoritarianism is greater from the subjectivist, since there is no way in which he can be shown to be wrong.

It may now be apparent that, in this sense, subjectivism is self-defeating. It arises largely as a result of a commendable and correct emphasis on individuality expressed in the possibility of differences of opinion. Yet differences of opinion are possible only if there can be an exchange of reasons for one's judgements, if there is agreement about what counts as a valid reason and if there is agreement about the issue which is in dispute.

Artistic appreciation is certainly an individual matter, in that fully to appreciate a work of art one must have experienced and thought about it for oneself. But so far from implying, that precludes subjectivism. What can thought here amount to if it is not thought about the work? The response is not simply a subjective experience; it does not depend solely upon the constitution or attitude of the spectator. The point becomes particularly clear, perhaps, when one considers not discussion with others, but working out one's own interpretations and evaluations of art. To focus on the formulation of one's own opinion underlines the fact that the work is independent of the spectator, and his response is given by his understanding of it. Although there can and should be individual responses, and perhaps differences of interpretation, such differences and individuality are possibilities which have and arise from limits. Beyond certain limits, as we saw in Chapter 2, one's response would not be an expression of individuality, but of lack of understanding. Not anything can count as a response to a work of art, just as not anything can count as a reason for artistic appreciation.

... nothing changed in Mr. Knott's establishment, because nothing remained, and nothing came or went, because all was a coming and a going.

(Samuel Beckett, 1963, p. 130)

It was argued in Chapter 1 that reasoning derives from learned natural actions and responses. Since the latter are assimilated from the ways of life of a particular society, this raises the questions of (a) how, if at all, one can come to understand the arts of other cultures, or differences of concept within a culture, and (b) how conceptual change is possible. It is, perhaps, largely because conceptual change and differences are so obvious and significant a characteristic of the arts that many are impelled to subjectivism, since it is difficult to see how it is possible to justify one's judgements with reasons. If understanding is rooted in natural actions and responses assimilated from a culture this seems to imply either that there can be no place for objective reasoning, or that reasoning is relative. The notion of an objective reason seems to imply universal validity, in which case it is difficult to see how the judgements made within different concepts of art can be justified by reason. On the other hand, if it is said that the justifying reasons are relative, this seems to be denying a central characteristic of the notion of a reason.

I shall approach the issue via relativism, since it seems to be a consequence of my general thesis, and since it is commonly assumed that schools of thought within a culture, and especially the art forms of different cultures, are entirely discrete in that the judgements within each can be justified only by its own internal canons of validity. The question I shall consider is, then, whether the reasons to which artistic judgements are

answerable are relative. As so often in philosophy, much depends on what is meant by the term. There is unquestionably a sense in which artistic appreciation is relative to socio-historical context, in that certain concepts may not have been available as possible factors in judgements at other places or periods. To take an obvious example, Freudian interpretations of the arts would not have been possible in pre-Freudian times. Moreover, different schools of thought, or approaches to art, incorporate different criteria.

It is worth a brief digression to explain what I mean by the term 'criterion'. I shall use it to mean 'necessarily a reason for'. Its meaning can be brought out by contrasting it with evidence. If, through my window, I see people walking past with raincoats on and umbrellas up. this is evidence that it is raining. If I put my hand out of the window and feel cold, wet drops, this is a criterion of its raining. Thus a criterion is directly related to meaning. It would be quite possible to know what 'It is raining' means without knowing that people put up umbrellas when it rains, but if in normal circumstances someone who feels the cold, wet drops does not know that this is a ground for saying that it is raining, then he does not understand what it means to say that it is raining. It should be noticed that a criterion is not equivalent to a sufficient condition. One could easily imagine cases where there were cold, wet drops even though it was not raining. There is much more which could be said about the notion of the criterion, but it is not necessary for the purposes of my argument.

In relation specifically to the arts, a criterion is necessarily a reason both for what counts as art and by which good art can be distinguished from poor art. Similarly, for instance, if a criterion of something's being a knife is that it is an instrument used for cutting, then a criterion for a good knife is that it should be an instrument which cuts well. In the case of the arts, the change from purely representational art to impressionism or abstract expressionism involved changes of criteria. Where formerly a criterion for what counted as art, and as good art, was accuracy of representation, this was changed to different criteria in the new concept. Clearly there is a close relation between criteria and concepts in that a criterion is an expression of a concept; where concept or meaning changes, so will the criteria.

To return, then, to the issue of the criteria of different concepts of art, the problem we are considering can be seen clearly in cases of conceptual innovation. Thus the question might arise whether *Finnegans Wake* is a novel. Consider the slighting remarks by critics when Martha Graham's

Dance Company first came to Britain; how the terms 'impressionism' and 'fauvism' were first used dismissively by critics of the respective styles of painting. There are numerous other examples, such as serialization in music, Henry Moore and Barbara Hepworth, Ingmar Bergman and Samuel Beckett. Each introduced a conceptual innovation requiring such a readjustment in the grounds of artistic judgement that many people were unable to make it. Such readjustments would certainly be no easier for the knowledgeable and perceptive since they might be more prone to a hardening of the conceptual arteries. Many, inevitably, continued to refer to the old concepts of art as grounds to judge the new works which were changing the concepts of art. Hence a work did not qualify even for the pejorative extreme on the scale of critical judgement, since it could not be understood as *art* at all – it was not even a painting, but merely an impression; the perpetrators were as crazy as wild beasts.

The problem of understanding conceptual differences can be most sharply brought out by considering the arts of very different cultures. There is a great temptation to say, and obviously some point in saying, that judgements, and the reasons given for them, must be relative to the cultures. Nevertheless, they cannot be entirely relative, if by that is meant that they involve criteria which bear no relation whatsoever to any other. For to be able to recognize something as even very different art, dance, drama, music, and so on, in another culture necessarily presupposes some overlap with our concepts. If someone were to claim that an activity of another culture, which bore no relation whatsoever to art in ours, should be regarded as their art, we should be at a loss to know why he wanted to use the term 'art' for it at all. Wittgenstein writes (1969, §599): 'To say: in the end we can only adduce such grounds as we hold to be grounds, is to say nothing at all.' That is, we can operate only with the concepts we have, and which give meaning to the terms we use. If it were asserted that the concept of art in another society was nothing like ours, then the assertion would be meaningless. For example, imagine that someone were to say that it is possible that there could be a different concept of mathematics such that 2 + 2 = 5, where this was not merely a terminological difference, that is, where the supposition is not that '5' in their language is equivalent to '4' in ours. The supposition is meaningless. To make the point with an apparent truism, an activity can be understood as mathematics only if it can be understood as mathematics. The same applies to art.

It is sometimes assumed or argued, because of its peculiarly innovative character and its being subject to frequent and radical change, that the

concept of art has no boundaries, and thus that *anything* can be understood as art. Yet those who argue in this way inevitably have implicitly to presuppose what they are explicitly denying, since only if 'art' has meaning can such a claim be made, and to say that the concept has no boundaries is to say that 'art' has no meaning. For example, attempts are sometimes made to argue that sport is art on the grounds that *any* activity or artefact is art if the creator intended it to be art, and that such an intention is a matter solely for the individual. But it makes no sense to suggest that an intention can be logically indepentent of concepts, practices and context. Intending is not a sort of context-independent subjective wishing or willing. What I am writing on this page cannot become mathematics by my 'intending' it to be so. Or rather, to put the point more clearly, it would make no sense to suggest that I can intend this to be mathematics.

There are, of course, cases where we are uncertain whether to call something art. But it certainly does not follow from the fact that a concept has vague boundaries that it has *no* boundaries. Still less does it follow that in that case anything could be art. On the contrary, if there are no boundaries to the concept, *nothing* can be art.

The overlap which justifies our use of the term 'art' to describe an activity of another culture offers the possibility of coming to understand and appreciate the arts of different cultures, at least to some extent. Examples here are listening for the first time to Japanese music played on the shakuhachi, and to Indian classical music, and watching Oriental dance. One needs to be cautious, though, for whereas an activity may have some relevant overlap, which allows us to call it 'art', it may also have, for instance, a mystical or religious significance in another society which it does not have in ours. It may be only in some respects like art in our culture. Thus one will need to understand the place of the activity in the whole culture.

The problem of relevance should be mentioned here and one aspect of it will be considered in Chapter 11. What I have in mind is that *some* similarity can be found between *any* two objects or activities, so the overlap has to be in *relevant* respects. Given the complexity of the concept of art it is, of course, impossible to state precisely what would count as a relevant overlap, since that would amount to saying that 'art' can be defined, in terms of necessary and sufficient conditions. The fact that 'art' has, and necessarily has, vague boundaries renders it commensurately difficult to state what counts as relevant. Nevertheless, it is possible to indicate in a general way some of the kinds of consideration which would

count. For example, I argue in later chapters that an art form must allow for the possibility of the expression of issues from life and that the object of one's attention and feeling may be fictional. Moreover, there is an important sense in which the concept of art is non-purposive, by which I mean that any supposed 'purpose' of a work of art cannot be identified apart from the artistic means of achieving it, which is the same as saying that, in the arts, there is no distinction between means and end. (I consider this issue more fully elsewhere; see Best, 1978, ch. 7.)

In practice it may be rare for someone of another culture to develop the complete grasp which is possible for a native. This is, of course, equally true of language. In relation to prayer, Simone Weil writes: 'Except in special cases the soul is not able to abandon itself utterly when it has to make the slight effort of seeking for the words in a foreign language, even when this language is well known' (1951, p. 117). The difficulty is largely created by the fact that both art and language are not independent, but are inextricably interwoven into the whole way of life of a society. This is a consequence of the issue discussed in Chapter 1, that both are grounded in natural ways of acting and responding, and it also relates to the question of the relation of art to life, which will be examined in Chapter 12.

However, to anticipate an issue which I shall discuss further shortly, it is important to distinguish between what is possible in principle, and what is possible in practice. That even a complete grasp of a foreign language is possible is shown by cases such as Conrad. But such cases are very rare. It will be clear from what has been said earlier that the possibility of

It will be clear from what has been said earlier that the possibility of coming to understand the arts of a different culture depends upon the possibility of sharing responses to them. In Chapter 1, I gave the artificial example of a foreigner with no grasp of the conventions of drama or any related activity. As I pointed out, it is difficult if not impossible to imagine a society in which there were *no* such related activities as children's make-believe, stories, and so on, to which they had learned to respond, and which would give some overlap with drama in our society.

As we have seen, the attitude which one assimilates as the substratum of artistic understanding is not subjective, in the sense that it can be adopted at will, or that any such attitude would be equally 'appropriate'. Coming to understand *is* in fact coming to respond in a certain way, and the notion of choice does not come into it. Thus there are two related issues here: (a) there are limits on what can count as art and as a response to art, that is, there is no question of choice; (b) one who understands art

cannot choose what counts as a response to it. If someone were persistently to respond in a way, or to reveal an attitude, which was completely at variance with the norms, that would constitute good grounds for saying that he did not understand the art form at all. To have learned to be involved in artistic appreciation just *is* to have acquired such an attitude, revealed in the way one engages in and responds to the arts. There is nothing which justifies one's having such an attitude, since it is that attitude which constitutes the *grounds* of justification and approppriateness.

To repeat the point, because of its importance, understanding the arts, like the ability to use language, is rooted in unhesitating responses to the relevant situations. In the case of the arts this will include, for instance, responding immediately and with emotional involvement to fictional objects. This is why it reveals a radical misconception to ask whether, or suppose that, responding emotionally to what one knows to be a fictional situation or character in a novel, play, or film is irrational. The unhesitating, immediate response is fundamental, and not only in the arts, but in language, mathematics and the sciences; that response is the ground which gives sense to the rational. It is not an unquestioning assumption, and it is not intuitive knowledge, since both assumptions and intuitions are given their sense by the possibility of justification and falsification, and thus by grounds which underlie them. This is not to suggest that one cannot speak of what is expressed in a work of art, or a verbal utterance, as true or false to reality. The point is that natural responses and ways of behaving are the roots of the sense of truth and falsity, and therefore of what counts as sound and unsound reasons. At this level, there can be no room for questions or doubt, since such responses and actions are what gives sense to questions and doubts. Thus it is not intelligible to ask what justifies one's having such an attitude to the arts: such a question is not open, since it is that attitude which constitutes the grounds of justification and appropriateness. The natural responses and actions which are an expression of the artistic attitude are not a consequence of the recognition of artistic qualities, they are fundamentally involved in the formulation of concepts of artistic qualities.

This, again, shows that the reasons given for artistic judgements, which are founded upon such an attitude, must be relative in some sense. In order to bring out my own position, I shall briefly consider an interesting symposium on Objectivity and Aesthetics by Sibley and Tanner (1968). Both symposiasts assume that a genuinely objective judgement requires the possibility of at least a fairly wide measure of agreement, at

least in the perceptive 'elite', even though, as Sibley puts it, this may be more like a concentrated scatter than convergence on a point. Sibley contends that although they may be disagreement *in fact*, objectivity consists in the possibility of achieving widespread agreement. One of Tanner's strongest criticisms of Sibley's case for objective judgements in this sphere is that it depends upon 'a pretty impressive amount of agreement' (p. 63) which, he argues, is in fact lacking.

Since he contends that Sibley overlooks the ways in which, for instance, socio-historical factors can affect artistic judgements, Tanner argues that it is necessary to introduce, in addition to the subjective—objective dichotomy, a third category. He illustrates his point by imagining a case where mankind is divided into two equal groups, and there is a class of objects which is seen by one group as blue, and by the other as yellow. Of this he says (pp. 60-1):

the fact that there *are* two groups shouldn't in the least incline us to say that their judgements are subjective. Equally, we may feel rightly uneasy about saying, simply, that members of each are making *objective* judgements. It looks indeed as if we need... the term 'relativism' and its cognates.

The first point to be made about this example refers back to the translation issue, that is, the appropriateness or otherwise of applying a term from one language to an activity in a different society. The two groups are supposed to agree generally in colour-judgements but to differ over one class of objects. Thus someone in group A could find a B member concurring, for instance, that the sky is blue yet saying that a dress, which A judges to be the same colour, is yellow. B is shown the cloth from which the dress was made, and he agrees that it is blue. He is shown a rag doll being made from part of the dress, and at some stage he agrees that it is blue. Yet he still insists that the dress is 'yellow'. There is at least a serious difficulty about this hypothesis. Clearly there are grounds for saying that he is making colour-judgements, in that in most cases there is a general agreement. Yet, on the other hand, since what he is doing in this case is so completely at variance with what can be understood as making colour-judgements, we also have grounds for doubting whether he is making them. Much depends on how the example is filled out. If this is a single aberration, we might conclude, for instance, that in some odd way this class of objects affects group B's vision. However, if this kind of incident were to occur more generally we might have to conclude that we did not understand what kind of judgements these were, and the use of 'vellow' would be of no help.

More important, Tanner's formulation of the issue suggests that since there may be differences *between* cultures, this precludes the attribution of objectivity to colour-judgements *within* a culture. It is true, and may be part of Tanner's point, that such differences in judgements by people of different cultures cannot be described as differences about objective matters of fact since, because of their different concepts of colour, what *counts* as a fact will be different. The point here is that there is no way to discover what their concepts are *apart from* considering the judgements which they make. There is no standard *external* to those judgements by which they can be judged. If the judgements of the two cultures are radically enough different, this means that they have different concepts. Nevertheless, this does not imply that there cannot be objectivity of normal colour-judgements. That there is no disagreement between two groups who have different colour-judgements within each group.

Both symposiasts accept that objectivity requires the possibility of wide agreement, at least in the 'elite'. Sibley argues that, with qualifications, such agreement is possible, whereas because he believes such agreement is unattainable, Tanner doubts the possibility of objectivity, and introduces the category of relativism.

I submit that the issue can be more clearly discussed in terms of giving reasons in support of judgements. The issue is the same, in that in each case the possibility of reaching agreement will depend upon an initial overlap of conception and natural response or attitude, which will give sense even to the minimal notion that what is under discussion is art rather than something else. It is no help to say that it is proper to speak of an objective judgement only where it agrees with the facts or reality, since what one means by the facts or reality is given by the underlying conception. The notion of the truth or falsity of a proposition presupposes grounds by reference to which it is possible to decide for or against its truth. It is not that we have an independent grasp of the truth which we can apply to a proposition, but that what counts as a proposition is that which carries with it canons of truth and falsity within a particular context or activity. That is, it would make no sense to suppose that the facts or reality give us our picture of the world; it is rather that the picture determines what can count as a fact, and as reality. The same applies to objectivity, and to what can count as a valid reason. Thus, partly because of the misleading connotations of 'objectivity', as being conceptindependent, and partly because it is more germane to my general thesis, I shall continue the discussion primarily in terms of reason.

Two matters should be mentioned before continuing to discuss this issue. First, neither the view that artistic judgements are relative, nor the view that they are capable of universal agreement, lends any support to subjectivism. A reason for an artistic judgement cannot be whatever *I* decide will count as a reason, even if it remains an open question whether the grounds of reason and objectivity are relative or universal. In the former case, what counts as a reason is still grounded in the normal responses and attitudes of a *society*.

Secondly, as we saw in Chapter 2, one can make legitimately objective judgements, or judgements for which one has sound reasons, which may nevertheless be fallible, and which may not be universally true. 'Objective' or 'rationally justifiable' should not be equated with 'infallible' or 'absolute'. There is a tendency to assume an idealized notion of objectivity such that 'objective' can be legitimately predicated of a judgement only if it is absolutely true and infallible. These two notions are often conflated. To say that a judgement is absolutely true is to say that anyone, in any culture, if he reasons correctly, must arrive at that conclusion. To say that a judgement is infallibly true is to say that it is not even in principle open to question. Neither is implied by saying that a judgement is objective. I shall consider the notion of the absolute shortly. In relation to the assumption that 'objective' implies 'infallible', almost the opposite is the case, for that a judgement is objectively true implies, at least frequently, that there must be, in principle, the possibility of showing that it is false.

As we have seen, there are different grounds, and grounds can change. Consequently what counts as rational, or objective, may also be different and may change. This is not an insuperable problem for, but reveals an important yet often misunderstood characteristic of, rationality, which is not universal and timelessly set. Tanner's feeling impelled to propose the *additional* category of relativism seems to reveal this misconception. For rationality and objectivity in any sphere are relative to the grounds of natural action and response which give them sense, and these grounds may be different at different times in the same culture, and in different cultures. Thus the imagined case where mankind is in two equal groups, with different colour-judgements, shows not the necessity for a third category of relativism, but that the grounds of objectivity and rationality may be different. They may also change.

The duck-rabbit figure is a useful illustration. If there were a society with knowledge of ducks but not of rabbits, the question of whether the

figure could be interpreted as a rabbit could not even arise. Yet if rabbits, or illustrations of rabbits, were introduced, this would allow for that interpretation. Different grounds give the possibility of different judgements and reasons to support them. This is a simple analogue of the way in which a concept of art may change, sometimes as a result of contact with a different culture, sometimes as a result of a change in the life of society.

Of course, conceptual differences cannot always be resolved, and changes understood, as simply as this. It is a matter of degree. To the extent that there is *some* overlap, this will give sense to the notion of a disagreement, and with it the possibility in principle of reaching understanding. For example, there are societies where the notion of a moral principle is given its sense only by its application to other members of that society, and where, consequently, robbing, cheating and even killing foreigners is not against the moral code. The overlap of a moral sense which applies within the society gives the possibility of reaching an understanding of a concept of morality which applies universally.

However, sometimes differences cannot be resolved or understood as simply as this. Sometimes they cannot be resolved or understood. If differences are sufficiently great, they cannot intelligibly be regarded as conflicts or disagreements, but rather must be seen as positions which pass each other by. But again, in relation to the arts, the question arises whether, in such a case, there would be any justification for referring to the difference as one of *artistic* understanding or appreciation. The possibility of coming to understand a very different concept, and thus extending one's own notion of what counts as intelligibility, depends upon connections with those concepts which already constitute the grounds of one's present understanding. The more tenuous the connections, or the further the innovation has moved from the grounds which give it sense, the more the innovator is likely to be regarded either as a fool and a heretic (Wittgenstein, 1969, §611), or as a creative genius. This is true, of course, in *any* sphere, not only in the arts.

An interesting problem arises at the limits, for one might feel that there is a sphere of rich artistic experience which is beyond one because one cannot grasp, or at least has not grasped, the relevant grounds of judgement. How can one account for this? Tenuous connections may allow some inchoate sense to this possibility, or one's feeling may be based on respect for the judgements of those whose views one has learned to trust within concepts of art one does understand.

It is the lack of such connecting reasons which justifies one's conviction

of the vapid pretentiousness of purported works in which, for example, one is invited to regard as serious art an artist walking about with a plank on his head, splashing about in mud, or contemplating his navel. Certainly those artistic innovations whose value and significance were not recognized in their own time are salutary reminders of the need for care and open-mindedness. Nevertheless, the onus is on the innovators or their apologists to provide the connections. Moreover, in contrast to the cases cited above, in the case of a genuine but diferent concept of art one may at least be able to recognize technical competence.

Change, and the recognition of different concepts which offer new grounds for rational judgements, are made intelligible only by implicit reference to some of the previous criteria. The logically free judgement is unintelligible. One cannot simply *choose* either to regard something as art, or one's criteria of evaluation. Where there are fundamental differences, to reach an understanding of another concept of art may well involve not so much a single work of art as a different approach to art, just as, in other contexts, it may involve progressively coming to understand not just a single proposition but a whole system of propositions. Moreover, given the relation between art and life which will be discussed in Chapter 12, different grounds of approach to art may often amount to a different *Weltanschauung*, a different conception of life.

Convincing someone of the validity and value of conceptual innovation, in any sphere, thus requires not proof but rather persuasion. This raises the problem of how to convince the sceptic who assumes that, in default of a proof to the contrary, what purports to be the rational discourse of artistic appreciation amounts merely to a thinly disguised, pretentious attempt to justify what are in fact no more than expressions of subjective preferences. The sceptic's demand reveals a fundamental misconception, for the notion of an external proof makes no sense. The only way to convince him is by progressively bringing him to understand the arts. No doubt he would be sceptical, and accuse us of what Tanner calls 'semicircularity'. Yet the same 'semi-circularity' applies to the sceptic's paradigms of reasoning, since in these too the grounds which confer validity on the proof have themselves simply to be accepted. For example, this is true even in the case of the simplest deductive syllogism. In 'All men are mortal, Socrates is a man, therefore Socrates is mortal', the conclusion follows only if one accepts, not only without proof, but without any reason whatsoever, that such a conclusion does follow from such premises.

Given, then, that artistic appreciation is relative to the grounds of natural response and behaviour, to what extent is it possible to reach agreement or understanding between diverging positions? There is a far greater possibility of reaching understanding than is often believed. To repeat, it is important to recognize the distinction between a disagreement or divergence which is of its nature incapable of resolution, and one which will actually, in fact, not be resolved. Even within the same culture and concept of art there are obviously intractable differences of opinion. Moreover, there are cases where each person in the dispute may fully understand the other's interpretation or evaluation of a work even though he does not share it. A similar situation arises in moral disagreements, although again, if one can recognize a position as a moral position, that gives good grounds for the possibility in principle of reaching agreement. Nevertheless, one may come fully to understand a differing opinion without sharing it. For example, one might fully understand and respect opposition to abortion because of a consideration of the sanctity of life, yet still incline to the view that, at least in some circumstances, abortion is justified. In the sciences, too, there may be situations where disagreement may persist although both parties have the same facts. There is still a geoplanarian society, whose members interpret differently the same facts, or construe differently the same observations, as those who are convinced that the earth is spherical. Kuhn (1975) gives other examples. In some such cases, it may cease to have much meaning to continue to insist that a conflict of opinion is resolvable in principle. Each case has to be considered on its merits. Nevertheless, the distinction between what is possible in principle and in practice is a useful one, and the acceptance of the general principle that it is possible to resolve conflict will encourage the search for the common ground or shared response which will provide the basis for a fruitful debate, and with it the possibility of achieving agreement, or at least understanding. It may or may not require a prolonged exploration of each other's positions to find such a shared response and understanding, which may be in an example or analogy to which appeal can be made as to what counts as a valid reason for both sides in the disagreement. Without such a shared response it will not be possible to conduct rational debate, for a genuine disagreement is founded upon a background of shared agreement or response at a more fundamental level. That is, a disagreement is about something, and is thus founded upon an agreement about the position in dispute, and about what counts as supporting or detracting from the conflicting views. It may be difficult to locate those shared foundations of disagreement, and it may require an

extensive exploration of a network of related issues. The same considerations apply to reaching an understanding of a different approach to art, or a different interpretation, for *oneself*, as a result of reflection.

Of course, it is often true that, in practice, one has to recognize the futility of attempting to continue rational debate, or the search for understanding, and this is as true of philosophy and the sciences as it is of morality and the arts. There is, for example, a distinction between having a valid reason, and having a valid reason which the other person can understand. In philosophy generally, as much as in the arts and morality, there are those with whom one does, and those with whom one does not, share a common language. That is, with some one shares assumptions and ways of approaching issues which one cannot take for granted with others. In the latter case debate may be so exhaustingly fundamental that one may regard it as not a fruitful enterprise, or even if one does undertake it, one may not succeed in locating the common ground. But that does not necessarily imply that further fruitful debate is *in principle* impossible. The possibility of further progress may be impeded by a failure of understanding, perhaps on both sides, which further discussion may remove.

Indeed, universal agreement in practice is neither desirable nor even, at least in some cases, coherent. Both a conviction that it is possible *in principle* to resolve problems and conflicts, and the persistence *in practice* of problems and conflicts, are essential for the continued progress and even existence of any area of inquiry. Kuhn (1975) points out, for instance, that contrary to what is often assumed, it is a mark of the fruit-fulness of a scientific theory not that it solves all problems and conflicts, but that it continues to generate problems and conflicts. *Within* areas of disagreement and difference understanding is extended.

What is of particular importance for my argument is that, because of the character especially of the arts and morality, to wish, even if it were conceivable, that there should be a considerable degree of agreement would amount to wishing that people were all the same. Leibniz expressed a profound insight, which would repay much more discussion, when he contended that to come genuinely to understand another person is to see life in *his* terms, and is thus to grasp another *Weltenschauung*, another perspective on the world. Differences of opinion, and perhaps, even more important, debating with *oneself* about the interpretation and evaluation of what is expressed in a work, are central to the character of artistic appreciation. Exchanges of opinion about, or reflecting upon, those issues may give an extended and enriched understanding not only of the arts but of other people and life generally, for considerations other than exclusively

artistic ones are often relevant to fruitful debate and reflection about the arts. This partly anticipates Chapters 11 and 12, where it will be argued that it is a misconception to regard art as entirely autonomous. For example, reflections on moral insights, character traits and personal relationships may be relevant in important ways to considering artistic interpretation and validity. Art is a constituent of an interdependent network of related activities which together provide concepts of truth, reality and value.

I have argued, then, that this inevitable and desirable range of individual variation in response, interpretation and evaluation is not incompatible with objectivity, rationality and the possibility of reaching understanding and perhaps agreement. I have tried to show that it is to mistake the character of rationality, or objectivity, to suppose that a separate category of relativism is necessary, since objectivity and rationality are, in an important sense, relative to their grounds of learned natural action or response.

Moreover, one may be convinced that education should primarily encourage critical, independent thinking, but that is certainly not to imply that it should encourage subjectivity. On the contrary, independent thinking in the arts as much as in science, mathematics and philosophy is not only compatible with but presupposes rationality. What is required is not conformity but that independent thought should be answerable to valid reasons. In that sense rationality is a precondition of the individual differences in the creation and appreciation of the arts which are such significant expressions of the rich diversity in human personality, although it is a fundamental misconception about this issue which is a major source of subjectivism. For example, in arguing the case for answerability to reason, one has sometimes encountered the, usually hostile, objection: 'Who are you to tell me how to interpret or respond to a work of art?' But who am I to tell the subjectivist that $12 \times 12 = 144$? As we have seen in Chapter 3, one can appreciate the hostility if answerability to reason is taken to imply authoritarianism and a denial of the importance of individual response. My argument carries no such implication but, on the contrary, is attempting to offer an intelligible account of originality and individuality. As Wittgenstein puts it (1969, §245): 'There is no subjective sureness that I know something', and (§271) 'a ground is not anything I decide'.

Bambrough (1984, p. 48) writes: 'In every sphere of enquiry the learner may come to question what he has been taught, but when he does

so he is appealing to what he has been taught as well as *against* what he has been taught.'

Some years ago a group of art students in Madrid were so determined to give art a completely fresh start that they wanted to destroy all existing works of art in order to free artists from the supposedly limiting influence of tradition. (I think that they even tried to burn down an art gallery but I forget the details.) But what if they had succeeded, and after the holocaust someone had created a work in the conventional style of one of those destroyed? All memories of art would have to be destroyed too. Yet if they could achieve even that, how could anyone create *any*, still less an original, work of art? For in that circumstance nothing could count as a work of art. Innovation makes sense as such only in a context of a tradition or convention. So if they were able to destroy the conventional they would *ipso facto* be destroying the possibility of originality.

Could the whole of space be six inches to the left? Could everything be twice the size it actually is?

The subjectivist 'ideal' of artistic individualism, in this sense, is selfdefeating. Since it connects with nothing there is nothing against which change, reaction and individuality can make sense.

Mozart's oboe quartet has passages of striking originality, which have similarities to Stravinsky, and some of Turner's later paintings are remarkably like precursors of modern abstract expressionism. In each case what gives sense to the attribution of originality is an implicit reference to a background of contemporary artistic conventions.

Ironically, if subjectivism were intelligible it would be condemned to eternal conservatism, the permanently static, since there would be no ground on which to move. Only a relatively stable background can give sense to the notion of movement. Hence the passage with which I introduced this chapter:

... nothing changed in Mr. Knott's establishment, because nothing remained, and nothing came or went, because all was a coming and a going.

Free Expression

The light dove, cleaving the air in her free flight, and feeling its resistance, might imagine that her flight would be still easier in empty space.

(Kant, 1929, p. 47)

An issue which is closely related to some of the preceding chapters and which has been central to discussion of general educational policy for some years is the conflict between those who emphasize freedom of expression to allow unrestricted individual development and those who emphasize learning the discipline of an activity or subject. Learning the discipline, in this sense, means progressively mastering the techniques and criteria so that, for instance, the valid can be distinguished from the invalid, the more competent from the competent, and the more from the less perceptive. The issue applies equally to the creator and the spectator, and although it is particularly significant in the arts, it raises a question of general educational concern.

Psychology and Philosophy

There has been for many years a reaction against the 'bad old days' of an educational policy whose overriding emphasis was on the formal imparting of knowledge and drill in techniques. But in many spheres the reaction has swung to an equally damaging opposite extreme of permissiveness, sometimes amounting to absurdity and incoherence. In Chapter 2, I gave the example of a professor who refuses to teach the discipline of dance, and to assess her students' work, on the grounds that this would

Free Expression

illegitimately restrict their individual freedom of expression. She insists that there should be no such 'external imposition' of criteria and techniques, but that each student should be free to develop in his or her own way, and to decide what is and what is not of artistic value. Hence she was unable to object to the eating of crisps as a purported dance performance. It has sometimes been objected that this is an extreme example, but although it may be extreme, the dance professor was at least commendably consistent in recognizing the consequences of her subjectivist convictions, unlike those who explicitly propound or accept subjectivism yet who implicitly contradict their theory in practice. For instance, as a consequence of her students' actions, the dance professor lost her job, although she had merely carried consistently to its logical conclusion a policy towards her subject which was well known to and therefore presumably implicitly approved by those who employed her. It was they who were inconsistent, since they also felt that it was incumbent on them as responsible educationists to require their teachers to help students to attain higher standards. In this they were right, since clearly no one can teach without some form of assessment. A teacher needs to know whether and to what extent his students are understanding and learning, and to achieve such knowledge is assessment. To fail to assess is to fail to teach properly. What form that assessment should take is, of course, another matter.

The misconception in this kind of subjective policy can be illustrated by the case of language-learning. As we saw in Chapter 2, a language is an expression of a conception of reality, so that in learning the discipline of correct linguistic usage a child is learning to see and understand the world in terms of that language. But it would be palpably absurd to suggest that this understanding is restrictive, and that for *real* freedom of individual development each child should grow up alone on a desert island, where he could form his own concepts and understanding of the world, free from conformist influences. Clearly, so far from conferring greater freedom of thought, this would severely limit the child's possible freedom of thought and individual development. A person with an inadequate grasp of reading, spelling, grammar and vocabulary incurs a limitation of possibility of free expression and individual development.

Nevertheless, even though it may have been exaggerated, there is an important truth underlying this 'free expression' approach. It arose as a reaction against an educational policy which undoubtedly was restrictive in, for example, elevating the ability to write grammatically to the status

of an end in itself, rather than regarding it as a means to the end of making possible greater freedom of expression. Thus imagination was stifled in an over-emphasis on stringent standards in modes of expression at the expense of a concern for what was expressed.

Some individuality managed to survive the conformist pressures, yet it underlines the point I am making that even a D. H. Lawrence was free to castigate the system *only* because he had mastered the disciplines conferred by that system. For instance, he condemned too much reasoning as morally and emotionally crippling, in that, in his view, it leads to a calculating and insufficiently spontaneous nature. Yet, inevitably, he had to support this contention with persuasive reasoning.

The philosophical misconception which seems still to underlie some educational thought is that to have the opportunity for *really* free individual development is to have been exposed to *no* influence, to have acquired *no* discipline, to have received *no* teaching. The conceptual error encapsulated in that kind of assumption is aptly exposed in the quotation from Kant at the beginning of this chapter.

There are two factors which contribute to this erroneous assumption, of which the first is a failure to distinguish between the psychological and philosophical issues involved. The valid insight of the 'free expression' school of thought is a psychological one, namely, that there are attitudes to and methods of teaching which can stifle individuality, imagination and self-confidence. This is quite distinct from the philosophical point for which I am arguing, namely, that if certain disciplines are not acquired, whether of language, the arts, or any other subject, students are not allowed but *deprived of* certain possibilities for freedom of expression and individuality.

Perhaps the confusion arises in this way. It is correctly recognized that *some* teaching of disciplines leads to restrictions on freedom, and from this it is erroneously assumed, at least implicitly, that to remove *all* teaching disciplines is to remove *all* restrictions on freedom. Thus a valid psychological insight is taken to the invalid extreme of a conceptual confusion.

A contributory factor, then, to this misconception is a conflation of the psychological and the philosophical issues, as a consequence of which 'free expression' is assumed to be incompatible with assessment, technical competence and the learning of objective criteria. In fact there is not necessarily any incompatibility here. It is quite consistent to maintain that a 'free' approach is the most effective method of attaining competence in the discipline without restricting individuality. 'Free' does *not*

Free Expression

mean the same as 'random' or 'arbitrary'. Someone who seriously insists that 3×7 equals whatever he feels he wants it to equal is exhibiting not freedom and individuality, but a failure of understanding.

Individual and Social

The second contributory factor to this subjectivist confusion is more complex and brings up an issue which is central to the argument of this book. It arises from a common misapprehension about the individuality of a person, and is underlain by a failure to recognize the intimate interdependence between the identity of an individual person and the character of society. It is obvious that a society is necessarily composed of individual people, but less obvious is the converse relation which is of greater significance for my argument, namely, the way in which individual personality is logically dependent on the language and practices of a society.

The subjectivist tendency is to conceive of the individual personality as an entity logically distinct from its social context; to think of the real person, what he really is, his essential individuality, as that which underlies and is independent of 'extraneous' factors such as the social practices in which he engages. This misleading tendency is sometimes manifested in theories of 'self-actualization' and 'self-realization', which imply that the real character of the individual can be fully revealed only by seeing through such distorting and irrelevant 'accretions'. This kind of assumption is particularly tempting where someone exhibits disparate and perhaps conflicting dispositions and attitudes. Yet the individual personality cannot coherently be regarded as something quite distinct from what he does and says. It is possible to make sense of the notion of individual personality apart from some, but certainly not from all, his actions. Clearly what he says depends upon the social practice of language. Less obvious, perhaps, is that what he does is also, to a large extent, dependent on social practices which he learns as he grows up in a community. For example, his paying for something depends upon the social institution of money and financial exchange.

One can appreciate why the subjectivist regards linguistic and artistic disciplines as inhibiting, for they appear to be extraneous influences, obscuring a person's essential character and hindering its free and natural development. Yet this kind of conception is fundamentally mistaken, and not only with respect to the arts. Discussing the question of how we can understand other people, Phillips (1970, p. 6) writes:

The problem is not one of discovering how to bridge an unbridgeable gulf between a number of logically private selves, contingently thrown together. On the contrary, unless there were a common life which people share, which they were taught and came to learn, there could be no notion of a person... Our common ways of doing things are not generalizations from individual performances, but the preconditions of individuality. The public is the precondition of the private, not a construct of it. This being so, what it means to be a person cannot be divorced or abstracted from these common features of human life.

This is not to deny that there are thoughts, feelings and experiences which are not expressed. It is to deny that at anything above a primitive level any sense can be made of the notion that the thoughts and feelings of an individual person can be regarded as logically distinct from the public media of a society, which necessarily incorporate certain disciplines and criteria. Yet the enormous significance of this point is frequently overlooked. For example, Argyle (1975, p. 386) writes:

It looks as if what is being expressed in music is an elaborate sequence of inner experiences including various emotions. It is because music can represent these experiences so well that it has been called 'the language of the emotions'.

This clearly implies that the 'elaborate sequence of inner experiences' exists in the mind prior to and independently of the public medium of music, and that, as a matter of contingent fact, it can be expressed in that medium. The notion is that such experiences are, as it were, awaiting the availability of the most appropriate form of expression so that they can be most effectively articulated. According to this conception, the 'inner' experience could exist even though the art form of music did not exist. But that is to assume that the experience would be possible in the absence of a medium in which it could be formulated, and which alone gives sense to the notion of such an experience. To take a clear example, no experience could possibly count as that of making a checkmate move in isolation from the discipline or practice of playing chess. Apart from that public medium and discipline, whatever physical movements were performed, it would make no sense to say that they could give the same experience. Thus the existence of the public medium of chess and of music is a precondition of the possibility of the individual's having the respective experiences. Moreover, the individual must have learned the discipline of the public practice in order to have the possibility of such an experience.

Free Expression

It is important to recognize the full force of this point, since it involves a common confusion exemplified by Argyle, who, significantly, writes of music that it can represent the experiences so well. This shows that Argyle regards the problem as *empirical*, that is, as if there were no problem about the independent existence of the experiences, but only the practical problem of discovering the best way of expressing them. Yet, as we have seen, the problem is not practical or empirical, but conceptual; it is a question of whether it makes sense to postulate the existence of such experiences which are independent of the art form of music. Argyle implies the intelligibility of comparison, in that, on his view, other media are able to express the experiences but when they are all tried music is found to be the most effective. Yet no sense can be made of the suggestion that the same experience could be expressed in some other way even if not so well. For what could count as the same experience? On this view, it would be intelligible to suppose that, in principle, a poem or a painting might be found which could express the 'inner' experience even better. Thus, on a cold night, one could say: 'Don't bother to go to the concert. Stay at home and read this poem which expresses the same experience as well as or even better than the symphony.'

Again, the example of chess is a clear illustration for it is obvious that the suggestion that the game of chess allows *very well* for the representation of checkmate experiences is nonsensical. Or, to bring out the point in another way, one could ask the subjectivist who argues in this way to which experience he is referring. The only way in which that question could be answered would be by reference to the notion of checkmate in chess. Similarly, it is not simply a practical difficulty which prevents what is expressed in a symphony from being expressed and experienced in an alternative way, but rather a supposition which makes no sense. The 'inner' experience is necessarily related to, uniquely identified by, the existence of that piece of music. The public medium is not merely the convenient but extraneous means of expression. If there were no such medium there could not be such an experience. Thus it is only by learning the discipline of the medium that an individual can have such an experience.

It may be remembered that a similar point was made in Chapter 1 about the supposition that men *invented* language. As we saw, such a supposition is unintelligible since the ideas given with language, and even the idea of the shared medium of language, would have to be presupposed in order to invent it.

Educational Consequences

There are important consequences for education, since it should be remembered that the cases considered, such as music, are merely particular examples of a conception which is held as a general principle applied, for instance, to all the arts and language. It should be noticed that the position we have reached is not only, by contrast, intelligible, but also amounts to a far stronger argument for the contribution of education. At most it is the argument of this subjectivist conception, if it were intelligible, that the relevant experiences could not be, or could not be adequately, expressed without the appropriate medium of expression. It is assumed that the experiences can exist independently, and that learning the art form provides the possibility for expressing them. But the rejection of that conception reveals a position of enormously greater significance for education with respect to responsibility for the development of individual potential. For it transpires that if, for instance, there were no art form of music, the respective experiences would not be merely inexpressible, but, more important, they could not intelligibly be said to exist. Moreover, the individual could not have such experiences unless he had acquired some grasp of the public discipline and objective criteria of the art form of music. Thus the existence of the subject or discipline, and the learning of its techniques and criteria, are necessary preconditions of the possibility of individual experience and development.

This clearly exposes the serious fallacy that freedom for unrestricted personal development depends upon the *avoidance* of the disciplines, since, on the contrary, the freedom of the individual to experience the relevant feelings necessarily *depends upon* his having learned those disciplines.

The examples we have considered are manifestations of a general misconception to the effect that ideas, thoughts, experiences and feelings are only contingently connected with their overt forms of expression in social practices. One of the most seriously misleading manifestations of this general misconception is expressed in the common assumption that language is symbolic. For, in the way that assumption is most naturally construed, this expresses or lends support to the prevalent misapprehension that language is merely a system of signs or symbols to convey messages which are formulated prior to and independently of language. (I have considered symbolism more fully elsewhere; see Best, 1978, ch. 8.) Thus it is often proposed as an intelligible supposition that it is possible to *think* without any medium of expression, even if one requires language to

Free Expression

communicate the thoughts. Yet it is a consequence of this assumption that one could intelligibly suppose an owl to be capable of profound philosophical ideas, even though it so happens that he has not managed to learn the language in which to express them. Clearly, however wise owls may be in fable, such a supposition makes no sense, since, without the requisite ability to express oneself in language, nothing could count as having the ability for profound philosophical ideas. One may be able to ascribe some thoughts to owls, but certainly not the kind of thought involved in philosophy. For example, to recognize even a simple selfcontradiction obviously requires a grasp of language, and it would make no sense to attribute any such thought to a creature without such a grasp. Thus the learning of the discipline of language is a precondition of the possibility in an individual for philosophical thinking and ideas. It is in this sense that the discipline, so far from inhibiting or distorting freedom of thought and individual development, is the only way of making it possible.

It is a seminal fallacy to regard language as a mere convenience, supervenient to the thoughts, ideas, activities and experiences of individual people. On the contrary, language provides the standards of truth and falsity; it gives the structure of possible reality, as the expression of the form of life of a society. With respect to the grounds of the reasons which are adduced in scientific proofs, Wittgenstein remarks (1969, §298): ""We are quite sure of it" does not mean just that every single person is certain of it, but that we belong to a community which is bound together by science and education."

The notion of a logically independent individual personality is, then, misconceived, since one's possible ways of thinking and experiencing are inextricably bound up with the language and practices of society. For example, the thought that it is five o'clock obviously depends on the existence of a society which has practices involving clocks and watches. This carries implications, which I can only briefly adumbrate here, of another misconception implicit in essentialist notions of the individual, often implied in the use of terms such as 'self-actualization', and 'self-realization'. For the notion of 'the *real* character' of a person seems to convey a picture of a self waiting to be released from the bonds and obscurities of what has been learned; a self which is permanent below the superficial changes on the surface. Yet there is an important sense in which it is more appropriate and intelligible to regard a person as being in a constant state of creation. It is an important insight of existentialism to conceive of each person as faced with an indefinite range of choices which will progressively

determine the character of his own individuality. This conception has the added psychological benefit of emphasizing the active possibility, indeed inevitability, of responsibility for what one is, and it is more constructive in that it allows for change where one is dissatisfied with one's self. However, in one important respect the existentialist view is seriously misleading, for clearly there are limits to the possibility of change. It would make no sense to suppose that one's choice is logically unlimited. To take an obvious case, and one which is most relevant to my thesis, one cannot choose to change in ways of which one simply has no conception. Someone in a society with no conception of chess cannot choose to become a chess player; someone in a society with no concept of art cannot choose to become an artist. The possibilities of changing oneself depend not only on inherent abilities, but also on the language and social practices which one has learned.

There are very significant consequences for educational responsibility, since, by contrast with the permissive subjectivist view, it transpires that the educationist carries an unavoidable responsibility for the individual development of students. It is undoubtedly enormously difficult to oppose the conformist pressures, for instance, of television advertising and the so-called 'pop culture', towards a bland, superficial uniformity of cliché phraseology. But a person with only trite forms of expression is a person who is capable of only trite experiences. Although I would wish to dissociate myself from his scornful way of expressing the issue, this underlies the following passage from Oscar Wilde (Hart-Davies, 1962, p. 501):

The intellectual and emotional life of ordinary people is a very contemptible affair. Just as they borrow their ideas from a sort of circulating library of thought... and send them back soiled at the end of each week, so they always try to get their emotions on credit, and refuse to pay the bill when it comes in.

The crucial educational point here is that if people succumb to the pressure to limit themselves to the circulating library of cliché forms of expression, then their capacity for individual thought and emotional experience is commensurately limited. The worst soiling is that language, and with it the scope for thought and feeling, is further debased by each member of the library, thus reducing even further the genuine possibility for others to think and feel in more varied ways.

To appreciate the point I am trying to make here, imagine that one were trying to understand the ways of thinking of an individual from a

Free Expression

very different society. At anything above a very primitive level, such as understanding that he was hungry, this would be impossible without to some extent coming to understand the concepts and practices of his society. As we have seen it, it is unintelligible to suppose that, for a great range, thoughts could be regarded as subjectively isolated, discoverable *only* by introspection, independent of the social media in which they could be expressed. For without those social media they could not exist. In this respect it is significant that such thoughts are attributed only to human beings, that is, to creatures with language. And a language is impossible for an isolated individual; it requires a society. Peter Winch (1972, p. 44) writes:

Unlike beasts, men do not merely live but also have a conception of life. This is not something that is simply added to their life, rather it changes the very sense which the word 'life' has when applied to man. It is no longer equivalent to 'animate existence'. When we are speaking of the life of man, we can ask questions about what is the right way to live, what things are most important in life, whether life has any significance, and if so what.

The conception of life of an individual has to be formulated in linguistic and artistic media, and in that sense it is dependent on the social practices which constitute the possibilities of formulation.

Conclusion

In the arts, language and many other aspects of human life the possibility of individual development in thought and experience, so far from being restricted by, actually *depends* upon, the learning of disciplines. It is seriously misleading to crave for and aim towards an unintelligible 'ideal' according to which individual potential can be fully realized *only* by avoiding all formative influences. Let me extend the quotation from Kant with which I introduced this chapter (I shall ignore the question of whether Kant's comments about Plato are justified):

The light dove, cleaving the air in her free flight, and feeling its resistance, might imagine that her flight would be still easier in empty space. It was thus that Plato left the world of the senses, as setting too narrow limits to the understanding, and ventured out beyond it on the wings of ideas, in the empty space of the pure understanding. He did not observe that with all his efforts he made no advance – meeting no resistance that might, as it were,

serve as a support upon which he could take a stand, to which he could apply his powers, and so set his understanding in motion.

There are, of course, no clear, definitive, general criteria which will determine when an individual is ready for extending his grasp of the discipline, and when, in the interests of his particular development, it is better for him to express himself freely within the limits of the discipline he has already grasped. The abstract philosophical principle that the possibility of free expression is extended by an extended grasp of the discipline may be a valuable guideline, but to assess the particular needs of particular individuals will always require sensitive, informed judgement. This is why there can be no substitute for high quality teachers who are able to judge the time and methods appropriate for the teaching of disciplines, so that individual potential in students is fulfilled, not inhibited.

The development of individual ability, in the arts as in other areas of human life, logically depends upon the learning of a disciplined structure of thought and action, in that only such a structure can provide the ground on which to stand, and which can make sense of the notion of progress. It makes no sense to suggest that one can stand on, and move forward from, *nothing*.

In short, the commonly assumed polarity between freedom to express oneself and the learning of disciplines is misconceived.

Kant's light dove would, both literally and metaphorically, be brought down to earth with a bump if it could attain its imagined ideal of escaping the resistant air in order to achieve *complete* freedom for flight.

Creativity

Introduction

This chapter and the preceding one are closely related, in that the genesis of the notion of ideally 'free' expression is almost if not quite identical with that of a certain conception of what it is to be really creative. Nevertheless, there are important additional points to be brought out in relation specifically to creativity.

Again, it is not only important *per se*, but also convenient as an expository device in order to point up the philosophical issue, to consider this question as it applies to education. Although our principal concern is with the arts, it should be emphasized, because of surprisingly prevalent misapprehensions on the issue, that one can be as creative in the sciences, mathematics and philosophy, and indeed in any other subject, as in poetry or painting. In education, for instance, there is often supposed to be a *creative* area of the curriculum, which is usually assumed to be the exclusive province of the arts. This reflects a serious distortion of the character of education generally, since creativity is equally important in all subjects.

Creativity presents a challenge to my thesis in that it is unquestionably of central importance to the arts, as it should be to all aspects of education, yet it does not appear to be compatible with the objective criteria which I have argued to be necessary for the rational support of artistic judgements, and *a fortiori* for any activity which has a legitimate place in education.

To put the point another way, it is not immediately obvious how the creative attitudes which are so important to the arts can be educated. If an activity cannot be rationally assessed it cannot be educated, and it is difficult to see by what criteria creativity can be assessed. No doubt it is

some such thought which, understandably, underlies the thesis of a recent article in a British newspaper, whose title stated starkly: 'Creativity cannot be taught' – a view which, one suspects, is shared by the majority of people, including many teachers.

The crucial question, then, which covers every part of the curriculum, is: 'Can creativity be taught?'

In some ways it may be less misleading to ask the question in terms of whether creativity can be *educated*, since the notion of teaching may carry, to some extent, different connotations. I shall return to this point later. However, the issues can, I think, be brought more sharply into focus if the former question is asked, and it will allow me to bring out some aspects of the concept of teaching.

The term 'creative' and its cognates are often used very loosely, so that anything one does is sometimes regarded as creative. To put it roughly, I shall be concerned with the concept of creativity as it is related to originality and imagination. Moreover, my argument applies equally to the creator and the spectator, for it requires imagination to understand a work of imagination.

Inexplicable

Any account of creativity has to recognize that, in a sense, there is something necessarily inexplicable about it, so that even those who are most creative are at loss to explain it, or to say where their ideas come from. Thus the composer Elgar speaks of plucking his musical ideas from the air; Mozart writes of his ideas: 'Whence and how they come I know not; nor can I force them'; Gauss, of an arithmetical problem whose solution had eluded him for years, writes: 'Finally, two days ago, I succeeded, not on account of my painful efforts, but by the grace of God. Like a sudden flash of lightning, the riddle happened to be solved.' And when Picasso was asked 'What is creativity?', he replied: 'I don't know, and if I did, I wouldn't tell you.'

This characteristic makes the quest for an explanation of creative acts distinctly odd. For there is a sense in which an achievement could not be correctly called 'creative' if it *could* be explained. If it were possible to provide a theory which comprehensively explained how one had arrived at it, this would be sufficient to show that an achievement was *not* genuinely creative. For it is central to the meaning of the term that to be creative is, precisely, to do something *original*, which necessarily could

Creativity

not be achieved solely by following rules or conforming to the norms. It is only if what is achieved transcends or even changes the rules or norms that it could be creative. Hence the surprise often experienced by those who are most creative. The touching story is told of Haydn who, on hearing his *Creation* performed for the first time, burst into tears and exclaimed 'I have not written this'.

It is important to recognize the character of the inexplicability of creativity. It has been objected against my thesis that the process of creativity is not now as inexplicable as it was. I do not deny that causal. perhaps psychological, conditions may be or have been found conducive to creativity in certain kinds of activity, and even that it is conceivable, if unlikely, that a regularity should be found which would justifiv our confidence that creative acts would inevitably ensue when certain conditions were present. What I do deny is that such a regularity could be an answer to the question 'How did he produce that creative act?' Similarly, as I have stated above, I deny that rules, or a series of steps of learning, could be formulated which would constitute an explanation of how someone was able to be creative. The inexplicability is not empirical, and solvable in principle, but is internal to the concept of creativity. Any act which could be explained comprehensively could not, as a matter of *logic*, that is, as a consequence of the *meaning* of the term, count as creative. Thus, it is necessarily the case that there is and always will be something inexplicable about creativity.

It is, of course, precisely this problem which has led to the common assumption that there cannot be criteria for creativity; that creativity is a purely subjective inner process which therefore cannot be taught. While this is understandable, it leads to some bizarre inconsistencies. For example, even after cursory reflection it is obvious that those who assume creativity to be a matter of a purely subjective inner process, for which there can be no objective criteria, inevitably contradict themselves. They insist that there can be no criteria for assessment of creativity, yet they usually have the highest esteem for those who are creative. But on what is this esteem based? Only, of course, on the basis of such criteria can one assess Mozart as more creative than Salieri.

An English poet who does fine work in schools insisted, at a conference, that there can be no criteria for poetic creativity, and that therefore it cannot be taught. One would already want to ask why, in that case, he visits schools as a teacher of poetry. Ironically, he gave the example of his first session with one class of rather dull children, to whom he was trying to explain the character of creative poetry. He asked them, by means of

the words they chose, to make him see some aspect of the countryside which they had recently visited. At first he was given a series of banal descriptions such as 'There was a blackbird hopping on the grass', 'The river was low', and so on. Then a boy at the back with the reputation of being the most backward and disruptive (these anecdotes always involve such a boy, always at the back of the classroom, of course) said that he had seen 'a living flash of blue at the water's edge' (a kingfisher). The poet excitedly exclaimed: 'That is what I want! That is the beginning of real poetry.' But how did he recognize this as creative, and the others as banal? To recognize something as creative is to employ objective criteria. It is not, of course, a matter of employing a technique. Moreover, one can recognize something as creative even though one may not be able to state the criteria for creativity. Indeed, as we saw in Chapter 1, a practice such as language, which will necessarily exhibit criteria for correct and incorrect use, must already be a going concern before it is possible to try to discern and state explicitly what those criteria are. And it is certainly possible to use language correctly without being able to state what are the rules of correct usage. The same is true of inductive and deductive reasoning, in that the ability to state or codify their criteria of validity is possible only as a description of criteria which are already in use. The distinction is important for several reasons, of which one is that there is sometimes a tendency to deny that there are objective criteria because of the difficulty of stating precisely what they are.

The Limits of Creativity

It may already be clear from the argument of the previous chapter that the creative *process* cannot intelligibly be regarded as logically distinct from the creative *product*. That is, the process can be identified only by the product; the process can be described only by reference to the product. So to assess and consider creativity we have to concentrate on the *product*.

The implications for learning and teaching the arts are of considerable importance, for I shall argue that creativity can indeed be educated but only by assessing the product as creative. To be creative requires a grasp of the criteria of validity and value of the activity in question. Originality is given its sense only against a background of the traditional. To count as creative an achievement must go beyond simply following rules or conventional practices, yet it cannot be merely subjective: it is not sufficient

Creativity

only to be divergent or different in any way whatsoever. It has to diverge from the norms in a way which is appropriate, and this implies that there are objective constraints. The quotation at the beginning of Chapter 5 illustrates the point, for just as the dove could not be free to fly without the resistant air, so there could be no sense to creativity in the absence of constraints. To adapt a phrase from Chapter 2, creativity has indefinite but not unlimited scope, for it is the objective limits which give sense to the notion of the creative or imaginative. Similarly, there may be indefinitely many ways of scoring a goal in soccer or hockey but clearly there are limits on what can count as scoring a goal.

To see the figure in Chapter 2 as a duck or as a rabbit would not count as creative or imaginative, since it would be too obvious or conventional, yet neither could it be creative to suggest that it could be seen as the Eiffel Tower. Certainly that interpretation is not obvious or conventional, but it cannot count as creative since it goes beyond the limits of intelligibility. An ingenious member of one of my audiences once denied even this, and suggested that the rabbit is looking up, over-awed, at an Eiffel Tower which is so extraordinary and beyond his comprehension that it could not itself be represented. Whether or not that could count as an interpretation of the drawing, it significantly underlines the point I am making that in order to make that interpretation intelligible ingenious reasons have to be given which derive their sense from the features of the drawing. The same is true of the suggestion of any other unusually imaginative interpretation. In Chapter 2 I said that the figure could be seen as a duck or as a rabbit, but not as a clock. Yet it can. It is a quarter to nine, or a quarter past three for someone standing on his head. To see it in either of these ways requires imagination, but it is certainly not purely subjective. Imagination is given its sense by the objective constraints. I would defy anyone, for instance, to see it as half past eight.

A philosopher in a meeting of a Canadian philosophical society once raised the supposed objection that the figure reminded him of a lake he knew in northern Ontario – with an island where the eye of the duck is. But, of course, so far from constituting an objection, this supports my case, since it reminded him of the lake *only* because of its similar shape. This again makes the point that imagination is *imagination* only in so far as it operates within limits. Perhaps one can see the figure as a Scottish bagpipe, and no doubt with some ingenuity one could think of many other possibilities, but what I wish to emphasize is that there is no sense in the notion of using one's imagination if anything whatsoever could count as a valid interpretation. The objective limits are the preconditions of and set

the scope for creativity, and it is in this sense that the scope is indefinite but not unlimited.

The Grounds of Creativity

The sense of creativity is given by the criteria which are already in use, although the creative person may modify and extend those criteria to some extent. An evaluation of Picasso's work said that he had altered the horizon of art. That is, the creative genius is involved in conceptual change, in that he is to some extent changing the criteria for what counts as art, and good art. As we saw in Chapter 4, the aspiration to change *everything*, to make *all* things new, is incoherent. It is possible to move somewhere else only if one is already somewhere, and where one can move next depends on where one is now.

The point can be illustrated by analogy with the sailor who wants to restructure his ship in mid-ocean. Obviously he cannot abandon the ship to rebuild it from the beginning, since he needs the support of the main structure while he makes the changes. What changes he can make, and how quickly he can make them, depend on the character of the original. Nevertheless, progressively, he may be able to make considerable, even radical, alterations in the structure of the ship, while depending upon its support.

There is also an important disanalogy here. The problem of rebuilding the ship is a contingent one, whereas the point I am making concerns the possibility of changing or extending concepts. Since it is the concept which gives sense to art and to what counts as innovation in art, one cannot simply abandon the concept one has in order to adopt a completely new one. Any innovation, to be understood as an artistic innovation, necessarily employs many of the criteria of the concept it is changing.

This issue is related to Chapter 5 in that a competent grasp of the discipline, techniques and criteria of an activity is necessary for the possibility of being creative in it. Yet it is often believed that to be really original or creative it is necessary to avoid such supposedly conformist influences. Thus, for instance, Witkin (1980, p. 92) seems to believe that creative vision is inhibited by learned technique. In fact, on the contrary, it is only if one has learned the techniques of philosophical thinking, for instance, that one can be original in philosophy. As we saw in Chapter 5, the methodological point that certain ways of teaching the disciplines of an activity can inhibit creativity should not be confused with the

Creativity

conceptual point that without a grasp of those disciplines it would be impossible to be creative at all. Moreover, the greater the mastery of the discipline, the greater is one's possibility of creativity, as will be clear from the example of language.

Another parallel with Chapter 5 is that artistic creativity cannot be purely private or subjective in the sense of being distinct from the public medium of the art form. In this sense individual creativity depends upon the public practice. However, this raises another issue which I have so far ignored. I have argued that there must be criteria for creativity; that there are limits to what can count as creative. But is it the case that these criteria must be publicly expressible, or could there be private criteria? It may be objected that although I have run these two points together, both here and in Chapter 5, it is not obvious that they are the same, or that the latter follows from the former. However, on reflection it can be seen that they are the same, since the notion of a purely private criterion would make no sense. Consider, for instance, the crucial notion of correctness. There could be no sense to the supposition of purely private correctness, since there could be no independent check, in which case there could be no distinction between seeming to be correct, and being correct. It is only in relation to an independent objective standard that anything can count as correct. This is not to say that a use of language, for instance, can be correct only if it is publicly expressed, but it is to say that it must be potentially expressible, since it is necessarily formulated, in a public medium. Similarly, the limits which set the criteria for creative acts must be public and in that sense independent. If the criteria for what counts as creative are necessarily shared, then they must be potentially expressible, even if in fact they are not expressed.

This point will arise again shortly, but it is worth pointing out that to insist on the existence of a public practice or medium as a precondition of individual creativity is certainly not to espouse behaviourism. There is a tendency to suffer from what might be called the disease of the dichotomous mind, that is, in this case, to assume that if one criticizes subjectivism one must be committed to behaviourism. Contrary to what is often assumed, these two kinds of theory do not exhaust the possibilities of accounting for mental phenomena. It is sufficient here to emphasize that my insistence that individual creativity depends upon the existence and grasp of a social practice is not a denial that there are mental experiences which are not publicly expressed. It is a denial that the relevant mental experiences could intelligibly be regarded as logically independent of public practices or media such as language and art forms.

The Creative Process

The preceding discussion indicates why one has suspicions about the intelligibility of a common use of the term 'the creative process' and of construing the distinction between process and product, in ways which suggest that creativity is a purely private process going on in the inaccessible recesses of the mind. That, of course, would make creativity purely subjective, and impossible to assess and educate. The point can be illustrated by reference to the notion of inspiration. It is sometimes thought that inspiration consists in a sudden flash of purely private, inner experience, perhaps culminating in a cry of 'Eureka'. Yet it is not the feverish mental experience which is the criterion of inspiration, but what is produced, and in order to be able to produce it one needs to have learned the requisite discipline of the medium of expression. A claim to be creative could not be justified by a mental experience of a creative process. in the absence of a creative product. Conversely, it would count as creative if one were regularly to produce work of striking originality even though one never had the mental experience of a creative process. The product, not some inner process, is the criterion of creativity.

Before continuing, I should like to mention that, although I have taken notable examples in order to make the point clearly, I do not wish to be misunderstood as implying that creativity is possible only for the genius. A child may legitimately be regarded as having manifested creative ability if he has produced something which transcends the rules even if his product, in comparison with others, is not original. Similarly, an undergraduate can show creative ability by thinking his own way to a position even though it may be a conclusion reached by Plato. It would not, of course, count as creative if he had regurgitated the Platonic argument, or, if that were possible, had simply followed certain logical rules which had led to that conclusion.

One reason for my raising this issue is that it is sometimes formulated in a misleading way. For instance, it has been said that the process of creating may result in a product which is not strikingly original, yet what matters is the distinctive *feeling* of being creative, since this *experience* is one of the great contributions which education can offer to almost all pupils. Although I entirely endorse the encouragement of creativity in all students and in all subjects, this way of putting the matter is seriously mistaken for three reasons.

(a) Although I neither deny nor accept that there may be characteristic feelings which accompany creative acts, it seems to me, in view of the

Creativity

huge variety of activities in which it is possible to be creative, that the occurrence of a distinctive creative feeling or experience is highly unlikely. The postulation of such a feeling may be a manifestation of the essentialist fallacy which will be discussed in Chapter 7.

(b) More important, even if there should be such a feeling or experience, it is irrelevant, since it is not the *feeling* of being creative but *being* creative which is of such importance in education. As I pointed out above, it is not the feeling or subjective mental process which is the criterion of creativity, but what is produced. To put the matter another way, if it were possible to give a drug which would produce a feeling of creativity this would not in the least imply that what was achieved as a consequence was creative, nor would it have any relevance to the education of creativity.

(c) If, on the other hand, it is objected that the feeling concerned is not merely a concomitant one, that is, one which is regularly correlated with creative acts, but is rather a feeling which is uniquely *identified* by creative acts, then it would be parasitic upon what is produced as a creative product. That is, the notion of such a feeling is given its *sense* by reference to behaviour or products which are recognized as creative. For example, one could make no sense of the suggestion that someone could have such a creative feeling as a result of picking up a spade, in normal circumstances, whereas it might make sense where someone was writing a poem.

In short, it is a serious confusion to be looking inwards for the criteria of creativity, as an inner subjective feeling or process; we should be looking rather at the creative character of activities and products.

The term does not necessarily carry implications of a subjective experience or event. To argue for the importance of the process rather than the product, in education, may be to emphasize the importance of learning to grasp the character of a subject, rather than concentrating on the details of a carefully finished result; it may indicate the importance of knowing *how* to achieve a result, and of experimenting freely with the methods, rather than simply achieving the result. Nevertheless, the term 'creative process' is often taken to designate a kind of private psychological mechanism, inaccessible to any observer, and therefore incapable of assessment or being educated. It is reported that one of his former students wrote to Wittgenstein to say that he had had the wonderful experience of being converted to Roman Catholicism. Wittgenstein replied: 'When I hear that someone has bought mountaineering equipment I want to see how he uses it.'

Although this subjectivist assumption remains prevalent, in practice teachers normally contradict it by teaching the disciplines of painting, drama, music, language, and so on, and by assessing progress. They are aware of the greater scope for creativity which they give to students as a consequence. It is important to recognize that one's scope for creative possibilities will be limited unless one has a good grasp of the relevant discipline. To take an obvious example, if one has no technique at all one cannot be creative in skiing; if one has limited technique one has some scope for creative skiing; and if one has mastered the sophisticated techniques of skiing one's scope for creative skiing is considerably greater. This is not inimical to spontaneous creativity. Martha Graham once said that it takes at least five years of training in the discipline to be spontaneous in dance.

This brings out how misconceived is the notion that creativity is inhibited by learned technique. On the contrary, although of course technical competence does not necessarily give creative flair, it is a necessary precondition for such flair, and in any subject, discipline, or activity.

Imagination and the Truth

In a lecture, the playwright Edward Bond pointed out a common misconception about imagination in art. It is commonly assumed that because imagination is central to the arts this implies that they are concerned not with truth or reality but with fantasy, illusion, escapism. In fact, it often requires imagination to peel away illusions in order to see the truth, and it can involve a creative struggle to achieve the precise medium necessary for expressing and recognizing true insights. The point struck me forcibly when I first studied the preliminary sketches, and then the finished work, in which Picasso expressed his reaction to the news of the bombing of Guernica.

The creative vision or imagination of the artist is required to penetrate romantic illusions which preclude a truthful conception of reality. An example will illustrate three of the points I have been trying to bring out, which are (a) imagination may be required to see the truth; (b) a medium is required in order to be free to express the truth; (c) creative or imaginative vision is possible only as a development out of already existent conventions. My example is that of the English poets of the First World War.

At the beginning of the war the prevailing spirit in society was that of a stirring romantic nationalism, and the language of poetry was that of the

Romantics such as Keats. Within this mode Rupert Brooke wrote of the glory of dying for one's country, and the spirit of national pride was evident in his writing of there being, when a soldier was killed and buried, 'some corner of a foreign field that is forever England'. Experience gave a very different conception of the reality of war. Thus, as a consequence of his bitterly disillusioning experience, Rudyard Kipling wrote: 'If they ask you why we died, tell them ''because our fathers lied''.'

The later poets, as a consequence of their personal experience, came to see war not as a matter of romantic, flag-waving heroism, but of mud, blood, and countless, utterly pointless, agonies, and senseless maiming and slaughter. It was out of the depths of this kind of experience that Wilfrid Owen wrote of the old lie 'Dulce et decorum est pro patria mori' – the old *lie* that it is sweet and glorious to die for one's country.

For the purposes of my example, it is important to recognize that, although one can appreciate Kipling's and Owen's bitter expression, there is an important sense in which this was not a *lie*. Before and in the early stages of the war this was effectively the only language for, conception of, and therefore vision of, war. The early poets could use only the medium they had, and this language and conception was so dominant that it was almost impossible for them to have any other kind of thought about war. The ways of seeing and thinking were necessarily tied to the language available to them. They did not have the language, the concepts, to see what they later came to recognize as the truth. Owen and the others had to create a language in terms of which this conception of the reality of war could be understood and expressed. The words did not have to be created, since they were already available. What had to be created was a very different use of those words to give very different conceptions of the realities of war. Even though the same *words* were used, they had to be used to express different concepts. For example, at certain periods in history, it would have amounted to a self-contradiction to say that a man who refused to fight in a war was exhibiting courage. That is, the concept of courage was such that it entailed a willingness to fight. Shakespeare's Coriolanus brings out very well how concepts such as courage, honour and loyalty can be logically tied to notions of military valour, and how dif-ficult it can be to think in different ways, and espouse different conceptions of virtue. This kind of creation is far more difficult to achieve than is often realized, since it amounts to changing patterns of thought which have been set by prevailing uses of language in a society. One needs only to consider some of the films about and propaganda of war to appreciate that hundreds of thousands of men have sacrificed their lives, at least

partly because of an inability to think and feel *outside* 'the old lie'. Films such as *All Quiet on the Western Front*, and *Gallipoli*, to name only two, bring out clearly the enormous power of 'the old lie', which can induce men, in wave after wave, to climb out of trenches and charge pointlessly at murderous machine-gun fire, knowing very well that there is no hope at all even of survival, let alone success.

The enormous power of the prevailing uses of language, which set the ways of thought of a society, and the difficulty of detaching oneself from them, can hardly be over-emphasized. It is commensurately difficult to change the uses of language. It needed a poet, and it could not be achieved immediately. Thus, if one examines Owen's poetry carefully it is possible, I submit, to see clear evidence of his creative struggle from his roots in the linguistic and poetic conceptions in which he grew up, and which constituted the foundations which made his originality possible. Inevitably, he often slips back to those neo-Keatsian Romantic roots, for he was involved in a creative struggle to construct a language in which his conception of the truth about war could be expressed. He was like the mariner restructuring his ship in mid-ocean. He could not start afresh, but had to depend on the given conceptions in order to alter them. Yet the changes made by Owen and his contemporaries were quite remarkable. By the end of the war they had no romantic conception of it; these poets were seeing clearly, and expressing vividly, what they could now see as the stark truth of pointless death and suffering. Nationalistic fervour, previously central to the poetic vision of war, became totally, inhumanly, irrelevant, and their compassion was for all soldiers, friend and foe, caught up in the mindless savagery of destruction.

The ability to see and express what was now recognized as the truth about war required the imagination to expose romantic illusions; it required the creation of a different poetic and perceptive medium of language; yet it necessarily had to grow out of conceptions which were already there.

Creativity and Education

There are crucial educational consequences, for in teaching the disciplines and criteria of a subject, the teacher is progressively extending the students' possibility of creativity. On a subjectivist view where, for instance, the 'creative process' is taken to be necessarily private, and independent of any possible expression in a public medium, no sense can

Creativity

be made of assessing what, if any, creative ideas a student may have. Any work produced could be the expression of *any* creative idea or none. Thus there could be no place for learning, and the progressive enlarging of understanding and scope for creativity. Moreover, for a student to recognize the progress *he himself* is making it is necessary that he should be learning the difficult task of self-evaluation – that is, of applying criteria to his own work.

Yet does not the most important question remain unanswered? An art educator once objected: 'I agree that you can teach and assess the techniques, but surely not the creativity *itself*, and that is the crucial problem.' There is, of course, a distinction between competence in expressive techniques, and having something to express. A work of art or an essay can be technically perfect, yet have nothing to say. It is significant, for instance, that to call a performing artist a good technician is in effect to criticize him as lacking the vital spark. But what does it amount to to say that creativity cannot be taught? One implication is that the *potential* to produce creative, imaginative original work cannot be taught. Yet it is impossible to teach *anything* to someone who has no aptitude. No amount of coaching in technical skills will make a tennis player out of a person who simply lacks an eye for a ball.

However, there may be more to this objection, and this raises the distinction between 'teach' and 'educate' to which I referred earlier. The term 'teaching' carries the implication, for many people, of something like giving a set of rules which, if followed, will produce the required results. In this sense, multiplication tables, the rules of chess, and many other activities, can be taught, whereas creativity cannot. Because of this implication, it may be preferable to ask the question whether creativity can be educated, rather than taught, although the use of the latter term does not necessarily carry the implications indicated. I shall use the two terms interchangeably, in order to bring out important aspects of both, and since my use of the term 'teaching' does not carry the implication of simply offering a set of rules.

There is a further objection which may arise. Someone may say: 'It is possible to show a person how to develop his own creativity, but it is impossible to *teach* him creativity.' But what kind of distinction does someone have in mind who talks like this? Often underlying it is the notion that teaching or education somehow *imposes limitations*, whereas learning is a matter of one's own free discovery. I do not wish to deny that there is something of importance in that distinction, but if we are not

careful we shall be on the slippery slope to the incoherent contention which we have already discussed, namely, that *real* creativity requires a complete absence of the supposed limitations of the disciplines of a medium. Yet even the most extreme disciple of free expression, who insists that the teacher must never impose on his students, will inevitably have to contradict his own view to some extent, for even setting up the conditions in which students can most effectively learn is imposing a situation on them in some sense. For example, what if he were to deny this and say: 'I don't impose any limitations whatsoever. I simply give out the paintbrushes, paints and paper and leave them to it'? But even this is to impose certain expectations on them. Wouldn't it be less of an imposition to give them, for instance, sticks, horsehair and glue? But even *that* is an imposition – so what about simply showing them an oak tree and a horse?

This should be enough to demonstrate the unintelligibility of supposing that learning can be achieved without the imposition of any expectations and therefore limitations at all. What is a serious question, of course, is how much and what kinds of imposition are the most fruitful for learning. (The term 'imposition' is an unfortunate one anyway. I have used it solely to make the point clearly.)

The important point is that we should try to ensure that the conditions which are set should progressively open doors for students, not close them. Nevertheless, we should be clear that setting conditions is unavoidable.

Can Creativity Be Educated?

Kant's light dove craves an impossible ideal. The resistant air is not a handicap but a precondition of free flight. The notion of being creative in a vacuum is not just impossible, but incoherent. The very sense of creativity is given by the medium, discipline and criteria of the relevant subject or activity.

In a radio interview, the extraordinarily original jazz trumpeter Dizzie Gillespie was asked whether it was his *lack* of any tuition which had allowed him to develop his highly individual style. He replied, most emphatically: 'No, I should say not. A teacher is a short cut.' The interviewer pressed the point and asked: 'But wouldn't a teacher, at least to *some* extent, have limited the development of your own particular style?' To which Dizzie Gillespie replied: 'Not a good teacher.'

Creativity

This indicates that a definition of good teaching or education might be that it consists in the creation of those conditions which are most conducive to the students' learning. It can now be appreciated how the original question can be answered, for in that sense creativity can certainly be educated.

Summary

- (1) Creativity has limits of intelligibility.
- (2) There are criteria for what counts as creative.
- (3) The creative process is necessarily identified by the product.
- (4) Creativity is not a feeling or experience.
- (5) A creative idea can be formulated only in a medium in which it is potentially expressible.
- (6) Creativity develops from and therefore depends upon cultural traditions.
- (7) A necessary condition for being creative is to have mastered at least to some extent the discipline, techniques and criteria of a subject or activity.

Feeling

Introduction

The kinds of feeling which play a central role in the creation and appreciation of the arts involve the possession of certain concepts. Thus, although an animal may respond to a work of art, it is not capable of the response appropriate to artistic appreciation, which requires understanding. This underlines the importance of the emphasis in Chapters 5 and 6 on the medium, of language and the forms of art, without which such concepts and therefore such feelings could not intelligibly be said to exist. In this respect the notion of the object of an emotion, that is, the object towards which the emotion is directed, is of central importance, since it determines the character of the feeling. Clarity about this notion helps to overcome a problem which has persistently bedevilled the philosophy of the arts, and which Bosanquet (1915, p. 74) has described as the central problem of the aesthetic attitude, namely, how a feeling can be got into an object. That is, it is difficult to understand how, for instance, a painting can be sad, or a piece of music joyful.

This brings out the important relation between philosophy of mind and philosophy of the arts. A central issue is the common misconception that the arts, like language, were created in order to express and communicate ideas and feelings. Yet, it makes no sense to suppose that these ideas and feelings could exist prior to and independently of the arts and language. This has important implications for education, in that in learning to grasp the media of the arts, students are acquiring the possibility of experiencing feelings which they could not have otherwise.

Feeling

Emotions

It is natural to ask what emotions consist in, and this inclines one to look for a common element. Clearly this cannot be the behaviour which expresses some emotions since not all emotions are expressed. There is then a temptation to assume that emotions must consist in sensations. This temptation is reinforced by the fact (a) that when the expression is suppressed there tend to be sensations, and (b) that intense emotions, on which it is natural to focus to find the essence of such feelings, are characterized by sensations and physical changes such as an increase in pulse rate, paling, perspiring and flushing.

However, it is misconceived to assume that, even in such extreme cases, the physical changes or sensations are what the emotion consists in. For instance, it would be possible in principle to produce the same sensations and physical changes by means of drugs, or electrical apparatus, but clearly the subject would not necessarily, as a consequence, be feeling the appropriate emotion. Incidentally, this reveals the confusion in the prevalent assumption that emotions can be measured, for instance, by measuring the intensity of physical changes by psychogalvanic reflex. Measuring the physical changes is not measuring the emotion. Emotions cannot be measured, not because it is too difficult but because the very notion of measuring emotions makes no sense.

The criterion of a man's being angry is not, for instance, his high blood pressure, but what he says and does. If it should be objected that nevertheless there is a correlation between anger and high blood pressure, then the point is implicitly conceded, since the behaviour has to be recognized as anger-behaviour prior to, and in order to investigate, the possible correlation. A scientist can conduct such an investigation only if he already knows what it is for someone to be angry.

Moreover, emotions which involve sensations and physical changes are by no means typical. There are no sensations, changes of pulse rate, perspirings or palings in very many cases which one describes by the use of emotion terms. For instance, I may be annoyed, disappointed, delighted or afraid without experiencing any sensations or physical changes.

The mistake is largely a consequence of the original question, which leads one to look for the essence of emotions in the supposed paradigms, that is, intense emotions, where sensations and physical changes do characteristically occur. It is wiser to eschew that question, and recognize that it makes no sense to ask, in general, what emotions consist in.

To illuminate this point it is worth considering the analogous question: 'What does expecting consist in?' There are various cases, and it is misleading to assume that there must be an essence, most easily recognizable in extreme cases such as expecting an explosion, for example, when a building is being demolished. In such a case there may be various physical sensations and behavioural characteristics, if one is crouching behind a wall, tense, covering one's ears, and with all one's attention directed on to the forthcoming event. Yet contrast my expecting someone to visit me on a specific date in a few months. The appointment may be written in my diary, and I have not forgotten it. If I were asked whether I am expecting the visit, I should reply in the affirmative, but there is nothing going on in me which constitutes the expecting. It could even be truly said of me, when I am asleep, that I am expecting the visit. In such a case it would be very odd to ask what my expecting consists in. In the case of expecting the explosion, there are plausible candidates for what the expecting consists in, that is, in my behaviour, sensations and thoughts. If one assumes that there must be an essence, which is most clearly manifest in such cases, this will lead to confusion in others. The temptation is to postulate some indiscernible mental event as what the expecting consists in. But whether or not it can be said to exist, what shows that I am expecting the visit is not my having such an event, but my saying that I remember the appointment, my not arranging to be out on that day and so on. The expecting does not consist in anything going on in me now. On the contrary, in order to appreciate that this is a case of expecting one has to take account of ways in which I speak and behave at other times.

Similarly, to ask what an emotion consists in tempts one to identify it with something which is going on at the time, and sensations are obvious candidates if one considers extreme cases. But, to repeat, many emotions involve no sensations, and even where sensations are characteristically involved, the emotions cannot be said to consist in them. This point underlies the humorous remark that someone had the sensation of a lump in his throat, and could not tell whether he had tonsillitis, or was in love. The important issue here is that contextual considerations are not merely extrinsic. On the contrary, it is not any sensation, but such wider factors as what a person does and says at other times, which are criteria of his being in love.

Much of what I have been trying to say here is captured in Wittgenstein's statement (1967, §504): 'Love is put to the test, pain not.' The strength and depth of a man's love, in one sense of that term, are revealed not by the intensity of his sensations but by, for instance, his sincerity,

Feeling

reliability, thoughtfulness, and so on. The notion of a similar 'test' of a sensation makes no sense. The criterion of love is not the occurrence of a sensation, but rather a complex of actions and attitudes. This partly underlies Simone Weil's writing (1952, p. 2): '''His love is violent but base'': a possible sentence. ''His love is deep but base'': an impossible one.'

Emotion and Object

An important characteristic of emotions, by contrast with sensations, is that in the great majority of cases they are directed on to objects. One is sad or angry about something, afraid of or irritated by something. The object, in this sense, is not necessarily a physical object. Thus one may be afraid of continued economic inflation, anxious about a debt, saddened by a friend's disloyalty or insincerity. It is important to notice that, in the cases with which we are concerned, the object of the emotion is determined by one's understanding of or belief about the phenomenon or situation. Thus a person's emotional response may be a consequence of a mistaken belief. For instance, I shall not be afraid when I hear the sound of a burglar's footstep if I believe it to be that of my father. Conversely, I shall be afraid if I believe the footstep to be that of a burglar, although it is in fact that of my father. To give another example, my emotional response if I believe that the object lying under the table is a rope is likely to be very different from my response if I believe it to be a snake.

There are complexities in the case of the object of the emotion in the arts which do not necessarily apply elsewhere. For instance, although sometimes the object of the emotion is quite straightforwardly the work of art, sometimes it may be at least partly the issue or situation which is portrayed in, or to which attention is drawn by, the work, as in the case of works which are concerned with social or moral issues. One's response to a poem by John Donne or Gerard Manley Hopkins may be fear of death; it is clearly not fear of the poem. Sometimes one's response may be partly to the structure of a novel or play and partly to a character in it. Or one's feeling may be *for* a character, or, if one identifies with him, *as if* one were in his or her position. There are various other possibilities. Thus the normal characterization of the object of the emotion, as in the case of fear of dogs, does not carry over exactly to the case of works of art, and it is not possible to give a precise general account of the nature of the object of emotion in relation to the arts.

It is of considerable significance that the object of the emotion cannot be characterized independently of the individual's concept or understanding of the phenomenon to which he is responding. That is, we cannot characterize *what* he is afraid of without reference to his concept of what the object is. The object, in this sense, is a central criterion of the feeling and it is given by one's understanding. For instance, I could not be afraid of ghosts if I had no concept of a ghost. In the cases with which we are concerned, the object and therefore the emotion depend upon an understanding of language and the arts. Thus in the relevant cases the object is given by the concept of art concerned. For instance, if one is moved by a dramatic performance, the object of one's emotion is not the actor but the character in the play. Unless one understood the concept one would be unable to respond appropriately to a fictional character.

To repeat, my thesis is not exclusively concerned with the spectator. It is sometimes assumed that while the art object may be of central importance to an understanding of the emotional response of the spectator, it is 'the emotion itself' which is important for the artist. Yet the character of the emotion expressed in the work is identified by the character of the art object. It would make no sense to suppose that it could be identified by a purely private 'inner' ostensive definition, which had no logical relation to the work. As we saw in Chapter 6, a criterion cannot be purely private, but requires public criteria. There is no sense to the notion of correct use of a term such as 'joyful', and therefore of meaning, on a purely private basis. Similarly, on such a basis any 'work of art' could be the expression of any feeling or none, and thus there could be no sense to the notion of expression of feeling in a work, even for the creator of it. There are complexities here which will be considered in Chapter 8, but at this point I simply wish to make it clear that, for the characterization of the emotion, that is, what counts as 'the emotion itself', the art object is equally important for the creator and the spectator of art.

My insistence that the artist's feeling cannot be characterized independently of the work does not imply that my thesis is a form of behaviourism or formalism; it does not imply that the feeling can be reduced to the physical constitution of the object, or the physical behaviour which created it. Behaviourism can give no coherent account either of emotions which are not expressed, or of characteristic emotionbehaviour which is not an expression of emotion, for instance, pretence. Indeed, more seriously, the behaviourist is not entitled to the notion of '*characteristic* emotion behaviour', since that is precisely what requires explanation. Thus the behaviourist has to characterize emotions solely in

Feeling

terms of the mechanical and physical movements of which, for example, a sophisticated robot would be capable. I submit that this cannot be achieved and thus the behaviourist has to presuppose what he implicitly tries to deny, namely, that emotional behaviour is possible only for living beings who have feelings which cannot be characterized in exclusively physical or behavioural terms, in the sense in which he conceives them. This does not imply that the feeling is other than and inferred from the physical behaviour. It makes no sense to suppose that meaning can be given by private observation of one's own mental processes, since, as we have seen, there could be no criteria for what counts as correct use, and the notion of learning the meanings of emotion terms would be unintelligible. Any kinds of behaviour or art could be the expression of any emotion or none, which is to say that no sense could be made of the meaning of emotion concepts even by the person himself.

Both the subjectivist or dualist, who regards the feeling as a separate mental event, and the behaviourist, share the presupposition that mental experience can be accounted for by reference to *physical behaviour*, construed as a mechanistic process of bones, muscles, flesh, and so on. For the behaviourist the mental can be reduced to such mechanism; for the subjectivist the mental is a separate non-physical phenomenon which can be inferred from such mechanism. Yet no coherent account of mental experience can be given if physical behaviour, in this sense, is regarded as the only datum, or as one of the basic data. What is required is a different basic datum, namely, that of the human being, the identity and character of whose experiences are given, very largely, by social practices, including language and the arts.

The position I am sketching may appear to be more complex because of the pervasive hold of subjectivism or dualism, and behaviourism, together with the assumption that they exhaust the possibilities. It should be emphasized, too, that my position is not a mid-position, or modified behaviourism, but rather a quite different approach to the concept of mind.

Perhaps I can put the point in this way. The fatal objection against dualism (body and mind as two distinct entities) or subjectivism is that, whatever the results of my supposed introspective observations, I have obviously failed to understand the concept of anger, for instance, if when I say sincerely that I am angry my utterance does not normally go with anger-behaviour directed on to an appropriate object. The fatal objection against behaviourism is that, equally obviously, I have failed to understand the concept of anger if when I say that I am angry this is always on the basis of my observation of my own behaviour.

One *learns* how to characterize *one's own* feelings, and the feelings of *others*, in the same way. It could not be said that a child had mastered the first-hand application of mental predicates unless his use of those predicates coincided appropriately with the rest of his behaviour. That is, the criteria of feelings, the meanings of emotion-terms, are given by certain forms of behaviour directed on to objects. But 'behaviour' here is not used in the way the behaviourist uses it, that is, to refer to mere mechanistic movements; it refers to that of which only a human being (or an animal) is capable. In short, the meaning of the terms I use to identify and describe *my own feelings* is given by the background of normal human behaviour.

To put the point another way, Wisdom (1952, pp. 226-35) writes of the asymmetrical logic of psychological statements, by which he means that the position of the person experiencing an emotion or a sensation, for instance, is not symmetrical with that of anyone else. Someone else's statement that I am in pain has to be made on the basis of my behaviour, including my verbal behaviour, whereas my statement that I am in pain has not. Moreover, as long as I understand the concept, I cannot be mistaken when I say that I am in pain, whereas others obviously can be mistaken in attributing pain to me. It is important to recognize that this asymmetry lends no support to dualism, that is, the notion that body and mind are separate entities, that concepts and feelings are purely private, and that only I can have infallible knowledge of my own experiences. That conception we have rejected as not making sense. The present point is not that, but that psychological predicates applied to a human being, that is, as contrasted with a conjunct of physical stuff and mental stuff, have this asymmetry. The meaning of 'I am in pain' is learned by the public criteria given with language. That is, contrary to what the dualist assumes, meaning cannot be purely private; neither can there be two kinds of meaning, in this sense, the private and the public, since 'I am in pain', said by me, is true if and only if 'He is in pain', said by an observer, is true. This asymmetry lends no support to the notion that only I can be certain, or can know directly, that I am in pain, whereas others can have only a degree of indirect probability. On the contrary, if, for instance you see someone hit by a falling rock, and he clutches his head, groans, bleeds, and so on, you can be as certain as you can be of anything that he is in pain. Moreover, as has been pointed out often enough, it makes no sense, in normal circumstances, to say 'I know I am in pain', since the attribution of knowledge is contrasted with doubt and uncertainty, and one can make no sense of the suggestion that one might doubt or be uncertain whether one were in pain.

Feeling

In brief, then, what the asymmetry amounts to is that mental experience is that of a human being, and he is obviously in a different relation to it from anyone else. He *has* the experience and thus might be said to be the subject of it. But that is not in the least to say that the experience is subjective in the sense that its *identification* is not answerable to objective criteria. A person can ascribe terms like 'pain' and 'anger' to himself only if he has learned the criteria for their correct use in a public language. His experience is certainly not subjective in the sense that its characterization is a matter solely of his private perception, wish or belief, independent of interpersonal standards expressed in language.

To repeat, the meaning of the terms I use to identify and describe my own feelings is given by the background of normal human behaviour. A human being can hide his emotional feelings and pretend to have such feelings; he can recognize the feelings of other people; he can be wrong about his own emotional feelings, or he can be right despite the contrary assertions of others. All these possibilities depend upon the *fundamental* fact that he is a human being, neither a conjunct of body and mind, nor simply a physical body. He learns the language of a society, and he responds to others *as* human beings who think, and have emotions. He does not see them as physical bodies, neither does he attempt unintelligible inferences to purely private feelings and thoughts. He *sees* that someone is angry, frightened, or thoughtful, because he has learned what it is for *human beings*, including himself, to be angry, frightened and thoughtful.

There is, of course, much more to be said on this issue in general. I have simply outlined the general base in philosophy of mind on which my thesis on the feelings expressed in the arts is founded. But our principal concern is in the application of these considerations to the arts.

Feeling and Medium

The issue we are now consideriang is closely related to a central theme of Chapters 5 and 6, namely, that the possibility of individual creativity and expression depends upon the existence and a grasp of the appropriate disciplines and social practices. The criteria for what feelings are, in the case of the artist, also depend upon such disciplines and practices. To take an analogous case, some years ago when I was learning to ski I reached a stage where I was struggling, largely in vain, to master parallel Christis. I

succeeded, to some extent, only in tantalizingly brief and evanescent moments. One day, after assiduous practice, I felt that I had succeeded, and at the bottom of the slope I exclaimed to a friend: 'At last I know what it feels like to do parallel Christis.' To which he replied: 'Oh no you don't. I saw you coming down.'

The point is that there are public criteria for feelings. Whatever my kinaesthetic or aesthetic feeling, it obviously could not have been that of parallel skiing. Moreover, the possibility of the feeling depends upon the existence and the learning of the activity. Similar considerations apply to the feelings expressed by the artist. The feeling is an artistic feeling, expressible only in that artistic medium, and it would make no sense to suppose that it could exist independently of that public medium.

In this respect there are subjectivists who, like Hume, accept that if artistic meaning is 'in the mind' there can be no criteria or answerability to rationality, and there are those who do not recognize the subjectivist consequences of their positions. These latter, for instance, assume that there is no problem about 'externalizing' or 'objectifying' into public media or symbols the 'purely private', 'subjective', 'felt life', 'in the mind'. If by such statements they mean that the meaning of what is publicly expressed is given by a private feeling or idea which exists independently of the public medium, then, as we have seen, such a notion makes no sense. In effect, they are helping themselves to public criteria for artistic feeling and meaning to which their own theory does not entitle them. A major source of this tempting position is that it is so often confused with the obvious fact that one can have artistic feelings and ideas which are not publicly expressed. Paradoxically, in view of their concern. often, to provide a justification for the arts, their misconception arises from a failure to recognize sufficiently the importance of the concept of art.

An example will illustrate the central issues. Eisner, in 'The role of the arts in cognition and curriculum' (1981), commendably recognizes the educational significance of the relation between the arts and mental development. A sound conception of mind is necessary for any coherent account of the philosophy of the arts, or of the arts in education. Unfortunately, and understandably, Eisner in this paper, significantly entitled in an earlier version 'Representing what one knows', espouses three misconceptions which are an inevitable consequence of insufficiently recognizing the fundamental importance of the medium, whether linguistic or artistic.

Feeling

(1) Eisner shares the prevalent assumption that meaning, whether linguistic or artistic, is given by reference, or at least answerability, to images. For instance, he writes (pp. 18-19):

it is easy to see how concepts such as dog or chair, or red or blue depend upon sensory information. But what about concepts such as 'justice', 'category', 'nation', 'infinity'? I would argue that these words are nothing more than meaningless noises or marks on paper unless their referents can be imagined... Unless we can imagine 'infinity', the term is nothing more than a few decibels of sound moving through space. I do not mean to imply that every time we hear a word we conjure up an image. We have so automated our response mechanisms that this is not necessary. But when I say, 'The man was a feckless mountebank' the statement will have meaning only if you know what 'feckless' and 'mounteback' refer to. If you do not then you turn to a friend or a dictionary for words whose images allow you to create an analogy....Concepts, in this view, are not at base linguistic, they are sensory.

There are two connected assumptions here, (a) that meaning is reference, and (b) that meaning necessarily depends, at least ultimately, on reference to images. With respect to (a), to assume that linguistic terms always refer is to adopt a very one-sided conception of language. While this may be initially plausible for words like 'dog' or 'chair', it loses even initial plausibility for words such as 'if', 'but', 'and'. What, for instance, does 'if' refer to? There are various uses of language other than the referential, such as the expressive, hortatory and exclamatory. It is misleading to assume that language functions in only one way.

However (b) is more important. Despite its prevalence, the assumption that meaning is given by reference, or the possibility of reference, to an image is fundamentally mistaken. For instance, even in the plausible cases, the concurrence of an image is neither necessary nor sufficient for meaning. If I have no image at all, or have an image of a bandaged arm because I was once bitten, whenever I hear or use the word 'dog', that does not imply that I do not know the meaning of 'dog'. On the contrary, whatever image I may have, or even if I have and can conjure up none, if I use the word correctly, then that shows that I know its meaning. So an image of a dog, whenever 'dog' is used, that does not imply that I know its meaning. On the contrary, even if I always have such an image when I use the term, yet I use it incorrectly in general, then that shows that I do not know its meaning. So an image is not sufficient for meaning. A mark or

sound which would otherwise be meaningless is not endowed with meaning by the concurrence of an image. For example, if the sound of a sneeze conjures up an image of Ann, who is prone to sneezing, there is no question of meaning at all here, and certainly the sound of a sneeze does not mean 'Ann'.

The concurrence or possibility of images is irrelevant to meaning. The criterion of knowing the meaning of a term is the ability to use it correctly in its various linguistic contexts. The central issue for my thesis is that the concepts, and thus the feelings with which we are concerned, could not exist prior to and independently of the public medium, of language or the arts.

It may be worth adding that it is a mistake to equate imagination with having images. Imagination sometimes involves having mental images, as in 'Close your eyes and imagine the Eiffel Tower'. But children who are asked to imagine that they are Red Indians do not need to have images to comply. Their imagining can be revealed in the way they act.

(2) Eisner's exclusively empiricist account assumes that meaning, understanding and education can be achieved solely by sensory experience. Although an understandable and common assumption, this involves a misconception which is seriously misleading for the arts, language and education generally. Simone Weil gives the example of two women who receive letters, during the war, informing them of the deaths of their sons. One can read, the other cannot. The former, on looking at her letter, faints with shock, while the latter, on looking at an identical letter, is completely unconcerned. The sensory experience of each is the same. The differences of emotional response can be attributed only to the former's understanding. Similarly, two people watching a game of chess, one of whom understands it and one of whom knows nothing of chess or any similar game, may have the same sensory experience. The difference between them is that only one has conceptual grasp.

Certainly the senses are necessary in order to learn language and artistic meaning, but that does not imply that linguistic and artistic concepts *are* sensory. It is difficult to know what it could mean to say that one *senses* the meanings of verbal terms. If by saying that concepts are at base sensory Eisner means, as he seems to mean, that sensory experience is sufficient to provide us with concepts, then clearly this is mistaken. Concepts are linguistic. They are part of a public language, and are acquired in learning how to use it correctly.

The point can be brought out by asking the question: 'Can a man who has been blind since birth have a concept of colour?' On the view of

Feeling

concepts as sensory experiences he cannot. Yet a blind man can use colour-words correctly in various contexts, and could, for instance, recognize inconsistencies in other people's uses of such words. He cannot have as complete a grasp of colour-concepts as most normally sighted people, but this is because there are various *uses of colour-terms* of which he is incapable. Nevertheless, such a blind man could have a far better grasp of colour-concepts than a man with perfect vision who is severely mentally retarded. This again emphasizes the point that meaning and understanding are not solely a matter of sensory experience. The difference between the two men is that the blind man, although incapable of the relevant sensory experience, has learned the public medium of language and thus has learned, to some extent, how to use colour-words.

It is misleading in this context, to write of 'sensory information'. A related confusion, which I cannot pursue here, is expressed in common talk of the nervous system's carrying messages, and the brain's understanding.

If sensory experience were sufficient to give concepts, then they would be independent of the public media of language and the arts. Yet, as the example reveals, concepts depend for their existence upon such public media.

An important educational consequence is that if we wish to help students to extend their conceptual horizons it is not sufficient simply to offer them extended sensory experience. It is at least equally necessary to help them to a richer *understanding* of the media which give sense to experience.

(3) Eisner writes (p. 22): 'Somehow an individual who wishes to externalize a concept must find some way of constructing an equivalent for it in the empirical world.' His thesis is that concepts are inaccessibly subjective, but that we find ways of expressing them publicly. The clearest short expression of this thesis is to be found in the abstract of his paper where he writes:

Humans not only have the capacity to form different kinds of concepts, they also, *because of their social nature*, have the need to *externalize* and *share* what has been conceptualized. To achieve such an end, human beings have *invented*...forms of representation [which] are the means by which privately held conceptions are transferred into *public images* so that the meaning they embody can be shared. (My italics)

On this view it makes sense to suggest that one can have knowledge or form a concept, purely privately, and that the medium, or form of

representation, is *subsequently* invented in order to share it with others. In fact, this is precisely the wrong way round, as we have seen in previous chapters. I cannot know or understand anything, even privately, unless there is something to be known and understood. I cannot have individual conceptions, whether private or public, unless there is a medium in which I can formulate them. Eisner seems to think that the forms of representation are required merely to *express* the inner conception. Yet, as we have seen, it makes no sense to suppose that knowledge or concepts could *exist*, even privately, if there were not the relevant public institution. The importance of the point can hardly be over-emphasized in a discussion of feeling and knowledge in the arts, since it underlines the fundamental importance of the *forms of art*. Without the art forms the individual could not have the relevant concepts and therefore the feelings.

The point can be brought out in another way. Eisner states that, because of his social nature, man invents, or decides to create, forms of representation and communication in order to share with others his inaccessibly private concepts. How is this achieved? Eisner suggests that, in each case, we invent 'a socially arbitrary sign whose meaning is conventionally defined to convey that meaning. Thus words and numbers are meaningful not because they look like their referents but because we have agreed that they shall stand for them' (1981, p. 21). But unless there is already a shared language of communication, there is no sense to the supposition that a group of men can get together to decide what these 'socially arbitrary' signs shall mean. To illustrate, contrast language with a code. A group of people can agree among themselves that certain signs shall have certain meanings. But this can take place only where there is a language which is already understood among them. It makes no sense to construe language itself as a code. Yet this misconception is surprisingly common. For instance, Argyle (1975, p. 56) writes: 'Communication of all kinds can be looked at in terms of a sender who encodes and a receiver who decodes, so that a signal has a meaning for each of them', and 'In discussions of communication it is usually supposed that there is an encoder, a message, and a decoder'. This implies that what is expressed in language is specifiable independently of language. There are two related fallacies here.

(a) It is unintelligible to suppose that acquiring language is a matter of learning to translate purely private concepts since, on that view, it would make no sense to suggest that one could ever know what the private concepts of other people were. Nothing could count as a translation since there could be no way of knowing what concept was being translated, for

Feeling

one could never get to the private concept to find out. Moreover, since, as has been pointed out, criteria have to be public, there could be no criterion of the correctness of a translation even for oneself.

(b) As we have seen, it makes no sense to suggest that certain feelings and thoughts are possible for beings without language. Thus it cannot intelligibly be supposed that what is expressed in language are preexistent, non-linguistic thoughts and feelings. Without language such ideas and feelings could not exist, even privately. Clearly this point is very closely related to (a), since the feelings with which we are concerned necessarily involve the possession of certain concepts.

It is fundamentally to misunderstand the character of language to regard it as a code, since the notion of a code necessarily *presupposes* the language which gives it meaning. Similarly, no sense can be given to the supposition of a correlation between purely private concepts or feelings, and the language, art form, or other 'form of representation' in which they can be expressed. This reveals the crucial relationship between the concept of mind and the concept of language and the arts. It becomes clear what a fundamental misapprehension of mind, language and the arts is involved in the supposition that 'Somehow an individual who wishes to externalize a concept must find some way of constructing an equivalent for it in the empirical world'.

To regard concepts as 'privately held' is to deny any possibility of language, forms of art, or other 'forms of representation'; it is to deny the *medium* without which such concepts could not be formulated, and therefore could not exist. It removes any intelligibility from the notions of agreement, shared use, or understanding. Moreover, it can give no sense to the possibility of mental and personality development, in the sense of the enormously varied and extended range of concepts and feelings which become possible for an individual *only* by learning the public media of language and the arts.

That Eisner helps himself to a notion of shared meaning to which he is not entitled by the terms of his own theory, and that such shared meaning must be taken as presupposed to any notion of understanding, is well brought out by his writing, in the quotation above, that if you do not know the meaning of 'feckless' and 'mountebank' 'then you turn to a friend or a dictionary for words whose images allow you to create an analogy'. On the view that concepts are purely private, sensorily derived images it would be pointless turning to a friend, since it would be impossible to know what purely private concepts he had. The appeal to a *dictionary* is an even more obvious concession that a public

language must exist as a precondition of understanding. On the hypothesis of concepts as private images there could be no sense to the notion of a dictionary, still less of understanding what is in it.

The Given: Language and the Arts

Any intelligible account of the concepts and feelings expressible in language and the arts has to take the medium of expression as what has traditionally been called in philosophy 'the given'. The given is that to which ultimate appeal is made in explanation, and which gives sense to reasons, explanation and justification. For example, as we have seen, it makes no sense to suppose that language was invented or created in order that men could communicate concepts or express their social nature. It is rather that men have the kinds of concepts they have, and the social nature which is peculiar to men, because of language. It is language which allows men to possess those concepts and to have that social nature. In this sense, contrary to what Eisner supposes, concepts are at base linguistic. That could sound like a trivial tautology. In this context it is to make the point that we cannot look outside language for an understanding of what it is to possess the concepts expressible in it, any more than one can look outside chess for an understanding of chess moves. This is not to deny that language cannot coherently be regarded as isolated from the natural ways of acting and responding which surround and give sense to the utterance of words. These natural forms of behaviour, not images, are the roots of language and the arts.

One learns how to use and understand language rather as one learns how to play chess. However, this analogy may be misleading, for whereas chess may have been invented it is unintelligible to suppose that language and the concepts given with it could be invented since this would have to presuppose an already existent language in which such an invention could be formulated. This brings out the full force of the relation between mental development, and the arts and language, for it is not that man creates language and the arts, but that, in an important sense, language and the arts create man.

An analogy will illuminate the issue. MacIntyre (1967) argues that one important reason why Christian practices have retained some tenuous general hold in Western society, despite the widespread rejection of doctrine, or rather, more significantly, the general assumption that such

Feeling

practices are irrelevant to ordinary life, is the lack of an alternative vocabulary or practice with which to respond to the major crises or events in men's lives, such as death. I am not referring to an *intellectual* inability to work out satisfactory formulas, but rather to the situations in which, faced with actual deaths, there should be formulas which would have emotional and moral relevance and significance. Perhaps the most fundamental and urgent question we have to face is: 'What is the meaning and significance of the life of someone we have loved, or whom we love?' How can this significance be expressed, since, in the absence of a possibility of expression, one feels that there can be no such significance? MacIntyre (p. 70) writes:

If you read contemporary theology carefully, its content amounts to this, that we are not to take literally what people in past ages said about Hell or Purgatory. Instead we are to treat these as informative metaphors, or myths. The degree of insistence that we are not to take these doctrines literally appears to be a recognition that what was said will not do any more, but at the same time there is nothing to put in the place of literal doctrines.

The possibility even of raising questions depends upon the existence of concepts, or a vocabulary, in which they could be formulated. In this case the questions are framed in a vocabulary which can no longer provide adequate answers, since it expresses concepts which are mere etiolated remnants of practices which are no longer genuinely part of people's lives. Of course, we can cease to involve ourselves with the arts whereas we are inevitably confronted with the problem of coming to terms with death. But if we continue to concern ourselves with the arts then, in the same way, the art forms set the limits of sense for possible interpretation, appreciation and artistic experience and creativity.

The set of related issues which are centred on the problem of death, such as the meaning and value of human life, and what human achievement amounts to, are determined by the vocabulary in which they can be formulated. I do not mean simply that the issues could not be expressed without a vocabulary or set of practices, but something more fundamental, namely, that they could not even *arise*. For the notion that there could be such issues if there were no medium in which they could be expressed is unintelligible. The point is made in Edward Bond's play *The Sea* (1973), where Hatch is dimly aware that the *mores* of post-Victorian society are dangerously inadequate to cope with the changes which he vaguely senses to be encroaching menacingly upon it. Lacking a vocabulary in which his fears can be formulated, his groping desperation leads

him to inane delusions of invisible forces from outer space. It is significant that the play starts with the drowning of a character who, although he never appears except as a body washed up on the shore, dominates the play by confronting the effete social ways of thinking and talking with the need to respond to death in the community.

The analogy with the problem of responding to death is particularly illuminating because in this case it is surely wildly implausible to imagine that, with the loss of the old religious customs, people could simply get together and *decide on* some new ways of marking the significance of a human life, except, of course, as a development of conceptions or practices which are *already* valued as being endowed with the requisite gravity. Not *anything* could count as an expression of the meaning of a human life. This tension, or fragmentation, is inevitably reflected in the prevalent reluctance to think about death, or the meaning of life.

Robinson, in Chapter 2 of The Survival of English (1973), argues that the change of language in the New English Bible amounts to a drastic reduction in experience. Part of his point is the same as a main theme of my argument, namely, that there is a misconception involved in the notion that different forms of expression are merely different ways of expressing concepts which are independent of those forms. Specifically, Robinson argues in convincing detail, in a chapter which is well worth reading, that the New English Bible cannot intelligibly be regarded, as is often claimed, as a modern translation of the same concepts and experiences expressed in the earlier version. The change of language involves, in subtle but significant ways, changes in what it expresses. In this sense the language gives and is not entirely distinguishable from the experience. Except in a crude sense, which would miss its full religious significance, there is no coherent distinction between the language used and the possible mental experience; the loss of the language of the earlier version, that is, the lack of the use of this language, incurs the loss of possible individual experience. 'Religious English is the style of our common language that makes religion possible (or not, as the case may be), (p. 55; my italics). Moreover, given the centrality of this kind of language to our concepts of the value and meaning of life, 'the New English Bible is a diminution of our whole language' (p. 60), and thus of our possible depth of experience, since 'the state of a language depends on everybody who uses it and is indistinguishable from their state' (p. 62).

Whether it is possible to translate the same concepts into another language depends partly on what is meant by 'language'. If it were possible for there to be a language in which precisely the same concepts,

Feeling

rooted in precisely the same ways of life, were expressed in different signs or sounds, then an exact translation would be possible. But if by a different language one means that at least to some extent the concepts and ways of life are different, then clearly no exact translation which involves them would be possible. Robinson shows how these particular changes of language necessarily involve changes of concept, and thus of experience.

Similarly, what is expressible and imaginable in an art form is determined by the vocabulary in which it can be formulated, by which I mean such factors as the limits of the particular physical medium, and the school of thought within which an artist is working.

Subjectivism and understanding

As we have seen, there are those whose conception of mind is subjectivist, vet who implicitly trade on what they are explicitly repudiating by accepting that there is artistic meaning, and that artistic feelings and ideas can be shared and understood. Phenix (1964, p. 167), for example, writes of a dancer's movements 'They make visible the subjective life of persons by a series of symbolic gestures', and Langer (1957, p. 26) writes that 'felt life' is objectified in a work of art, and in this way 'The arts objectify subjective reality'. These quotations by themselves need not commit the authors to the subjectivism I am criticizing, although further examination of their work shows that they are so committed. I quote them to bring out another important issue. If, by 'subjective' they mean that the 'life' or conception is independent of the medium then, as we have seen, such a thesis is untenable. If, on the other hand, they mean that it is possible to formulate ideas and feelings which need not be overtly expressed, then that is correct as long as it is recognized that such a possibility presupposes the existence of a form of art.

If, by saying that art is feeling objectified, or that the arts objectify subjective reality, one means that there are to a large extent shared criteria for what counts as the expression of feeling in an art form, and that reasons can be given to support one's contention that a work falls under a particular description of it as expressing a certain feeling, then, while that is correct, it should be recognized that feelings *in general* are already objectified. That is, quite apart from the misconception that the peculiar province of the arts is to objectify independently existent non-artistic feelings, this implies that there are no objective criteria for non-artistic feelings. Yet clearly there are criteria for what counts as sadness, fear,

anger, and so on. Such criteria are learned in learning language. In short, the feelings expressed in art are no more and no less objectified than any other feelings.

How Can a Feeling Be in an Object?

In response to my previous sentence, the objection may arise that there is an asymmetry here, for whereas human beings clearly do express feelings, it is not clear how works of art can do so. Reid proposes what is still a very common and tempting thesis (1931, pp. 62-3):

How do perceived characters come to appear to possess, for aesthetic imagination, qualities which as bare preceived facts they do not possess? How does body, a nonmental object, come to 'embody' or 'express', for our aesthetic imagination, values which it does not literally contain? Why should colours and shapes and patterns, sounds and harmonies and rhythms, come to mean so very much more than they are?... The embodiment of value in the aesthetic object is of such a nature that the value embodied in the perceived object of body is not literally situated in the body. The joy expressed in music is not literally in the succession of sounds... Our question is, How do the values get there? The only possible answer is that we put them there – in imagination.

In a similar vein, as we saw in Chapter 2, Ducasse (1919, p. 177) writes: 'The feeling is apprehended as if it were a quality of the object'; and Perry (1926, p. 31): 'It seems necessary at some point to admit that the qualities of feeling may be ''referred'' where they do not belong...' (those with a background in philosophy may recognize the similarity to Locke's thesis about secondary qualities).

In fact, there is not only a symmetry but an important connection between the feelings expressed by people and those expressed in art. To bring out what I mean, consider a point made by Reid in a more recent work (1969, p. 76). Discussing the problem of content and medium in the arts he writes that there is a similarity to the way we 'see' character in a person's face. In the context of his general thesis his inverted commas imply that one does not *literally* see someone's character since it is possible literally to *see* only physical things like flesh. Yet this raises the problem of how a purely physical thing like a human body can express nonphysical feelings – which is precisely parallel to the problem of how a physical work of art can express feelings.

Feeling

No theory which assumes *two* entities, however closely united, can solve this problem, in either case. One cannot give a coherent account of the expression of feelings if perception is limited to physical bodies or objects, in this sense. The crucial point is that we are not concerned, in either case, with *physical* objects, in that sense. The symmetry between the two cases can be brought out by reference to the notion of the 'given', mentioned above, for the given is not a physical body but a *human being*; the given is not a physical object but a *work of art*. One does not 'see' the character in a person's face, one *sees* the character in a person's face. One does not refer a feeling into a physical artefact where it does not belong, one recognizes the feeling *as if* it were a quality of the object, one recognizes the expressive quality of the art object.

The intractable nature of the problem is created by a confusion of objects, or kinds of explanation. For example, Reid says that the joy expressed in music is not literally in the succession of sounds. It is true that no physical or chemical examination will reveal joy in a succession of sound waves, but it is precisely *that* way of posing the problem which makes it impossible to offer a coherent solution. For if one looks for the feelings (or meanings and values) expressed in art in that way one will have either to conclude that there cannot be any, since they cannot be found, or postulate subjective non-physical entities lying behind, or imaginatively referred or projected into, as if they were qualities of, the physical stuff. This last notion is, of course, simply another formulation of, and largely underlies, the common assumption that 'Beauty is in the eye of the beholder', and 'Beauty is no quality in things themselves; it exists merely in the mind which contemplates them'.

The problem is created by moving from 'The joy is not literally in the succession of sounds' to 'The joy is not literally in the music', or by regarding these two sentences as equivalent. This is a case of crossing conceptual wires, rather like asking for the weight in grams of heavy sarcasm or light entertainment. A largely contributory factor here is the scientism of our age which too easily seduces one into assuming that the only things which *literally* exist are physical entities which can be scientifically examined and quantified. Of course, a physicist could examine a Beethoven symphony to determine its constitution in terms of sound waves, but it would be a confusion to think that this could explain its meaning or value as *music*.

Thus what Bosanquet regards as the central problem of the aesthetic, namely, how a feeling can be got into an object, is created by the

presuppositions in the question. For to formulate the question in those terms both manifests and conduces to subjectivist confusion. It is rather like asking: 'How can what is really nothing more than a carved piece of wood be a king in chess?' There is no temptation here to assume a separate quality of 'kingship' lying behind, or projected on to, a piece of physical wood. For those who know what chess is, it is not normally seen as a piece of wood, but as a chess-piece. Similarly, a written word is not literally simply physical marks on a paper, but a *word*, which is given its sense and identity by the concepts of the institution of language.

Once the perspective is changed and we recognize that the given is a human being, or an art object, respectively, the problem evaporates, for there is no question of how a feeling can be in a physical object. A physical body is not the kind of thing which can have feelings, but a human being is; a physical object is not the kind of thing which can express feeling, but a work of art is. The feeling is a quality of the art object; that is, the kind of thing an art object can be. There are not two entities, a physical object and a feeling, there is only one, a work of art which may have an expressive quality. Similarly, one does not try to carry out incoherent inferences to a non-physical entity of sadness, somehow 'inside' a physical body. One *sees*, for instance because he is sobbing, that a human being is sad. In learning the language one learns that such behaviour by a human being is a criterion of sadness, just as in learning to understand an art form one learns what are the criteria for the expression of feeling within it.

It can now be understood why it was necessary briefly to consider philosophy of mind in general, since the misconceptions we have considered about understanding, meaning and the expression of feeling in the arts are a manifestation of an underlying misconception about the concept of mind. The lack of a coherent concept of mind may have confusing consequences for our conception of the arts, and damaging consequences for the arts in education, in theory, policy and therefore in practice.

It can also be seen why analogies have been drawn between the arts and language. Indeed, in important respects it is misleading to refer to them as analogies. For while it is mistaken to regard an art form *as* a language, there is an opposite danger of overlooking their interdependence. Both language and the arts give a conception of life and value. The character of the individual thoughts and experiences of individual human beings is given, except at the most primitive level, by the culture of a community, by which I mean that amalgam of social practices, language and art forms which give man his conception of the meaning and value of life.

Feeling

Summary

- (1) Artistic feelings necessarily require the possession of certain concepts. That is, the object on to which attention is directed, and which is a principal criterion of an emotion, cannot be characterized independently of a conception of the phenomenon.
- (2) Meaning, or concepts cannot be exclusively a matter of sensorily derived images; they cannot be regarded as purely private in the sense of being independent of and translated into the public media of language and the arts.
- (3) The relevant concepts, and therefore the feelings, could not exist without language and the arts.
- (4) Consequently, the given, that is, that which ultimately gives sense to reason and explanation, is language and the forms of art.
- (5) Therefore to ask, with respect to the arts, how a feeling can get into an object is a confusion parallel to asking how a physical body can have feelings. The given is not a physical body and a physical object, but a human being and a work of art. In this respect the concept of art is underlain by the concept of mind.

This chapter considers the way in which reasoning for a different conception of a work of art can change one's response to it. It also considers whether reasons related to the feeling or intention of the artist, and to the response of the spectator, are relevant to the meaning and understanding of a work. The common tendency to deny their relevance springs from a failure adequately to appreciate the significance of the concept of art, and from a dualist conception of mind according to which the feelings and intentions are identifiable independently of the work.

Reason and Object

The object of the emotion, in the sense of one's conception of the phenomenon, related in an important way to the kind of reasoning which was discussed in Chapter 2. For the object is a central criterion for the character of the emotion, and reasons may be given which change one's conception and thus the feeling. However this does not imply that one always reasons one's way to a feeling. On the contrary, if that were necessary it would indicate inability fully to appreciate the arts, and a limited capacity for emotional feeling generally. Such a misunderstanding may underlie the tendency to deny that reason has a place in involvement with the arts, and to assume that reasoning is inimical to feeling.

Robert Browning's sonnet XIV makes the point:

If thou must love me, let it be for nought Except for love's sake only. Do not say 'I love her for her smile – her look – her way Of speaking gently – for a trick of thought

That falls in well with mine, and certes brought A sense of pleasant ease on such a day' – For these things in themselves, Beloved, may Be changed, or change for thee – and love, so wrought, May be unwrought so...

It is true that love is not achieved rather like reaching a conclusion from a reasoned argument. One would suspect the sincerity or the capacity genuinely to love of someone who said that he loved because the beloved satisfied certain desirable criteria. Such considerations induce some philosophers to deny that reasoning has any place in some emotions, and especially love. Yet although it may be inappropriate to talk of the justification of love, there is a sense in which one can give reasons in explanation of why one loves or likes someone. Browning could have referred to her smile, her look, her way of speaking gently, and so on. Moreover, although it may be unacceptable to speak of justification of love, there is no sharp distinction between justification and explanation in this sense.

A further parallel with the arts is that one may create the possibility of love or liking for a particular person by reasoning. This could be achieved by showing another a different conception of, a new way of seeing, someone. It may be that reason has a less central role in such a case than in the arts, but it certainly has a place.

Of course, what it is about the person which moves us cannot be adequately captured in words, but that is not to say that no reasons can be given. Similarly, one of the motives for denying the place of reason in the arts is the recognition that what is expressed in a non-verbal work of art cannot be comprehensively captured in words, and what is expressed in a verbal work cannot be captured in other words. But this point should not be exaggerated. First, as we saw in Chapter 2, reasoning, in the sense of bringing someone to a different conception or understanding, should not be limited to the verbal. A musician could show a different interpretation of a piece by playing or singing it with particular emphases; a dancer could demonstrate the significance of a particular sequence of movements to the meaning of a dance. Secondly, from the fact that not *everything* can be said about the non-verbal arts in words it does not follow that not *anything* can be said. On the contrary, verbal reasoning is a principal way of learning to appreciate both verbal and non-verbal arts.

It is commonly assumed that feeling and reason are mutually exclusive, and that reason is inimical to feeling. This partly underlies a damaging

caricature of the arts, knowledge and mind. Education, and the human personality, are taken to consist in at least two distinct realms. Mathematics, the sciences, and so on, are supposed to be concerned with unfeeling, unimaginative matters like concepts and reasons, while the arts are supposed to be involved not with concepts and reasons but with the separate realm or faculty of feeling. Attempts are then made to justify the arts by claiming that education traditionally concentrates almost exclusively on the rational and intellectual aspect of man, and that in order to correct the imbalance more attention should be paid to the feeling aspect, that is, the arts. (This notion is sometimes rather bizarrely supported by citing neurological discoveries about functions of brain-hemispheres – as if such purely physiological considerations could be even remotely relevant to the question of the educational justification of the arts. But I cannot digress to discuss that issue.)

A related misconception, which is as much a caricature of mathematics and the sciences as it is of the arts, is that it is the peculiar province of the arts to offer scope for creative abilities. This notion seems to be reflected in such titles as 'Creative Arts' departments, which seem to imply (a) that some arts do not offer scope for creativity, and (b) that there is no scope, because of their nature, for creativity and imagination in other subjects such as mathematics and the sciences. That seriously damaging misconception is all too often manifested in the way in which these subjects are taught, and thus the expectation inherent in it fulfils itself, and the myth is self-perpetuating.

This is not to disagree that there tends to be an excessive emphasis on certain kinds of subject; nor is it to disagree that there is something seriously amiss with an educational policy which relegates the arts to a peripheral place. As I argue in this book, there are important aspects of education which are central and unique to the arts. It is the appeal to the postulated Two Realms, or Two Faculties, which I repudiate, for so far from supporting, it does serious disservice to the arts. To deny the relevance of reasons and concepts is to deny understanding, and thus any sense to the notion of appropriateness of emotion to its (art) object. This is, at best, to reduce 'artistic' response to that of which an animal would be capable, which would be to remove the sense of 'artistic appreciation'. Bambrough (1979, p. 99) draws a similar distinction in relation to morality:

even a complete vegetarianism *may* be based on a mere revulsion like that of the insular Englishman against frogs: but in that case, by the very fact of no longer allowing for argument, it disqualifies itself from being a moral

position and becomes instead a mere reaction, to be sharply contrasted rather than closely compared with any typical moral attitude or opinion.

In such a case the *object* of the revulsion is the crucial distinguishing feature. For example, as we saw in Chapter 1, Swift suggested in *A Modest Proposal* that the twin problems of insufficient food and overpopulation could easily be solved by eating babies. One's reaction, as he expected, is immediate revulsion, but this, unlike the revulsion Bambrough refers to, *is* a moral one. So it is not the revulsion which distinguishes the two kinds of case, but the character of it, which is given by the object. Thus the distinction is, for instance, between (*a*) when the object is that which was recently a living creature, by contrast with (*b*) when the object of the revulsion is simply the texture of meat. The important distinguishing feature is that in moral revulsion it is possible to bring others to understand it. For example, where someone does not share this response one may refer to the slaughter of animals and show him live animals. In this way he may be brought at least to understand the revulsion, and perhaps to feel it for himself.

A confusion of a parallel kind contributes to subjectivism in the arts. For example, I may respond with sadness to a joyful Mozart rondo because it was my dead mother's favourite piece of music. This is subjective, in the sense that it would be quite out of place to give reasons for the inappropriateness of the response in such a case; understanding may be irrelevant to it. The feeling just happens to be related to the music by association, since another piece might have been her favourite. Such a response is not part of artistic appreciation; it is not related to features of the music, and notions such as understanding and appropriateness to the character of the music play no part.

That kind of case tends to be confused with the particularity of the response, that is, its logical relation to a particular work of art, which is an issue to which I shall refer shortly, and discuss more fully in Chapter 10. It is also confused with a justifiable emphasis on the individuality of artistic response. We considered this issue in Chapter 3, but briefly to recapitulate, that an artistic judgement is necessarily individual, in the sense that each person must experience the work for himself, is not to deny the relevance of the notions of appropriateness and understanding. While an artistic judgement could not count as such unless the individual had made it as a result of his own experience, it equally could not count as an artistic judgement if questions of understanding and appropriateness were irrelevant. As we have seen, a precondition of being able to respond

to an art object is that one should have grasped the relevant concept of art, and that includes a grasp of its criteria of appropriate response. Once again, in order to avoid misconception it is worth considering the case of one's own reflection about a work of art, how one can work one's own way to an understanding of it, and thus respond to it.

The comparison with morality can be pressed further. Reasoning one's way to a moral repudiation of the killing of the innocent is not simply *unnecessary*; it is rather that if it were deemed necessary, that would be a significant indication of a *lack* of a certain moral commitment. Nevertheless, even in such a case, reasoning is not necessarily out of place. For example, where a child is born severely deformed, or where someone is suffering severe pain from an incurable disease, rational discussion may well ensue about whether it would be morally right to terminate innocent life. Moreover, some of the firmest moral feelings which people have can be changed or modified by reason, as in the case of prejudice, or one's conversion to, or coming to reject the validity of, a particular religious belief.

There is a further parallel. It is sometimes said that the media or conventions of art are mediating influences on artistic responses. In a similar vein, it is also sometimes said that the purpose of convention in art is to distance one from the object, and thus to reduce or eliminate emotional response. We shall discuss some of these issues in Chapters 9 and 12, but it is worth saying now that if these notions imply that emotional response cannot be *immediate*, then they are confused and mistaken. As in the distinction between the two cases of revulsion, the distinguishing feature between artistic and non-artistic responses is not the immediacy of response in the latter case, but the *object*, that is, the character of the response. A response to a moving musical, theatrical, or dance performance can be as immediate as any non-artistic response.

An exaggerated emphasis on reasoning can be inimical to spontaneous, immediate feeling, but that is *far* from saying that reasoning is necessarily inimical to spontaneous feeling. On the contrary, in at least the great majority of cases it would be impossible to have such spontaneous feelings in response to the arts unless one had learned to understand them as a result of reasoning. Paradigm cases in the arts are those in which a great deal has to be learned in order to appreciate that they *are* paradigms, and in order to be able to respond fully. For instance, in such cases there may be various possible interpretations – what has been called the 'creative ambiguity' of some of the greatest works of art.

My objection to the prevalent myth of the Two Faculties, or Two Realms, is not only philosophical but educational. It is a caricature of the

arts, if a persistent one, to assume that concepts and rationality are irrelevant or inimical to appreciation and creation. The arts are often concerned with feeling, but equally with reason. Indeed, as I have tried to show, it would make no sense to suppose that the feelings involved in artistic expression and appreciation could even exist independently of rational understanding. To regard the arts as exclusively the province of feeling and imagination as opposed to reason is to endorse a confused conception of mind which, so far from repudiating, perpetuates a traditional and inadequate approach to education. For too long there has been a disastrous failure to understand the contribution of reasoning to the emotions generally, and to the feelings involved in artistic experience in particular, and this failure continues to handicap the case for the inclusion of the arts in education. What is required is a coherent conception of mind, rationality and feeling which recognizes the inseparably cognitive character of emotional feelings, and in particular those involved in the creation and appreciation of the arts.

Rationality is, then, central to artistic appreciation since it gives the understanding which allows for appropriate response. Moreover, within limits, reasons for a different interpretation may change the object, that is, one's conception of a work, and therefore the character of the feeling.

There are numerous examples of ways in which reasons can change one's conception and with it one's feeling. This may occur even in the case of love or liking where, as we saw above, some contend that reasons have no place. Reasons here, too, may consist in bringing the person concerned under a certain description or pattern of comprehension. Shakespeare's Othello illustrates the point. Early in the play, Othello's love for Desdemona is largely characterized by his conception of her as ideally virtuous. Iago gives him reasons for seeing her as unfaithful, and in accepting this changed conception Othello's emotion changes to such violent jealousy that he kills her. Too late, Emilia gives him reasons for recognizing that his attribution of infidelity to Desdemona had been unjustified. His changed conception again determines a different feeling, namely, of remorse. This example shows the conceptual or logical connection between one's belief about, interpretation or understanding of, an object, and the character of one's emotional feeling about it. It also shows how radically mistaken it is to deny the relevance of concepts and reasoning. There are also cases which are closer to the arts in that one's changed conception of and feeling about a person do not involve a change in beliefs, in the sense of acquiring new facts, but are a matter of coming to see him

in a different light. An emotional feeling is a mode of apprehending an object and without that apprehension, given for instance by language and the arts, there could not be such a feeling.

Understanding is not, of course, necessary for all emotions. Obviously some emotional responses, such as many kinds of fear, are instinctive. But, in an enormous and varied range of cases it makes no sense to suppose that feelings would be possible for any creature which had not some mastery of certain practices or media which give substance to the notion of understanding. For instance, competence in the use of language is a necessary condition for a whole range of emotions, such as remorse about one's behaviour a few months ago, fear of continued economic inflation, and dismay about the likely result of the next general election. Nothing could count as fear of a happening in the distant future, or regret about the distant past, if there were no language. Learning a language, and with it what counts as reason and understanding, is a necessary precondition for the possibility of experiencing such feelings. As we saw in Chapter 5, the same applies to the arts.

It has been objected that my thesis is a form of elitism, since it implies that only those who have learned to understand an art form can have the relevant feelings. The objection is confused. In a social sense, the thesis is not in the least elitist since one wants to offer to *everyone* the chance of extending conceptual horizons, and thus the possibility of an extension of feelings. In an educational sense, one is merely saying, in effect, that those who have been educated in certain ways have advantages over those who have not. If *that* is what is meant by 'elitism' then every educational activity is elitist, and would be of no value if it were not.

Tolstoy's confused insistence that true art should communicate itself easily to all mankind would disqualify his own works and, if it makes sense at all, would reduce the arts to banality. That no great work of art can be easily understood by all is an inevitable consequence of there being so much to be learned in and through the arts.

The Artist's Feeling

To return to an issue raised in Chapter 7, it is often assumed that there is a special problem about the relation of the artist's feeling to the art object. The greatest difficulty in understanding this issue is, one suspects, the underlying influence of dualism, that is, the assumption that the feeling is a separate event, independent of the art object. A consideration of a

remark by Collingwood (1938, p. 111) will illustrate the important points. He wrote: 'Until a man has expressed his emotion, he does not yet know what emotion it is. The act of expressing it is therefore an exploration of his own emotions.'

In one sense there is a mistake here, since I can know that I am angry, for instance, before or even without ever expressing it. However, more important, it is true that knowing what I am feeling and knowing what I am inclined to *do* are inseparable. Unless there were a background of a general conceptual connection between feelings and the way they are expressed, no sense could be made of the notion that an individual could know what feelings he is having. As we have seen, one learns how to characterize one's own feelings as one learns to characterize the feelings of others. Similarly, it is possible to know that one has an artistic feeling which has not been expressed, but only because there is an artistic medium in which such feelings are expressible.

More important issues are raised by Collingwood's second assertion, that the act of expression is an exploration of the artist's own emotions. Again a qualification is needed, since this may give the impression that such emotions could exist independently of the art form, whereas, as we have seen, they depend for their existence on the existence of the medium. Nevertheless, there is something important here which is concerned with the distinction between having a feeling and knowing what that feeling is. Enough has already been said to expose the misconception that a feeling can be purely private, in the sense that it is impossible in principle for anyone else to have direct knowledge of it. A corollary of that subjectivist or dualist misconception is that only the person himself can have infallible knowledge of the character of his own feelings. Yet since the criteria for emotions are behavioural, including verbal behaviour, it cannot be the case that one is necessarily in a better position than others for identifying the character of one's feelings. For example, much of a psychoanalyst's task is bringing people to recognize the character of their own feelings, for instance, of jealousy or envy, which they have failed to identify accurately. We shall return to this issue shortly with respect to intentions. In relation to the present issue, it is possible for the artist to have a feeling which he cannot, or cannot adequately, identify or describe. The exploration of the precise form of expressing it is the exploration of its identity and character. In this sense the feeling is not an independent mental event. Discovering how to express it in the artistic medium is discovering the artist's feeling.

Moreover, the act of expression, at least often, involves an exploration

of the medium and thereby confers a greater or confirmed grasp of its expressive possibilities, and with it a greater possibility of feelings.

This issue raises the question of what I meant when I said that there is an important sense in which the emotion of the artist cannot intelligibly be regarded as distinct from the work of art. First, it should be remembered that we are concerned with an art object, not simply a physical object. Even so, it sounds odd to suggest that what the artist experienced was a painting. Nevertheless, if that object, or kind of object, did not exist then neither could that emotion or kind of emotion. The clearest and most appropriate illustration is that of a highly particularized emotion, directed not on to a kind of object, but on to a particular object. (This kind of case will be further discussed in Chapter 10.) For instance, take the case of my feeling of affection for my former college. In one sense the college and my feeling are distinct, since the college could have existed without the feeling. But this particular feeling could not exist if the particular college had not existed. This emphasizes the point that the relation is logical or conceptual. On a dualist, or subjectivist, basis the emotion just happens to be related to the college, and its character is discovered by introspection. In that case, it would be logically possible despite the fact that I have various mementoes of the college, regularly attend reunions, visit it frequently and speak of it with affection, that I could discover by introspection that my affection was not for the college but was for walking in the Lake District, which, of course, is senseless. (For those with a philosophical background it may be worth pointing out that I do not deny that there are also causal factors, and that I neither wish nor need to take sides on the issue of whether reasons can be construed as causes.)

The appropriateness of the example is that, in the arts, we are concerned with particular emotions characterized by particular works.

The problem of the relation between the object and the emotion in the arts is parallel to that between thoughts and words. If you ask what are my thoughts on a certain issue, I may refer you to an article I have written. In this case there is little temptation to say, analogously: 'But what went on in you was not marks on pieces of paper, or printed words.' My thoughts are *identified* by the printed words. Without the medium of verbal language such thoughts could not exist, even unexpressed.

A philosophy undergraduate, struggling with a problem, may say that his thoughts on the issue are clear 'deep down' but that he is simply having difficulty in expressing them. But, in general, I should want to say that there is no such thing as a clear idea which cannot be clearly expressed. The qualification is that it is possible for there to be a case

rather like that of inability to find the right word, although one is clear about what one wants to say. Nevertheless, in general, if the expression is confused, so are the thoughts 'deep down'. The struggle for clarity of expression, generally, *is* a struggle for clarity of thought.

There are two issues here: (a) it makes no sense to suppose that one could have the particular feeling or idea unless one had to a relevant extent mastered the art form; but (b) does it make sense to say that one may have a clear idea or feeling which cannot be expressed? We need to distinguish between a specific feeling or idea, and a clear one. An artist may have a *specific* idea for which he may struggle, in the manipulation of the medium, to find a precise expression. A notable example is that of the series of preliminary sketches, leading up to the finished work, in which Picasso expressed his feelings about the bombing of Guernica. Of course, it could have been, and seems more likely, that he did not have the specific idea prior to working through his sketches, but only a relatively vague one which was refined in his experimentation with them. But it is possible that the final version clearly expressed or captured the original specific but unclear idea. The idea could not have been *clear*, even to him, until he had found the precise expression for it.

The distinction can be brought out in terms of choreographing a dance. The choreographer, searching for a particular piece of music, may listen to several pieces, some of which may be quite near to what he wants. At last he hears one which is just right. How are we to describe this? His idea may have been specific since he was able to recognize the precise piece of music immediately, but it could not have been clear, since he himself could not express precisely what it was.

To repeat, this does not imply that one cannot have clear but unexpressed thoughts and ideas. Thus Collingwood's remark would have to be amended to something like: 'Until a man knows how he would express it, he does not yet know precisely what emotion it is.'

There are, then, two possibilities:

(a) An idea or feeling which is only relatively specific, in that, for instance, the artist may be aware that there is only a fairly narrow range of expressive possibilities, and can certainly say that some possibilities are inappropriate. Within that range he needs to explore and experiment to find the precise one he wants. He will make the idea or feeling both specific and clear in working it out in the medium.

(b) An idea or feeling which is specific, since the right expression

can be recognized, but which cannot be clear to the artist since he is unable to say precisely what he wants, or otherwise to formulate it clearly.

Consider my analogy with the philosophy undergraduate. The most likely case is as (a) above. But it is possible, as an exceptional case, that he may have an idea which is specific but not clear. He may repudiate every other formulation, and give good reasons for denying that it expresses his thoughts, until he is offered precisely the formulation which he accepts. One would describe him as having had an idea which was specific but not clear; what he is offered makes clear what was already a specific idea.

The Artist's Intention

The misconception of assuming that the feeling expressed in a work of art is a separate mental event, identifiable independently of the work, is parallel to the assumption that the artist's intention is irrelevant to questions of meaning and appreciation. The most influential source of this view is a paper by Wimsatt and Beardsley (1962), entitled 'The intentional fallacy'. It would be a digression to discuss this issue in detail. I shall consider it only to bring out the way in which it manifests a parallel misconception about mental phenomena. The authors make two major points: (a) we cannot usually discover the artist's intention, and (b) even if we could, it is irrelevant to the meaning of the work.

It is plausible to assert that the artist's intention cannot usually be discovered since, for instance, he may be dead and cannot be asked what he intended. It is similarly plausible to assume that the intention is irrelevant to artistic meaning since what matters is the work itself. But the plausibility of both contentions depends upon the presupposition that the intention is a separate mental event, independent of the work, which can be infallibly known only to the artist. Enough has been said in relation to feelings, ideas and concepts to show that such a presupposition involves a fundamental misunderstanding of mental concepts. An intention, like a feeling or concept, cannot be purely private, and infallibly known only to the person himself. As in the parallel case of feelings, there is a distinction between (a) having an intention, and (b) being able to identify it. Again, it makes no sense to suppose that certain intentions are possible without language, the arts and other social practices. The attribution of the intention to make a particular move in chess could not intelligibly be made to

someone who knew nothing about the game. Such an intention could not exist independently of the social activity, although the intention need not be expressed. Having an intention should not be confused with, or taken to imply, the ability to identify it. One may be mistaken about one's own intentions. It is strange that the prejudice persists that the person himself has infallible knowledge of his intentions and thus is necessarily in the best position to say what they are. For quite apart from philosophical considerations, it is contrary to common experience. For instance, a psychoanalyst's task may be to help a patient to recognize that he has misconstrued his intentions. Less dramatically, we often learn that we have been mistaken about our own intentions, and it is an effort progressively to identify them more accurately and honestly. The point underlies a comment by an anonymous medieval religious writer: 'Swink and sweat until thou knowest thyself, and then, I trow, thou shalt know thy God.'

Necessarily, in general, what I say about my own intentions coincides with what others say about them. That is, of course, a consequence of my having learned how to use expressions of the form 'Iintend to do X'. Ilearn to characterize my own intentions as Ilearn to characterize the intentions of others. It becomes clear that an intention is not necessarily or normally separate from what is *done*. That is, the intention with which an action is carried out is not normally or necessarily a preceding or concurrent mental event. There are not two events but only one. To refer to an action as being done with a certain intention is to characterize it as of a certain kind. This is not to deny that some intentions can be formulated in advance, or that sometimes they are not carried out. When I lift my cup to drink tea, that is an intentional action, but it is rarely if ever preceded or accompanied by a formulated intention to do so. I simply lift the cup intentionally, and I am usually thinking or talking about something else. Nevertheless, I can, in advance, form the intention to go on holiday in Brittany, or to telephone my brother tomorrow evening, and sometimes I do not achieve what I intend.

Again, it can hardly be over-emphasized that the difficulty is to rid oneself of dualist or subjectivist presuppositions, that is, of assuming that the notion of an intentional action or product involves the 'given' of two separate entities. The 'given' is a human being, whose feelings, concepts and intentions are to a very large extent conferred by the language, arts and social practices of society. A human being, when he has learned the discipline of a medium, can keep his intentions, given by it, to himself, or he can carry out intentional actions in that medium. There can be conflicts of criteria in that what a person says about his own intention may conflict with what observers say about it.

The most important point, which sums up much of what I have said, is that it is what a person *does* which is the principal criterion for what his intention is. If someone strikes out because he has been attacked or insulted, we do not need, even it it made sense, to attempt to conduct an inference from that 'external' behaviour to an 'internal' intention. In such a context such behaviour *is* a criterion of his intention. This point was well illustrated in a talk I once heard by Ron Geesin, an artist who creates the most extraordinary sounds out of the most ordinary by an ingenious use of tape-recorders. After one illustration, a member of the audience asked him what he had originally intended to produce. He looked puzzled for a moment, and then, gesturing to the tape-recorder, he said that *that* was what he had intended. The questioner was not satisfied, and said that he knew that was what was eventually produced, but what had been his original intention. Ron Geesin looked even more puzzled for a time, then burst out: 'That was my intention. You've just heard it.'

In this kind of case there need be no further answer, and further questions therefore make no sense. The work of art is a criterion of the artist's intention; it is normally what identifies that intention. To assume, in general, that the intention can be identified independently of the work is fundamentally to misunderstand the concept of an intention. There is a logical relation between the intention and the form of its expression. Of course the work is not always and necessarily what the artist intended, any more than, in other contexts, one always and necessarily achieves what one intends. Once when visiting an artist friend I expressed admiration for an unusual piece of pottery. He laughed and confessed that its unusual shape was the result of an accident in firing. Nevertheless, this kind of case is necessarily the exception. I can intend to do only what I believe I can do, thus although I may wish, I cannot intend, to fly like a bird. Consequently, unless one normally achieves what one says one intends, it could not count as an intention.

We have seen that one is not necessarily the best judge of one's own intentions; hence the question may arise: 'What about a conflict of criteria, where the person says that his intention was X, while others who know him well say that it was Y? How can we discover what he really intended?' There can be no general answer to this question. One has to consider the strength of the conflicting reasons in each case. In some cases there may be no clear answer. As we saw in Chapter 2, the fact that reasoning is involved does not necessarily imply that a decisive resolution of different interpretations or conceptions can be achieved.

To interpret a work of art is, normally, to interpret the artist's

intention. Whether or not one takes into account the artist's *stated* intentions, perhaps implicitly in the title, depends upon the particular case. The stated intention is neither necessarily decisive nor necessarily irrelevant, although in view of the artist's intimate connection with the work, it would normally be a factor to which one would give serious consideration.

There is a criterial relation between the artist's intention and the meaning of the work. One cannot say simply that the work is his intention since there can be other criteria, such as an explicit repudiation of a certain ascribed intention by the artist, or other aspects of his life. Thus there is room for debate about the extent to which these other factors should play a part in interpretation of the work. Nevertheless, the work is the principal criterion for what the artist intended. Works of art are normally the intended creations of human beings, and they are necessarily formulated in the public media of art forms. The supposition that works of art could, in general, be purely fortuitous occurrences would make no sense since it would take away any sense from the notion of a work of art. 'Happenings' and objets trouvés, to be regarded as art, are necessarily parasitic on, or extensions of, a concept of art whose sense is given by works which are intentionally created. It is worth noting that objets trouvés are intentionally selected. Analogously, cracks in a brick wall might form a meaningful word, but the meaning is derived from a medium in which, normally, words are used intentionally to communicate. Word meanings could not normally be given by cracks in brick walls

The notion that the artist's intention is irrelevant to the meaning of a work of art is, then, based on a misconception about mental events which is parallel to subjective or dualist accounts of how feelings can be expressed in art. Both assume that the mental event is independent of the work of art. The relation of the issue to my argument is that in giving reasons for thinking that this was what the artist intended one is giving reasons for a certain conception of the work.

The Spectator's Response

What is, in some respects, the opposite side of this dualist coin can be seen in the 'anti-affectivists', whose most influential proponents are again Wimsatt and Beardsley, in a paper entitled 'The affective fallacy' (1960, pp. 21-39). According to this view the legitimate concerns of artistic

appreciation should be phenomenal features, such as coloured patches, and to use affective terms such as 'moving', 'inspiring', 'joyful', and so on, is to talk not of the work but of one's response to it. This time it is not the feeling or intention of the artist which is taken to be independent of the work, and therefore irrelevant, but the feeling of the spectator.

One argument is that since people have different emotional responses, what counts as the meaning of a work of art would vary if affective terms were to be regarded as legitimate. But a similar argument applies to perception of phenomenal features, since people vary in their ability to discriminate. This kind of argument, if taken to an extreme, would completely eliminate the possibility of meaning, or saying anything about a work. The distinction between the individual and the subjective is again important here. That individuals vary in their abilities is clearly no reason for denying the objectivity of mathematics and the sciences, or that linguistic terms have meaning.

That one is using affective terms does not imply that one is not talking about the painting itself. There is a distinction, as one saw earlier, between a response which just happens to be related to the work, perhaps because of association, and a response which one might characterize in affective terms but for which one could offer reasons by reference to features of the work. These would count as reasons, of course, only if they could be understood as such within the concept of art.

There is an important distinction to be drawn here. When one is engaged in artistic appreciation one is not concerned with how others respond to a work. As we have seen, individual response is central. But this should be distinguished from the contention that affective terms cannot be legitimately applied to works of art, and from the fact that the intelligibility of their application depends on and is rooted in a general uniformity of response. For example, one might apply the term 'moving' to a convincing performance of King Lear's agonized grief at the death of Cordelia. One could give reasons for the legitimacy of the application of the term 'moving', for instance, by reference to Lear's having learned as a consequence of his harrowing experiences that, contrary to his initial belief and despite his harsh treatment of her, Cordelia was the only daughter who had genuinely loved him, and who continued to do so. Moreover, if only the message revoking her death had arrived minutes earlier, her life would have been saved. In answer to the question 'What is the justification for calling the scene "moving"?", one's reasons would consist not in referring to the reactions of other people but in citing the circumstances in the play and the convincing way in which they were

portrayed. If the question were *then* asked 'Nevertheless, given those circumstances, why was it a moving scene?', one could make no sense of the question. For the intelligibility of the original question, and of the justification for the application of the term, is *given* by the fact that people *are* normally moved by such circumstances. This emphasizes again the importance of the issue discussed in Chapter 1, that artistic appreciation, artistic meaning, and the sense of reasons given for judgements, are rooted in the ways in which people instinctively respond.

Similarly, unless there were general uniformity in colour-judgements there could be no meaning to colour-terms. Yet it is possible in both cases that even the whole group could be mistaken on occasion. Everyone could be wrong in a particular colour-judgement, just as all the knowledgeable could have an inappropriate affective response to a particular work of art. The relation between the meaning of affective terms, as of colour-terms, and the response or judgements of people, is not straightforward, but in both cases it depends upon a certain uniformity of response.

There are, then, two points here: (a) there are affective qualities in works of art, and the attribution of them can be supported with reasons; (b) the meaning, or intelligible application, of affective terms depends upon a general uniformity of response among those who understand the art form.

There are two major points for my thesis which arise from this and the preceding section.

(1) To deny the relevance of questions of the artist's intention, and of the affective response, is to presuppose a clear and unproblematic distinction between what the work means and those considerations which are extrinsic to it. That is, it is to presuppose that the question of what is and what is not extrinsic is *independent* of the question of the meaning of the work. But this is confused, for the question of what counts as intrinsic and extrinsic is part of the question of how the work should be understood or interpreted. For example, the question of whether or not we should accept, or at least seriously consider, the account given by Berlioz of what it means. Our conception of a work may be in intentional or affective terms, and to rule out such discourse as extrinsic is to beg the question of what is and is not extrinsic; it presupposes an incoherently oversimple conception of artistic meaning.

(2) A medium of expression, such as a language or an art form, necessarily requires both an expresser and a receiver. That is a consequence of its being a public medium. It is a misconception to assume that the

feelings and intentions expressed in art could exist independently of the art form, and that the question of the intention of the artist is normally distinct from and irrelevant to the question of the meaning of the work he has created. In one respect at least, the misconception of the anti-affectivist can be seen as the other side of the same coin, for to deny the relevance of the response is equally to fail adequately to recognize that an art form is a public medium of expression. There has to be the possibility of some degree of match between what the artist has expressed in the work, and the response of at least some of the audience. As in linguistic expression, the match may not be exact. To insist on such a possibility of match is implied by saying that an art form, like language, is a social practice.

However, there is an important difference between the two points. While the intelligibility of application of affective terms depends upon a general uniformity of response, in any *particular* case the actual response of any individual or even a whole group is not relevant to the question of the meaning of a work of art. By contrast, there is a logical relation between what the artist intended and the meaning of a work in any particular case. That is, while the question of the artist's intention is always relevant to the question of the meaning of a work, this is not true of the affective response to a work.

The Education of Feeling

The preceding discussion provides the basis of an account of how emotional feelings can be learned, both in the arts and generally. The education of feeling in the arts consists in giving reasons for, and encouraging people to recognize for themselves, different conceptions of a work of art. As we have seen, a different concept of the work will constitute a different object of the emotion, and thus a different feeling. Progressively recognizing the validity of reasons for more finely discriminating conceptions of the arts will allow for the possibility of the progressive development of more finely discriminated feelings.

Some people are prepared to accept my thesis up to a point. They concede that expressive meaning is partly a matter of a logical relation between the work and feeling, but, they are inclined to say, there are also subjective aspects. To this I would reply that to the extent that they involve subjectivity, in the sense in which I am using the term, no sense can be made of learning, and thus there could be no place in the arts for

the education of feeling. To repeat, a major confusing factor is that the term 'subjective' is usually so unclear and is used with a variety of very different meanings. If by saying that the arts are partly subjective one means that personal involvement and feeling, and individual differences, are central to the creation and appreciation of the arts, then, so far from being incompatible with my argument, that contention is a main theme of it. By contrast, there are two other meanings of 'subjective' which are often confused with the foregoing and which, if accepted, fatally damage the case for the arts in education. One refers to the purely private realm of mental events, which has been shown to make no sense. The other, within limits, does make sense, and it refers to the idiosyncratic. Thus, to use my previous example, if I have a sad response to a joyful Mozart rondo because it was my dead mother's favourite piece of music, that is subjective in the sense that it is inappropriate, and the notion of giving reasons to bring about a changed response through understanding is out of place. The qualification, 'within limits', is necessary because, of course, if all or most responses were idiosyncratic in this sense, then this meaning of 'subjective' would collapse into the former one, that is, it would make no sense. Neither, of course, could there be any sense in the notion of being idiosyncratic since there would be no notion of appropriateness by contrast with which anything could intelligibly be said to be idiosyncratic.

This is not to oppose the idiosyncratic in art, where this means something like the highly individual or unusual. I refer to the kind of response which is inappropriate to the character of its object. An idiosyncratic response would be appropriate to an idiosyncratic work of art. The kind of idiosyncratic, or subjective, response which I am opposing cannot legitimately be regarded as part of artistic appreciation. It is an important part of the individuality of involvement with the arts that experiences in life generally may give the possibility of deeper feelings in response to art. But those feelings must be appropriate, and the sense of the notion of appropriateness involves understanding. That is, deeper feelings will be inseparably bound up with deeper conceptions of works of art.

Summary

- (1) Reasoning to give understanding or a changed conception of a work of art can determine a change of feeling about it.
- (2) The kind of feeling which is involved in the arts requires understanding.

- (3) The artist's feeling may be part of the meaning of a work of art. He may clarify his own feeling in expressing it.
- (4) The meaning of a work is criterially related to, and is therefore not normally independent of, the artist's intention.
- (5) The concept of art includes the notion of appropriate responses.
- (6) To say that there must be the possibility of some degree of match between artist's feeling or intention, and response to the work, is part of what is meant by saying that an art form is a social practice or medium of expression.
- (7) Reasoning for extended understanding gives the possibility of an extended range of feeling. It is this which gives sense to and scope for the education of feeling through the arts.

Two Attitudes

It has been argued that a precondition of the possibility of expressing feeling in the arts is that there should be a medium in which it can be formulated. Since a medium is a social institution this implies the possibility, at least in some degree, of communication, that is, of a sharing or understanding of what is expressed. Yet the argument thus far applies only to *understanding* the feelings, it does not show how it is possible to *share* them. It is to that issue that we now turn.

Detached and Involved

In order to give an account not just of understanding but of responding with feeling to the arts, it is necessary to distinguish between what I shall call the detached and the involved attitudes. There is no sharp distinction between them. Although at the extremes they are very different, they are not always clearly distinguishable. The detached attitude includes a predominant concern with structure and technique, but is not limited to such a concern. For instance, one might recognize the emotional meaning in a work without experiencing the relevant feelings. Similarly, one may adopt a relatively detached attitude to other people, and in some professions, such as medicine and the law, this is, to some extent, necessary.

By contrast, one may respond with feeling to both works of art and people. One may alternate between these attitudes. For example, at a concert of choral and orchestral music one might sometimes read the score, following chord progressions, or selecting for attention the part of a particular voice or instrument. Sometimes, closing the score, one might immerse oneself in the expressive qualities of the music, no longer consciously aware of structural or technical aspects. During a long work,

such as Bach's *St Matthew Passion*, one might alternate several times between these attitudes. Similarly, one's interest in a play or novel may be centred on the development of the plot, structure, style of writing or acting, or the significance of the language used; or one may instead identify with some of the characters or situations portrayed. Examples of these two attitudes can readily be given in the appreciation of the other arts.

It is often assumed that genuine artistic appreciation consists in only one of these attitudes. This is an assumption made, at one extreme, by romantic or traditional expressionist theorists, and at the other extreme. by formalists. They regard either emotional identification, or detached critical appraisal, respectively, as the only legitimate form of artistic appreciation. One extreme censures the opposition's unimaginative, sterile, dissecting, cold and impersonally rational missing of the real point of art; the other extreme censures the opposition's heart-on-sleeve, sentimental, uncritically imaginative and irrational missing of the real point of art. The theorist who is rightly convinced of the central importance of feeling and personal involvement sometimes wrongly assumes that he has to repudiate rationality and critical appraisal; conversely, the theorist who is rightly convinced of the central importance of rationality and critical appraisal in the arts sometimes assumes that he has to repudiate feeling and personal involvement. What underlies the conflict is their shared misconception that feeling and reason are incompatible, and even inimical to each other. We have seen good reason for rejecting that presupposition. The narrow conception of rationality and of feeling which is inherent in it is one source of the restricted conceptions of what counts as genuine artistic experience. Each protagonist holds too restricted a view of the possibilities of artistic experience, for both attitudes are appropriate and enriching, and even, in one sense, complementary.

The current tendency among artists and critics towards an exclusive concern with the formal is an understandable reaction against the excesses of romanticism, which more readily appeal to popular taste, and are manifested, for instance, in the sentimentalism of many films, television programmes, popular songs and the reproductions of paintings sold in large department stores. But, of course, it is not simply a reaction. It would reveal a failure to understand much contemporary art if one were unaware that it consists to a large extent in extending the grammar or vocabulary of the art form. For example, Schoenberg considered that Wagner had extended the possibilities of tonal structure to their limits, so although he was influenced by expressionist music, and initially wrote in that idiom

Two Attitudes

himself, he reached the point where he felt he had to abandon the framework of key signatures and tonality altogether. This was a grammatical exploration, since Schoenberg considered that the tonal idiom was largely played out, and that new possibilities were required. So he experimented with the twelve-tone composition. In serial music a tone-row is established, and the composer can invert, or transpose it, or invert the transposition, or create a retrograde series, or a retrograde inversion, and so on. This allows forty-eight possibilities.

These approaches to music, and the modern idiom generally, would on the whole be regarded as manifestations of the detached attitude. They are structural explorations. A tone-row is difficult to recognize, and requires some technical expertise to follow the composer's manipulation of it, particularly on the first few occasions of listening. Without the ability to recognize, at least minimally, such compositional adroitness, the music is of little interest or meaning. This shows again the fallacy inherent in the assumption that a criterion of the value of a work of art is ease and generality of communication. Schoenberg expressly believed that great music can be understood only by a listener educated and experienced in the art form and particular idiom.

Similar formal explorations occur in the other arts as, for example, in Picasso's abandonment of chiaroscuro, and his 'conceptual' distortions of the human figure as a result of his conviction that the traditional idiom had been almost fully explored. Picasso's innovations opened the way for others, as Schoenberg's had in music. Hence Paul Klee, Mark Rothko and Piet Mondrian, to name but a few, are highly experimental, using colour and line in unusual juxtaposition, simply for its own intrinsic interest – indeed, Klee is sometimes referred to as a modern Leonardo da Vinci. One could cite similar examples across the range of modern arts, such as Samuel Beckett, Barbara Hepworth, James Joyce, Alwin Nikolais, Ingmar Bergman. In each case there is a strong interest in grammatical problems, in extending the formal, structural possibilities, *per se*.

However, although these approaches are manifestations of the detached attitude to the arts, we can begin to appreciate the incoherence involved in supposing that the two attitudes are necessarily opposed to each other when we recognize that such grammatical explorations may create expressive possibilities. It has been argued earlier that the feelings involved in the arts are inseparable from the concepts given by the particular medium of art. Thus an extension of the medium of an art form provides extended possibilities of feeling. Analogously, the grammar and vocabulary of a language set limits, although not rigid and timeless limits, to what words

can mean, to what can be expressed, and to what can be thought and experienced. For example, it would make no sense, normally, to say that one had experienced pride in a cloud. There are logical limits, set by the normal uses of the term, to what can count as an object of pride. Similar considerations apply to the arts, although there may be greater flexibility in this sphere. There is a range of emotions which are expressible within a particular style and, as Wollheim points out (1970, p. 80): 'it is virtually impossible for us to imagine the expression of a state which falls outside this range being accomplished within the style. The supposition of an optimistic painting by Watteau, or a tortured or tempestuous group by Clodion, verges upon absurdity.' The innovations, in extending the formal possibilities, are extending the range of what can be formulated in the medium, and therefore of what can be felt and expressed.

Although one may sympathize with a strong reaction against the excesses of expressionism, as, for instance, in Stravinsky's assertion that music by its very nature is incapable of expressing anything, it is a misconception to exaggerate it. Those whom I shall loosely call the Romantics may err too far towards uncritical personal involvement, but the current tendency is often to err to an opposite extreme. For example, there is a prevalent acceptance of a view most notably propounded by Kant that the aesthetic attitude is essentially one of disinterested contemplation, requiring 'distancing' for detached critical appraisal. In this vein Scruton (1974, p. 130) writes: 'It is a purpose of convention in art to overcome emotional involvement.' But although there is a point of substance here, there is also a confusion. First, as we have seen, the conventions, so far from overcoming, are inseparable from the feelings which are a legitimate and appropriate part of artistic expression and appreciation. It is true that part of one's understanding of the concept of art is revealed by the fact that one does not run up to the stage to save Desdemona. But it is a confusion to assume that this implies the necessity for distancing and detachment, in that artistic appreciation, properly so called, requires the overcoming of emotional involvement. On the contrary, in many cases it would be a mark of one's failure fully to appreciate a work if one were not emotionally involved. The artistic conventions do not overcome, but rather determine the character of the emotional involvement, so that, for instance, one does not respond to a situation in a play as one would to a real life one. The object towards which the emotion is directed, and which determines what response it is, is a fictional character. One responds not to Mary Smith, who is playing the part, but to Desdemona, the character in the play. This again underlines the importance of the concept of art. The relation between life and art will be discussed in Chapter 12. Here I

Two Attitudes

want to emphasize that emotional response to art is different in important respects from emotional response in life, and it is a confusion to regard the former as a diminished version of the latter. The Eskimos who, attending a performance of Othello, were appalled to see what they took to be the killing of people on a stage, experienced an inappropriate emotional response because, having no grasp of the concept of drama, they misunderstood what was going on. Once they discovered that people had not been killed, and were shown what is done in such circumstances, without a concept of drama they would simply find the whole thing thoroughly silly. It would be a confusion to conclude that a grasp of the concept would give them detachment, distancing and thus an overcoming of emotional involvement. On the contrary, if the play were well performed, those with the relevant conceptual grasp might well reveal their appreciation of the performance bytheir emotional involvement. One might be tempted to make the point by saving that such spectators, as compared with the Eskimos, could be equally involved emotionally, but, of course, that might be misleading in implying a comparison on the same scale, whereas the point I am emphasizing can be better made by saying that the scales are different.

The formalist who exaggerates the significance of conceptual grasp to the point of excluding emotional involvement misunderstands the character of the concept, for it gives sense to the notion of appropriate emotional involvement with the arts rather than entailing an overcoming of it.

The second point I want to make against the contention that artistic appreciation is essentially detached is a consequence of the characteristic mentioned in Chapter 3, that an artistic judgement is made as a result of personal experience, and is partly an expression of one's feeling about or attitude to the work. The experience of an emotionally expressive work on which any adequate judgement is made will often require a personal identification with it. To repeat, even in such a case, this is not to deny that an exclusively detached attitude could even count as artistic appreciation, but it could not allow a *full* grasp or appreciation of the work. Only if this is accepted can one make any sense of the revulsion one feels for sentimental art, since one is implicitly invited to identify with, and thus experience on one's own behalf, feelings which one recognizes to be insincere.

Sentimentality

The point will arise again in Chapter 12, but it is worth pointing out now that to say that sentimentality is insincere is not to imply that it is intended

to deceive others. One may deceive oneself. The point is brought out by D. H. Lawrence (1936, p. 545):

Sentimentalism is the working off on yourself of feelings you haven't really got. We all *want* to have certain feelings: feelings of love, of passionate sex, of kindliness and so forth. Very few people really feel love, or sex passion, or kindliness, or anything else that goes at all deep. So the mass just fake these feelings inside themselves. Faked feelings! The world is all gummy with them.

The point becomes clear when we consider music, which can be sentimental although the question of deception, in the ordinary sense, cannot arise. Robinson (1973, pp. 39-40), for instance, cites Brahms as a composer who is 'when he seems most serious, insincere because sentimental', in that he 'worked off on himself' feelings, for example, of affirmation and serenity, that he had not really got. This issue is related to the quotation from Wilde in Chapter 5, about the intellectual and emotional life of ordinary people:

Just as they borrow their ideas from a sort of circulating library of thought ... and send them back soiled at the end of each week, so they always try to get their emotions on credit, and refuse to pay the bill when it comes in.

To work off on oneself feelings one hasn't really got *is* to get emotions on credit, and because they are not genuinely felt, there is no bill to pay. One is, as it were, *playing at* having feelings, and one can withdraw from the game. This is one of the pernicious effects of television. People may, in a sense, be moved by the plight of the starving or homeless portrayed in a documentary. That the feeling is spurious is revealed by their ability to enjoy a comedy programme which immediately follows. Television innoculates against feelings which one ought to experience by progressively dulling the sensibilities.

However, there is another central point here. Robinson (1973, pp. 39-40) endorses Lawrence by saying: 'all real insincerity is self-deceiving rather than trickery'. Yet, while this is an important aspect of sentimentality, there is an even more important one. For to call his feelings sentimental may not be to say that someone is working off on himself feelings which he has not really got but, more seriously, it may be to characterize the feelings which he *has* really got. That is, it may not be a case of 'unconsciously suppressing knowledge of the rottenness within' (ibid., p. 39), but that a person with only trite concepts, or forms of expression, is

Two Attitudes

a person who is capable of only trite experiences. This shows the crucial relation between the rational and the emotional in general, for to accept uncritically the shallow wash of cliché gushing forth from, for instance, the popular press and television is to restrict one's concepts, and consequently one's feelings, to that level. This is why the most important contribution of education is to extend conceptual horizons, and to encourage students to continue to do so for the rest of their lives. For, as I have emphasized, to extend the possibility of emotional experience requires the extension of concepts. Beckett's Happy Days illustrates the point. Winnie, buried in a growing mound of cliché, which limits her thoughts and experiences to the banal, can exclaim, of each of her days: 'Another happy day.' So restricted are her conceptual horizons that this is what happiness amounts to for her. There are numerous examples of the ways in which shallow criteria for what *counts* as a worthwhile and fulfilled life are set for a frighteningly large proportion of people by advertisements. television, and the popular press and radio. In my view, the most pernicious sentimentality is where a person has really got trite and superficial feelings: such feelings are what count as genuine responses to life for him. In such a case he may indeed pay the bill to the full, as have many soldiers, in many wars, for feelings of nationalism or jingoism which were sincerely yet uncritically held, but which some of us would regard as specious and tragically mistaken. Hence, of course, the motive of some of the poets of the First World War was precisely to expose 'the old lie' that it is glorious to die for one's country. As we saw in Chapter 6, it took a creative struggle to change that conception, and thus the relevant feelings.

Involved and Detached Attitudes: Complementary

It should be emphasized that the involved attitude does not in the least imply the abjuring of critical reasoning. On the contrary, the development of expressive and responsive capacities *requires* the development of critical abilities. This is part of what is meant by saying that the feelings involved in artistic experience are those which are tied to concepts and rationality. The point could be made by saying that artistic feelings are inevitably thought-impregnated, in that they are identified by a mode of understanding. Thus it should not be assumed that critical reasoning is exclusively the province of the detached attitude, for rationality is contained within the involved attitude. The distinction between the two attitudes marks a distinction between *kinds* of reasoning. For instance, the

kind of reasoning which is part of the detached attitude may be concerned with the formal structure of a work rather than the emotional response which is appropriate to it.

It is not always possible to adopt either of these two attitudes, but in many cases it is only by adopting both that one can fully appreciate, or perhaps be fully possessed by, a work. One can and should alternate between the detached and the involved attitudes. Even when fully involved one may be aware of, for instance, the artist's mastery of his medium, and one may want to experience the work again in order to concentrate more upon his technical expertise, partly to see how such a powerful impact was achieved.

The distinction may not always be sharp or clearly recognizable, but it is important, and central aspects of artistic experience can be missed if there is an exclusive adoption of one or the other, or the assumption that only one of them is legitimate. That there are two attitudes which are in some ways very different no more implies that only one of them is legitimate than the fact that one may respond emotionally to a verbal utterance implies that one cannot also consider its grammatical propriety. A parallel loss of richness of experience would be incurred by anyone who adopted only one of these attitudes to language. An exclusively involved attitude, if that were possible, would preclude the extension of conceptual understanding which is necessary for the possibility of extending the relevant emotional experience; an exclusively detached attitude, centred, for instance, on logical aspects of language, would equally incur loss of emotional experience. In the case both of the arts and of language, a failure, in relevant circumstances, to employ and develop both attitudes incurs the loss of a dimension of central importance. It may tend, at one extreme, to susceptibility to sentimentalism, and at the other extreme, to shallow intellectualism. Fully to appreciate the arts one needs both detached critical appraisal and the educated emotional capacity to involve oneself in a personally meaningful way.

The Particularity of Feeling

A work of art is something which is unlike anything else. It is art, which, best of all, gives us the idea of what is particular.

... it is due to feeling (friendship, love, affection) that one human being is different from others. To label, classify someone one loves, that is impious.

... It is due to feeling alone that a thing becomes freed from abstraction and becomes something individual and concrete.

So, contrary to what is commonly believed, the contemplation of particular things is what elevates a man, and distinguishes him from animals.

(Simone Weil, 1978, p. 59)

Although there are illuminating analogies between language and the arts, a significant difference between linguistic and artistic meaning is that whereas there are synonyms in language, there is an important sense in which it would reveal a failure to understand the nature of art to suppose that what is expressed in one work of art could be expressed in another. This chapter will consider the particularity of emotional response to the arts, and in order to bring out the matters involved I shall consider the objection that the notion of the intentional object which we considered in Chapter 7, that is, that to which the emotion is directed, is such that the object cannot be particular, but is one of a kind, and that therefore since each work of art is particular, experience of the arts cannot be emotional. It will be argued that this common notion of an intentional object of an emotion is misconceived not only with respect to the arts, but also with

respect to other important aspects of life. Our discussion shows how another problem can be overcome, namely, how the arts can be regarded as involving emotions in view of the vast range of subtly discriminated feelings expressible in the arts, which cannot be encompassed within the relatively narrow range of emotion-terms. Since my argument applies indiscriminately to expression and response, these and related terms will be used interchangeably.

A Spectrum of Intentionality

At first sight one might suppose that there are no limits to objects of emotion, in that, for instance, one might be afraid of anything. However, on reflection it can be seen that there are limits to the kinds of object on to which emotions can be directed. For example not anything could be an object of fear, since one can be afraid only of objects of a kind which are believed to be threatening or harmful in some way. Hence, in the absence of a special context, one could make no sense of the supposition that someone was afraid of an ordinary currant bun since one could not understand how he could believe it to be dangerous. If recognized as such, an ordinary currant bun is outside the limits of sense given by what is called the intentionality¹ of the concept of fear. Nevertheless, these limits leave open the question of what is the object of fear on any particular occasion. To take another example, in normal contexts it would make no sense to speak of pride in a cloud. To make it intelligible, that is, to bring it within the limits of sense set by the intentionality of the concept of pride, there would have to be a special context such as that of a scientist who has created a cloud for rain-making purposes, since one can be said to be proud only of what one thinks of as an achievement. Within those limits it is possible to change the object of pride without changing the feeling of pride. For example, the scientist may equally be proud of a book he has written.

It would seem, then, that emotions are always of a kind, in that the intentional object of an emotion such as fear is always substitutable without incurring a change in the emotion. This is how Beardsmore, in an interesting article (1973), puts the point:

The intensionality of emotions like fear or grief lies in their being directed towards *objects of a certain kind* and not towards particular objects. The creaking of my stairs at midnight may awaken in me a nameless terror, but one reason why it is possible for a terror to be nameless is that in the

The Particularity of Feeling

circumstances it need not matter whether the creak is brought about by an escaped leopard or by an axe-wielding psychopath. In either case the terror may be the same.

He concludes that responses to works of art cannot be emotional since it makes no sense to suppose that one could have the same response in relation to two different works. The objection, then, is that objects of emotion are always of a kind, and thus substitutable, rather than particular. This objection depends, however, upon an oversimple, if common, conception of intentionality. I shall argue that, on the contrary, particularity is an important and frequently overlooked aspect of the emotions, with respect not only to the arts but also to other central areas of human experience.

Emotions can be seen as forming a spectrum with at one extreme those feelings which are relatively undifferentiated and at the other those which are highly particular. Placing on the spectrum depends upon the variety of intentional objects, that is, the possible objects on to which typical behaviour may be directed, and by which each such emotion is identified. Thus feelings at the former extreme may be identified in widely different ways as they are intentionally related to a diverse range of objects. For example, if someone were afraid of people, his feeling would be directed on to any of the great variety of kinds of people. Another example at this extreme would be fear of reptiles.

Towards the centre of the spectrum the feelings are more particularized in that there are fewer possible objects of each. Fear of aggressive people would come into this category, for although there are various possible intentional objects of this feeling, since aggression can be manifested in various forms by different people, the possibility is obviously considerably more limited than in the preceding case. Thus any aggressive person could be the object of such a feeling. Similarly, fear of snakes has fewer possible objects than fear of reptiles.

At the other extreme of the spectrum are those highly particularized feelings each of which can be experienced and identified in only one way. In the case of such a feeling it would make no sense to suggest that there could be another intentional object since, apart from its relation to *this particular object*, the emotion could not intelligibly be said to exist. An example might be fear of a particular person with a peculiarly sneering and sarcastic manner, or, more obviously, love or friendship for a particular person. In these cases the emotion is directed on to and is identified by only one object. Caution is required about what counts as a particular

emotion in this sense. For example, consider: 'He is afraid of Pecco, Jenny's aggressive dog.' This would not count as a highly particularized fear since the fact that it is Pecco and Jenny's dog, adds nothing to our understanding of the kind of fear he feels. Any aggressive dog would induce the same emotion.

The feelings expressed in works of art are placed at this extreme. For example, to speak of the sadness of Mozart's Fortieth Symphony is to speak of a feeling which can be identified only by that piece of music. To change the particular form of the expression, whether within the same artistic medium, or into another, would be to change the object of the emotion, and consequently the emotion itself.

However, a qualification is required, for clearly the response to a work of art could be specified in a general way, for example as 'sad', or, according to the theme of the work, it could be specified with varying degrees of particularity. It could be placed at any point on the spectrum according to the way in which it is specified. That is, it will always be possible to redescribe a 'particular' response in more general terms. This does not, however, undermine my thesis since it will not always be possible to identify more precisely an emotion characterized in general terms. Fear of a snake would not normally be so described that it could be placed at the 'particular' extreme. By contrast, it is quite normal for characterizations of responses to people and places to be at this extreme. In the case of a work of art, it will always be possible to provide a specification of the response which will locate it at that extreme.

In support of his thesis, Beardsmore (1973, p. 352) takes an example from Orwell. It concerns a Belgian journalist:

like nearly all Frenchmen or Belgians, he had a very much tougher attitude towards 'the Boche' than an Englishman or an American would have. All the main bridges into the town had been blown up, and we had to enter by a small footbridge which the Germans had evidently made efforts to defend. A dead German soldier was lying supine at the foot of the steps. His face was a waxy yellow. On his breast someone had laid a bunch of the lilac which was blossoming everywhere.

The Belgian averted his face as we went past. When we were well over the bridge he confided that this was the first time he had seen a dead man...For several days after this, his attitude was quite different from what it had been earlier...His feelings, he told me, had undergone a change at the sight of 'ce pauvre mort' beside the bridge: it had suddenly brought home to him the meaning of war.

The Particularity of Feeling

Beardsmore says of the journalist (p. 360):

He had to be shown what death was like. And his experiences changed him, not by contradicting anything which he had previously regarded as a fact, but by replacing the picture which he had held of the death of an enemy with a new picture, by showing him what a soldier's death is really like.

This experience was certainly a profound one, and it could be characterized only by reference to its object, namely, the dead soldier lying beside the bridge, and so on. But is it true, as Beardsmore suggests, that any dead soldier might have brought about the same change in what the journalist felt on seeing the soldier, and hence that there was some degree of substitutability in the situation? On the contrary, this example, so far from undermining my thesis, actually supports it. For the journalist's emotional response would be placed towards the 'particular' end of the spectrum, since nothing as general as 'grief', or 'sadness', or even 'the sick realization of the meaning of war' could adequately characterize his experience. In some sense it was bound up with that particular set of circumstances. For, although some aspects of the situation might have been alterable without a change in the journalist's feeling, it is at least possible, or even likely, that some aspects were of ineliminable importance. For instance, one such aspect is, surely, the fact that on his breast someone had laid a bunch of the lilac which was blooming everywhere - perhaps, and this might well have occurred to him, one of the allied soldiers. Moreover, it is surely significant that Orwell mentions not only the bunch of lilac, but that lilac was blooming everywhere. The contrast no doubt brought home to him all the more powerfully the meaning of war, and thus was constitutive in an important way of the object of his feeling about the incident.

It might be objected that the impact was created by the fact that this was the *first* dead man the Belgian had seen, in which case any dead soldier would have had the same effect. But there are limitations to the possibility of substitution here. For example, what if the dead soldier had been a Belgian, or, especially, the journalist's father or brother? Given his attitude, is it not at least very probable that his emotional reaction would have been very different, and this might be revealed in an attitude of even more bitter hatred towards the Boche? In the case imagined it is highly improbable that he would have acted in the way that Orwell described in the actual case:

When he left he gave the residue of the coffee we had brought with us to the Germans on whom we were billeted. A week earlier he would probably have been scandalized at the idea of giving coffee to a 'Boche'.

This sort of different dead soldier would very probably define a totally different intentional object of the emotion, given the previous attitude of the journalist.

Leaving that example aside, it is not difficult to imagine a situation in which someone thoroughly hardened to the brutalities of war might suddenly have his feelings jolted by a particular case, such as the sight of a dead soldier with a bunch of violets placed on his breast by an enemy soldier. In this case not any dead soldier in any situation could be said to characterize the same feeling. The feeling could be identified as the same only if the intentional object were specified in a relevantly similar way. And what would count as a 'relevantly similar way' here would depend upon one's conception of the incident.

Beardsmore seems implicitly to concede something of this, since he says (p. 352; my italics):

One would have to recognize that there could be no answer to the question: And what was it like, then? What death is like, was something which came out in *the* pathetic scene to which he has been a witness. Unless you had seen *the* soldier lying by *the* bridge you could not know what it was like.

His use of the three definite articles in this passage is significant. Here we have a life situation in which the experience of the journalist is identified by '*the*' pathetic scene, and so on. Now all mental experience is cognitive to some extent, and emotional experience in particular can be adequately characterized only in terms of a certain mode of apprehension of its object. In this case, the emotional experience of the journalist could not be adequately characterized apart from his conception of certain particular features of the situation he encountered. Without these features and his conception of them, the intentional object, and therefore the emotional experience, could not be regarded as the same; which is to concede my present point, that the limits of intentionality are narrow in this example. (Where, for brevity, I write of the situation, it is of course always the conception of the situation which is crucial to the correct characterization of the object.)

What of the feelings situated at the 'particular' extreme of the spectrum? Is it true that there are no such highly particularized emotions in life outside the arts? On the contrary, such particularized feelings, which

The Particularity of Feeling

can be characterized only by non-substitutable intentional objects, are a very important, though often overlooked, part of human emotional experience in general. Hepburn (1965, p. 192) writes of emotions which are:

functions of an alert, active grasping of numerous features of my situation, held together as a single gestalt. In my compartment I make into one unityof-feeling the train-wheels drumming, the lugubrious view from the window (steam and industrial fog), and the thought of meeting so-and-so, whom I dislike, at the end of my journey. My depression is highly particularized. Or again, if one is in love, an encounter with the loved one may acquire a specific, unrepeatable emotional quality – meeting so-and-so, on that particular day, in that particular park, with that wind and those exhilarating cumulus clouds overhead. Our scale...is a scale of increased emotional discrimination.

Similarly, Ruby Meager (1965, p. 196) writes of the characteristics which provide rational support for her young man's judgement that Rosie is lovable:

It is the particular form in which Rosie manifests them, and the particular way in which they are combined in her, that make just this occurrence of them together lovable...However precisely we discriminate Rosie's peculiar virtues in *general* terms, and without the help of pointing to her, we cannot pin Rosie down in this way, and it is just her individual manifestation of her characteristics which makes them lovable *in her*.

Given a highly complex object to be evaluated for its own sake and not functionally with some general end in mind like Rosie or a symphony, it seems perfectly rational to refuse to commit oneself to generalizable evaluations of particular characteristics, however precisely defined.

Similarly, the intentional object of the young man's emotional feeling, that is, what identifies it, or what the feeling *is*, is a unique object; it cannot intelligibly be regarded as an object, and therefore a feeling, of *a certain kind*. Indeed, it is significant that if such a substitution were possible this would constitute a good reason for *denying* that the attribution of love was legitimate. This concept of love is such that the young man could not be said to love Rosie if there were or could be another object of his feeling. This is not to say, of course, that he could not love someone else, say, Jane. But it is to say that there is an important sense in which his love for Jane *could* not be regarded as the same feeling, since the object of

the feeling, defined by the particular characteristics of Jane, would be different. We could speak of 'the same feeling' only in the trivial sense of a more general description which would fail to capture the important characteristic of this concept of feeling. The acquisition of what Rush Rhees (1969, ch. 13) calls the language of love determines the possibility of experiencing the highly particularized feelings characteristic of this kind of emotion, just as the understanding of an art form allows for the highly particularized feelings characteristic of art. This is, I think, part of the point of the following quotation from Winch (1958, p. 122):

imagine a society which has no concept of proper names, as we know them. People are known by general descriptive phrases, say, or by numbers. This would carry with it a great many other differences from our own social life as well. The whole structure of personal relationships would be affected. Consider the importance of numbers in prison or military life. Imagine how different it would be to fall in love with a girl known only by a number rather than by a name; and what the effect of that might be, for instance, on the poetry of love.

The man who could say 'I love Rosie, but Jane would do instead' would have as little understanding of love as the man who could say 'You need not bother to read Tolstoy's *Father Sergius*, since Shakespeare's *King Lear* says the same thing' would have of literary appreciation.

One could cite many other examples of such highly particularized feelings. For example, it is characteristic of the feeling involved in a lifelong, close friendship that it could be described only by reference to numerous specific incidents which occurred over a long period of time. The suggestion of substitution in such a case would make no sense. Similarly, nostalgic feeling about places, or various feelings about incidents or phases in one's life, may be equally intimately related to particular details such that the notion of the 'same' feeling identified by different details would be unintelligible. I may speak of 'the Cambridge feeling', which is located by a wide variety of incidents and particular places, and people at a particular stage of their lives. The notion of substitutability, where the feeling is determined by such a complex concatenation of circumstances, is again unintelligible.

If it were objected that surely *some* of these details could be altered without affecting the identity of the feeling, then one would reply that it depends upon the details. For whether in life or in art some aspects will be so significant as to constitute defining criteria of an interpretation and response, whereas others will be merely incidental.

The Particularity of Feeling

The Material Object

One can be afraid only of what one thinks to be dangerous. But what one is afraid of may not actually be dangerous. Thus there is a distinction between what is usually called the material object, which is what the object actually is, and the intentional object, which is how a person conceives it. Someone may be afraid of an object which he thinks is a snake when it is actually a piece of rope. Anscombe (1965, pp. 166–7) gives the example of a man who aims at a dark patch in the foliage, believing it to be a stag, but in fact shoots his father. His *intention* cannot be given in terms of the material object since he did not intend to shoot his father, even though he intended to shoot what was in fact his father.

The material object is, then, what the object really is, whereas, to quote Anscombe: 'An intentional object is given by a word or phrase which gives a description under which.' Yet it is equally important to notice that no sense can be given to the notion of what an object really is apart from some description or other of it. Complications arise where there are differences of conception about what the object actually is. This raises a point of importance with respect to the possibility of resolving disagreements about the character of works of art. To bring out the point, I shall adapt Anscombe's example of a tribe which worships the sun as a god. What is the material object in this case? The notion of a material object does not necessarily imply physical existence. For example, a debt can be a material object in this sense. In the example of the sun, for a Western scientist the material object is nothing but a mass of burning gas. But a tribesman could not accept that as a description of the material object, since it would be unintelligible to suppose that he worships what he thinks of as a mass of burning gas. That is, the limits set by the intentionality of the concept exclude such an object as an intelligible object of worship. In such a case there is no neutral description of the facts to which the scientist and the tribesman could refer in order to discover the character of the material object. For the facts which define the material object are determined by the set of concepts with which each is making his judgements. It is correct for us to say that they worship what is actually a mass of burning gas, but that is not how they conceive of what the sun actually is. Similarly, a chemist might insist that the water used in christening is actually merely H₂O, but that cannot capture its religious significance, that is, what it actually is for a Christian.

There are three kinds of case. (a) This is of the kind mentioned above where a man mistakenly believes that what he saw was a stag. Similarly,

someone may be afraid of what is actually a rope because he believes it to be a snake. These are simply mistakes which are, in principle, easily rectified by discovering what the object actually and uncontroversially is. (b)The examples of the sun and of christening water given above are in this category, where no appeal to the notion of a material object, that is, what the object really is, will necessarily settle a dispute between those with very different conceptions of it. (c) The cases which are central to the arts are much more like (b) than (a) in that where there are differences no sense can be given to the notion of what the character of a work of art actually is apart from conflicting conceptions. Of course, each conception has to be answerable to objective features of the art object, but within that limit indefinitely wide variations of equally valid interpretation may be possible. (I shall have to ignore the complex problem of identity, that is, to what extent different interpretations may still count as interpretations of the *same* work of art.)

There is also an important asymmetry between the case of the sun and that of differing interpretations of a work of art. The tribe speaks a different language, and they use a certain word, say 'X'. We are inclined to translate this as 'the sun', because there is some overlap between what we call 'the sun' and what they call 'X'. Asked to point to X, they point to the sun. They tell us that X rises in the morning in the east, and sets in the evening in the west, and so on. However, they also say many things about X which are unintelligible if taken to mean what we mean by 'the sun', and many of which seem more intelligible if taken to mean what we mean by 'a god'. Obviously 'the sun' is an inadequate translation of 'X', even though some aspects of the situation give *some* point to such a translation. The two symbols cannot intelligibly be said to mean the same, since the employment of each symbol in each language is so very different. The fact that the same ostensive definitions may be used to explain the meaning of the symbols is of little significance.

In the case of a work of art, the situation is different. Even where there are two widely divergent interpretations both critics would certainly agree, normally, on *some* description of what they are discussing. If, for instance, the work were representational they must agree to some extent on *what* it represents in order to have an intelligible base for their differences of opinion about interpretation. For example, agreement that a painting represented Churchill would have to be assumed before there could be disagreement about how it should be construed. Nevertheless, *what* they see when they look at the same work of art may be quite different. Yet the difference is not as fundamental as it is in the example of the

The Particularity of Feeling

sun, unless, of course, one were from another culture which lacked the concept of a work of art.

Thus the notion of a material object is necessary in order for the disagreement even to arise, but no appeal to this will be relevant to solving differences about the character of a work of art. To a large extent disputants could agree on their specification of what they are talking about, yet such an agreement would be quite irrelevant to settling their dispute about how it should be interpreted.

The relationship of the foregoing discussion to my thesis is, of course, that it is the interpretation of the work of art which determines the character of the response to it. This ineliminable cognitive element, the grasping of the significance of features of the work under a certain description, is the particular intentional object of, and therefore defines, the feeling it expresses, and which is experienced in response to it. A work of art is of highly particularized emotional content in this sense. Matisse has said: 'The whole arrangement of each of my pictures is expressive – the positions my figures occupy, and even the space around them.'

Individuality of Response

Of course, it would not be self-contradictory to assert that a dance was performed, but that a person watching it did not experience the appropriate feeling. For instance, in the case of subtle irony, he might miss its meaning entirely. Moreover, it would be quite possible for the spectator to give every indication, at the time, of understanding and responding appropriately to the dance, while in fact failing to do so. We may withdraw our attribution to him of the appropriate response in the light of wider considerations – his background knowledge, subsequent reactions, and so on.

This underlines again the point on which I laid some emphasis earlier, that the concept of art is ineliminable in characterizing responses to works of art. A spectator may have little or no grasp of the cultural tradition, art form, or school of approach, and thus, although absorbed in watching a dancer's movements, he cannot respond appropriately. Similarly, a spectator cannot learn from a work unless he already has a background of some knowledge on which to build, and on which the work implicitly relies.

We have been considering the particularity of the emotions expressed in works of art, but there are also individual differences in the sensitivity,

acuteness of perception, background knowledge, and so on, of different spectators. As was pointed out in Chapter 4, it is neither conceivable nor desirable that there should always be identical understanding of and response to the same work of art, since this would amount to conceiving and desiring that people should be identical. But this concedes nothing to subjectivism, in the sense that interpretation and response are purely private, and thus that *any* interpretation and response is equally appropriate, or, which is the same thing, that the notion of appropriateness is unintelligible here.

There is a particularly strong temptation to assume that a response must be purely private in those situations where one is at a loss to offer any account of an emotional experience, in that any attempted account seems not only inadequate, but even distortingly inaccurate. In the example from Ruby Meager quoted above, the young man is unable to offer any adequate account of his feeling for Rosie without the help of pointing to her. But whether understanding can be achieved even in this way will depend on the person to whom Rosie's characteristics are pointed out. To cite another example, in Patrick White's novel A Fringe of Leaves Mrs Roxburgh, a sensitive, reflective woman who has been through a series of experiences which have profoundly changed her understanding of and attitude to life, is expected to describe them to a pompous and insensitive military commandant whose experiences of life are regimented into oversimple categories, and who consequently is a congeries of clichés. Mrs Roxburgh is unable to give any account of her most disturbing experience. The commandant is perplexed and irritated: 'If it made such an impression on you, I should have thought you'd be able to describe it.'

With respect to understanding spiritual qualities, Holland (1980, p. 63) writes:

The kind of understanding open to us here is such that we can (and most often do) have it without being able to say what it is we understand. It is an understanding that is not exhausted in whatever the discursive intelligence manages to render explicit, even when someone comes out with a form of words that seems to hit off exactly the nature of the spiritual quality before us ... And while the feeling for the fineness of a civilization, which this understanding mainly amounts to, is not the same thing as being able to categorize it as thus and thus and does not demand the kind of analytical acumen which goes along with that, nevertheless it is tantamount to having a sense of wordth, because above all else it is a matter of responding towards something wonderful...

The Particularity of Feeling

However, it is of the first importance to recognize that even in such a case there are certainly descriptions which one would reject as totally failing to characterize the experience, and others which one might say come a little nearer. That alone is sufficient to make the point that the experience cannot be purely private and subjective in the sense in which I am opposing it, that is, in the sense that no sense could be attached to the notion of the appropriateness of a response in this context. As we saw in Chapter 6, if an experience is purely private in the sense of being totally incommunicable even in principle, then there could be no sense to the notion of criteria of appropriateness, since the supposition of purely private criteria is unintelligible. That is, if absolutely any response could count as 'appropriate' there could be no sense in the notion of appropriate responses and therefore no possibility of artistic appreciation. Moreover, as we have seen, an appropriate response in the arts is possible only for someone with a grasp of the criteria of the medium of art. Those criteria give the limits of sense and appropriateness to the possibility of individual emotional responses.

It should be emphasized again, because the point is so important and so frequently misunderstood, that to insist that the response must fall somewhere within the scope of appropriateness does not in the least imply that there cannot be a wide variety of individual differences. It is simply to say that there could be no sense to artistic appreciation at all if there were no limits whatsoever to that scope. The concept of art, as we know it, would be unimaginably impoverished without the wealth of individual differences of insight and sensitivity of response.

Summary

- (1) There is a spectrum of emotions, from those with a wide range of possible intentional objects, through those with a progressively more restricted range, to the limiting case where the feeling is so specifically prescribed that only one object will satisfy it.
- (2) The particularity of emotional responses applies not only to the arts but to other central areas of human experience, such as personal relationships.
- (3) It is a mistake to suppose that appeal to the notion of a material object can settle differences in conception of an object of emotion.
- (4) That there are individual differences of sensitivity and understanding, and that it may sometimes be impossible adequately to describe

one's emotional experience, does not imply that no sense can be made of the appropriateness of response, whether to works of art or to other situations.

Note to Chapter 10

1 I use the spelling 'intentional' to refer to the object-directedness of mental arts. 'Intensional' I take to be contrasted with 'extensional', in the sense that an intensional context is one in which it is not necessarily the case that the substitution of a co-referential expression in a given linguistic context will give a sentence with the same truth-value. The two phenomena are distinct though related, since a mental state is directed on to an intentional object only under a certain description, hence not any substitution of a coreferential expression will adequately characterize the object of the mental state. The nature of the relationship is complex. For a detailed discussion see the symposium by Kneale and Prior, 1968.

11

The Aesthetic and the Artistic

There is a widespread failure to recognize the distinction between the aesthetic and the artistic and, where it is recognized, to characterize the distinction adequately. In this chapter it will be argued that there are two distinct although sometimes related concepts. A central feature of an object of artistic as opposed to aesthetic interest is that it can have a subject matter. This is of considerable significance to the principal theme of this book. For one's feelings in response to works of art, and some of the most important reasons by which one can come to understand works of art, are frequently inseparably bound up with a wide variety of issues from life generally. There are crucial educational implications.

The Distinction

The aesthetic is generally assumed to be the genus of which the artistic is a species, in that the objects or activities which are characteristic of aesthetic interest or, as it is sometimes expressed, of the aesthetic attitude are taken to include works of art, but to extend beyond them to natural phenomena. But the relationship between 'aesthetic' and 'artistic' is usually left unclear – so much so that the two terms are often used synonymously. Implicit in the views of many writers is the assumption that the term 'aesthetic' can legitimately be applied not only to works of art but also to natural phenomena such as sunsets, birdsong and mountain ranges, whereas 'artistic' is limited to artefacts or performances intentionally created by man for aesthetic pleasure or contemplation. Thus, except in

an extended or metaphorical sense, it would sound odd to speak of a sunset in terms of the 'artistic', but quite normal to assume that, with respect to a novel, poem, painting, dance, or piece of music, the terms 'aesthetic' and 'artistic' were equivalent. In one of the few explicit statements of this kind of view, Reid (1970, p. 249) writes:

When we are talking about the category of art, as distinct from the category of the aesthetic, we must be firm, I think, in insisting that in art there is someone who has made (or is making) purposefully an artefact, and that in his purpose there is contained as an essential part the idea of producing an object (not necessarily a 'thing': it could be movement or a piece of music) in some medium for aesthetic contemplation.

Similarly, Beardsley (1979, p. 729) writes that 'an artwork can usefully be defined as an intentional arrangement of conditions for affording experiences with marked aesthetic character'.

It is true that there is an important sense in which the term 'aesthetic' can be applied to both natural phenomena and works of art, but this is not the sense in which the artistic is a *species* of the aesthetic. On the contrary, the aesthetic and the artistic are distinct though sometimes related concepts. Although a work of art may be considered from an aesthetic point of view, that does not imply that 'artistic' can be defined in terms of that which is intentionally produced for aesthetic effect. To begin to bring out the character of the distinction let us consider another common and perhaps related conception that there is a unique aesthetic attitude which is identifiable by reference to and developed by experience of either works of art or the contemplation of natural phenomena. For instance, Beardsley (1979, p. 728) writes that

the concept of aesthetic value as a distinct kind of value enables us to draw a distinction that is indispensable to the enterprise of art criticism: that is, the distinction between relevant and irrelevant reasons that might be given in support of artistic goodness.

And later (p. 746):

many natural objects, such as mountains and trees...seem to have a value that is closely akin to that of artworks. This kinship can easily be explained in terms of aesthetic value...

Controversy arises over whether the experience of natural phenomena,

The Aesthetic and the Artistic

or that of the arts, is the central or paradigm case. Carritt (1953, p. 456) criticizes those writers who concentrate exclusively or predominantly on the arts since, in his view, the experience of natural beauty is of the same kind and may well be indistinguishable from it. Hepburn (1966) has a similar view, as Beardsmore (1973), in an interesting paper on this issue, points out, while Urmson (1957) is an example of a writer who takes natural beauty to be the central case.

Wollheim (1970, p. 112), by contrast, criticizes Kant and Bullough for taking as paradigm cases a rose, and a fog at sea, respectively:

A serious distortion is introduced into many accounts of the aesthetic attitude by taking as central to it cases which are really peripheral or secondary; that is, cases where what we regard as a work of art is, in point of fact, a piece of uncontrived nature.

All parties to the dispute, then, presuppose the notion of a general aesthetic attitude. Their disagreement centres on whether natural phenomena, or works of art, are the paradigm expressions of it. As Beardsmore puts it (1973, p. 357):

Wollheim's argument seems simple. Carritt, Bullough, Urmson, have all got it precisely the wrong way round. Our understanding of art cannot be explicable as one variety of an attitude which we adopt primarily towards natural objects, if only because the aesthetic contemplation of nature is itself an extension of an attitude established on the basis of works of art.

This view of Wollheim's position is confirmed by his offering the following illustration (1970, p. 119):

when the Impressionists tried to teach us to look at paintings as though we were looking at nature – a painting for Monet was *une fenêtre ouverte sur la nature* – this was because they themselves had first looked at nature in a way they had learnt from looking at paintings.

Wollheim contends that the aesthetic appreciation of natural phenomena is possible only to the extent that the aesthetic attitude has been developed by means of an understanding of art forms as the central cases. Such a view is quite common. For example, Margaret MacDonald (1952-3, p. 206) suggests that to admire a garden or the lines of a yacht is to admire it as a work of art; Nelson Goodman (1969, p. 33) claims that 'Nature is a product of art and discourse'; and Karl Britton (1972-3,

p. 116) argues that to appreciate the beauty of a natural phenomenon amounts to appreciating it as if it were a work of art.

However, both the thesis that the central cases of the aesthetic attitude are to be found in appreciation of natural beauty, and its antithesis that they are to be found in artistic appreciation, share the mistaken presupposition that the aesthetic and the artistic are indistinguishable, or not significantly distinguishable, aspects of the *same* concept.

Beardsmore argues against this notion that there is a distinction between two ways in which the term 'aesthetic' and its cognates are employed – one of which is in relation to the arts, and the other in relation to our appreciation of natural beauty (op. cit., p. 351):

There are aspects of art appreciation which cannot be understood if one thinks of our reactions to a play as a complicated version of our reactions to a rose. And there are aspects of the love of nature which make no sense if one has before one's mind the way in which people respond to paintings and sculptures.

Later (pp. 364-5) he puts the point:

I can imagine a society in which men are untouched by any form of artistic activity and yet still possess a love of nature which one might call aesthetic. I can imagine this because it is to some extent true of children in our own society... There is little enough temptation to see in a child's love of what is grotesque or surprising in the shape of a toadstool, the influence of artistic tradition.

Beardsmore's arguments show convincingly that there are two distinct concepts, but in my view he has misconstrued their character, since the distinction should be drawn not in terms of two senses of 'aesthetic', but in terms of a contrast between the aesthetic and the artistic. There is a far more substantial question here than a mere terminological difference.

Beardsmore conceives of the two senses of 'aesthetic' in terms of our appreciation of nature, and our appreciation of the arts, respectively. Certainly these are paradigm kinds of case to show clearly *that* there are two different concepts. Nevertheless, that there must be more to the distinction becomes apparent when we consider the numerous phenomena which characteristically, or at least often, attract terms of aesthetic appreciation but which are neither natural, in that sense of the term, nor works of art. Obvious examples are the shape of a telephone, suitcase, car and aeroplane (Concorde is a classic case); the design of a kettle, cooker and

The Aesthetic and the Artistic

pen; the decor of a room; the structure of a mathematical proof and a philosophical argument.

No doubt the advocates of the opposing positions would argue that such examples should be construed as extended cases of a concept centred in art, or in natural beauty, respectively. Certainly there are extended cases where, for instance, one may be invited to consider what is not art from an artistic point of view. Yet that possibility cannot overcome the problem to which I am now drawing attention, for, at least in many cases, a work of art can be considered from *botb* the aesthetic *and* the artistic points of view, so the distinction cannot be as either of these positions supposes. Some years ago I was privileged to attend a performance by Ram Gopal, the great Indian classical dancer, and I was quite captivated by the exhilarating and exquisite quality of his movements. Yet I was unable to appreciate his dance artistically since I could not understand it. For instance, there is a great and varied range of subtle hand gestures in Indian classical dance, each with a quite precise meaning, of which I knew none. It is clear that my appreciation was aesthetic, not artistic.

Among the various classifications she offers of works of art, Ruth Saw (1972, p. 48) includes the following:

There is another important class of aesthetically pleasing performances in which the performers are not carrying out the instructions of another artist but are acting spontaneously. Star performers in ice hockey, cricket, football, and sports generally are valued almost as much for their elegance in action as for their run-making and goal-getting ability ... Sports commentators use the terms of aesthetic appraisal as freely as do art critics.

This reveals in another way the misconception to which I wish to draw attention, which is implicit in Ruth Saw's failure to distinguish between kinds of sporting activity. I have considered this question elsewhere (Best, 1978, ch. 7) but to put the matter briefly, there is a class of sporting activities, which would include the great majority, in which the purpose of the activity can be specified independently of the manner of achieving it, for example, football, tennis, cricket and hockey. By contrast, there is a class of sports in which the purpose of the activity cannot be specified apart from the aesthetic manner of achieving it. That is, in this latter class the aesthetic is intrinsic to the activity. For example, it would make no sense to suggest to a figure skater, Olympic gymnast or diver that he should ignore aesthetic considerations and concentrate exclusively on achieving the purpose of the sport, since that purpose is necessarily

concerned with the aesthetic manner of performance. By contrast, it would make perfectly good sense to urge a football or hockey team to concentrate exclusively on scoring goals without paying any attention to the manner of scoring them.

Once the distinction is recognized, it can also be seen that it is misleading to assert that sports generally are valued almost as much for their elegance as for the achievement of their ends. With respect to the former, 'purposive', class of sports that is an intelligible observation, but in the case of the latter, the 'elegance', or aesthetic quality, is inseparable from what the performer is trying to achieve; it could not be a successful performance unless it were an elegant performance. Certain aesthetic norms are part of the meaning of terms such as 'vault' and 'dive', for whereas not any way of getting over a box or dropping into the water could count as even a bad vault or dive, any way of sending the ball between the opponents' posts, as long as it is within the rules, does count as a goal, albeit a clumsy or lucky one.

However, the main point is that there is no support for the case for an object's or activity's being a genuine form of art in that terms of aesthetic appraisal are freely applied to it. It is surprising that the point is so often overlooked. That a lady is beautiful does not imply that she is a work of art. Nevertheless, on the grounds that terms of aesthetic appraisal are freely applied to them, Ruth Saw accepts that sporting activities generally are forms of art. Yet in the case of purposive sports, which constitute the great majority, it is clearly a contingent matter whether there is a concern even for the *aesthetic* manner of achievement. That is, to use the term indiscriminately for a moment, aesthetic considerations are merely incidental, in sharp contrast to works of art.

As we saw above, Reid is aware that there is a distinction, and his characterization of the artistic is initially tempting. On this view the artistic is that which is intentionally created or performed for aesthetic value. Beardsley, too, defines art in terms of aesthetic intention (see, for instance, op. cit., p. 730). But there are many counter-examples to this suggestion. For instance a wallpaper pattern is normally designed with the intention of giving aesthetic pleasure, but it would not necessarily, or usually, on that account be regarded as art. There are numerous other cases, some of which I cited above, such as the shape of radiators and spectacles, and even coloured toilet paper. The intention, in each case, is to give aesthetic pleasure, but none is art (which is not to deny, of course, that there may be certain unusual circumstances in which any of them could be considered as art, or as part of a work of art).

The Aesthetic and the Artistic

Art Form and Subject

Referring back to the distinction I drew above, a much more plausible case can be made for the credentials, as forms of art, of the 'aesthetic' sports, that is, those in which aesthetic considerations are intrinsic. To show why the case does not succeed will bring out the general thesis for which I am arguing.

Reid is prepared to accept that these 'aesthetic' sports can legitimately be regarded as art, As he says: 'The question is whether the production of aesthetic value is intrinsically part of the purpose of these sports. (If so, on my assumptions, they will be in part, at least, art)' (1970, p. 258). Beardsley would be committed to the same view. But this fails to recognize the significance of the distinction between the aesthetic and the artistic which is implicit in my example of Indian dance.

To put the point generally, what underlies my rejection of the contention that the artistic is that which is intentionally created or performed for aesthetic value is the recognition of a particularly important characteristic of the concept of art. It would seem, in view of the casualties littering the field of aesthetics, that any attempt to characterize art in terms of definition, or by reference to particular kinds of object or performance, is almost certainly doomed to failure. My proposed account places emphasis on a characteristic which is central to the notion of an art form, rather than to a work of art within that medium; it is intrinsic to an art form that there should be the possibility of the expression of a conception of life issues. Certainly, this characteristic is central to many art forms, which can express a view of, for instance, contemporary moral, social and political problems. An account in such terms has in its favour that it emphasizes that crucial aspect of the concept to which any characterization must be adequate, namely, the inseparable relationship between the arts and the life of society. To take a clear example, it is reported that during the occupation of France in the last war a German officer visited Picasso, and noticed Guernica, which Picasso had painted as an expression of his revulsion at the bombing of the little Spanish town of that name by the German fascists. Impressed by the painting, the officer asked 'Did you do that?', to which Picasso replied 'No, you did'.

This is not to say that, where this characteristic is present in a work, the artist's view of the situation is always directly apparent. In many cases, as often with Shakespeare, the issues may simply be presented, without any, or any clear, indication of the artist's view. The characteristic to which I am drawing attention covers both kinds of case.

In order to avoid misunderstanding it may be worth mentioning the objection which has been raised that in sport too there can be comment on life-issues, as in the case of the black American athletes at the Munich Olympic Games who gave the clenched-fist salute for black power during the playing of the national anthem. But this does not constitute a counter-example, since the gesture was clearly *extrinsic* to, not expressed by means of, the conventions of sport. By contrast, it is certainly intrinsic to the concept of art that a view could be expressed, for instance, on colour discrimination, as in Athol Fugard's plays about the problem with respect to South Africa.

It becomes clear why I contend that Reid and Ruth Saw are mistaken to allow even the aesthetic sports, as I have called them, to be regarded as legitimate forms of art. For this is to overlook the importance of that aspect of the concept of art on which my account lays emphasis. Although, unlike purposive sports, aesthetic considerations are intrinsic, there is no possibility, within the conventions of aesthetic sports, of the expression of a conception of life issues. It is difficult to imagine a performer of gymnastics, diving, figure skating, synchronized swimming or trampolining including in his sequence movements which expressed a view of war, of love in a competitive society, or of any other such matter. Certainly, if such movements were included they would, unlike art, detract to that extent from the performance.

There are, of course, abstract works of art, where it would be a mistake to look for meanings. In such a case one may be concerned solely with, for instance, the line, colour, movement, structure, and so on, and it would reveal a failure to understand the character of the work to try to 'read' into it some relevance to life issues. Such cases, do not, I think, constitute an objection to my account since that is proposed in terms of what it is to be an art *form*. However, they do raise problems which I shall consider below.

It should be emphasized that I am offering here only a *necessary* condition of an art form, thus, for instance, journalism, preaching and political speeches would not constitute counter-examples. I am proposing not a definition, but a necessary condition specifically to distinguish the artistic from the aesthetic.

A further objection which might be raised against my account is that it is merely stipulative. Certainly no philosopher can legislate the correct use of terms, and hence 'artistic' could be used synonymously with 'aesthetic'. Moreover, there could be no philosophical objection to uses such as 'the art of cooking', 'the arts of war', and, as a classic case, a book I

The Aesthetic and the Artistic

noticed recently which was entitled *The Womanly Art of Breast Feeding*. The conceptual point is that even if 'art' and its cognates should continue to be used as broadly as this, there is still a distinction between those activities which have, and those which do not have, intrinsic to their conventions, the possibility of expressing a conception of life issues in the way I have tried to describe. Moreover, in such a case it would be necessary, or at least desirable, to use some other term to mark the distinction. It is much less conducive to confusion to restrict 'art' and its cognates to such activities.

An example of a conflation of the two concepts which raises questions central to the argument of this book occurs in an interesting and important symposium on objectivity and aesthetics by Sibley and Tanner (1968). Sibley states clearly at the outset that he is concerned with 'aesthetic descriptions', by which he means 'assertions and disagreements about whether, for instance, an art work (or, where appropriate, a person or thing) is graceful or dainty, moving or plaintive, balanced or lacking in unity' (p. 31). He later adds other terms such as 'beautiful', 'elegant' and 'charming' (p. 47). As we have seen, it is certainly possible, at least in many cases, to consider works of art from an aesthetic as opposed to an artistic point of view. Moreover, to anticipate part of my later discussion, it is not part of my case that the two concepts are always clearly separable, or to deny that aesthetic considerations often form a significant part of artistic judgements. So it does not follow that to consider the use of aesthetic descriptions with respect to works of art is necessarily to misconceive the character of artistic appreciation. Nevertheless, it is clearly implicit in Sibley's paper that he does fail to distinguish the two concepts, and as a consequence assumes that an argument about the use of these aesthetic descriptions is ipso facto an argument about artistic appreciation. For instance, one of Tanner's principal arguments against Sibley's case for the objectivity of *aesthetic* judgements – an argument in which he himself takes over the same conflation of the aesthetic and the artistic - is that there is not as much agreement in critical artistic judgements as Sibley claims: 'One has only to look at the variety of reasons for which Shakespeare has been admired to see that this is so' (p. 65).

It is significant that Sibley bases his argument for the objectivity of aesthetic judgements on an analogy with colour-judgements, which he takes to be a paradigm of objectivity, arguing that the use of aesthetic descriptions is relevantly similar. But whatever the merits of the analogy in support of his argument for the objectivity of the use of *aesthetic* descriptions,

such as 'graceful', 'delicate' and 'dainty', such terms cannot be regarded as central examples of the discourse of artistic appreciation. Indeed, at least in many cases, an exclusive or even predominant use of such terms would *ipso facto* cast serious doubt on the user's capacity for genuine appreciation of an art form.

Largely as a consequence of overlooking the distinction for which I am arguing, there is an illegitimate extrapolation from an argument about the use of aesthetic terms to a conclusion about the objectivity of artistic appreciation. This is not to deny the usefulness of an examination of the use of aesthetic terms. What I do deny is that the use of such terms can be regarded as typical of artistic appreciation. Indeed, it is a further consequence of the important characteristic which is central to my account of the concept that there are no terms which could be said to be typical of artistic appreciation. For instance, a critical appreciation of Shakespeare's Measure for Measure might be concerned with such questions as the extent to which characters such as Angelo and Isabella were deceiving themselves about their own characters and attitudes early in the play; whether their learning from their experiences is central to the play, or whether the intention is rather that those reading or watching it should learn from the inability of the characters to recognize their own weaknesses; the extent and effectiveness of Shakespeare's sense of irony; the extent to which profound and perennial moral questions are raised in terms of the play. Such discussion is hardly aesthetic at all, but rather concerned with insight into human character and relationships, and an understanding of life situations.

The contention over the character of this play is a good exemplification of the point, for it certainly does not involve a consideration of the aptness of applying to it aesthetic descriptions of the kind of which Sibley gives instances. Instead, to give brief examples, it ranges from Coleridge's view that it is the only painful Shakespearian play, in that both the comic and the tragic parts are disgusting; to Wilson Knight's conception of it as an allegory, in which each main character has a counterpart in the story of Christ; to Empson who thinks of it in terms of an analysis of various uses of 'sense'; to Goddard's view that it expresses the corruptive effects of power on human character; to Marxist interpretations of the play as an assertion of life and love in an unjust society – hence the centre of the play is taken to be Claudio's speech to Isabella to save his life; to T. S. Eliot, who takes the opposite view, that the centre of the play is the Duke's speech to Claudio extolling death.

Such considerations support my contention that an adequate account of

The Aesthetic and the Artistic

the concept of art must place the emphasis on a characteristic far more significant and wide-ranging than the way in which people apply aesthetic descriptions. Hence my suggestion that it is intrinsic to at least most of the arts, by contrast with the aesthetic, that they can give expression, for instance, to moral and social concerns, insights into personal relationships and character development. One can appreciate why it is impossible to compile a list of *typical* artistic judgements – and indeed that it reveals a misconception even to attempt to do so – for the arts can give expression to conceptions of the *whole range* of the human condition.¹

Learning and Understanding

This raises another closely related question, which casts further doubt on the general validity of approaching questions of artistic appreciation by analogy with colour-judgements. For a crucial difference, of which Sibley is certainly aware, but whose significance he does not, in my view, sufficiently recognize, is that the notions of learning, knowledge and experience are of far greater importance for artistic appreciation than for colour discrimination. Indeed, in this respect even the supposed parallel between colour and aesthetic judgements is questionable, for by contrast with the case of colours, an aesthetic appreciation of nature, for example, may be inseparably bound up with, one expression of, a conception of life which also finds expression in an attitude to moral and social matters. That is, a description of nature, unlike the ascription of colour predicates, might reveal a good deal about one's life.

The point I wish to emphasize, however, is that although there may be some plausibility in arguing that, for example, 'graceful' connotes a property rather as 'red' does, the analogy with artistic appreciation is highly implausible if this is taken to imply that the terms used in artistic judgements connote properties, however loosely that term may be interpreted. That is, if the notion of ascribing a property is construed on the model of colour-judgements, then artistic judgements are so very different that they cannot be regarded in terms of ascribing properties. The relevance to my argument is that even if we accept Sibley's analogy, there is a significant difference between aesthetic and colour judgements, on the one hand, and artistic judgements on the other. This difference, which is implicit in much of my argument so far, consists in the fact that, in the arts, the notions of learning, understanding and experience cannot intelligibly be regarded as distinct from learning, understanding and experience

in life situations generally. It could much more easily be supposed that the use of aesthetic descriptions could be learned in isolation from such general experience of life. Moreover, with respect to the analogy, young children generally could very well have excellent colour discrimination – indeed, far better than their elders. But it is inconceivable that young children generally could be capable of equally or more perceptive artistic judgements than their elders.

This aspect of the concept of art is also, of course, what makes it so difficult to appreciate artistically, as opposed to aesthetically, the arts of another culture. An artistic appreciation of the dancing of Ram Gopal, to which I referred earlier, would require an understanding not simply of an independent activity but, to some extent, of the traditions and ways of life of a different society. It is his recognition of the importance of this point which leads Tanner to say (op. cit., p. 72):

One may feel, reading poetry in a foreign language, that even though one has a mastery of the vocabulary, syntax, and even to some extent the idioms of the language, one is still bound to miss much of the significance of the poetry, because the only way to grasp it is to have spoken the language from the start, living in the community that speaks it.

The Relation between the Concepts

To revert to a point to which I have already referred briefly, I do not suggest that the aesthetic and the artistic are always clearly, if at all, separable. In some cases it may be impossible to distinguish them. Moreover, artistic judgements often involve aesthetic judgements. For instance, in many, perhaps most, cases one's judgements of the aesthetic quality of the movements of the dancers will be part of one's artistic appreciation of a dance. Similar considerations apply to the other arts. It is, at least often, possible to consider paintings, plays, novels, poems and pieces of music from an aesthetic, as opposed to an artistic, point of view - for instance, in terms of purely structural considerations and, respectively, the colour or sound but such aesthetic qualities may nevertheless be relevant to artistic appreciation. An art lecturer of my acquaintance who had hung a painting he admired in a prominent position in his college was asked by the principal to move it because it did not blend with the decor of the corridor. Clearly the principal's concern was an aesthetic one, whereas the lecturer's had been with the artistic quality of the work. But that is not to say that a consideration of the background on which it should hang is irrelevant to the

The Aesthetic and the Artistic

artistic appreciation of a painting. And in many cases it may be impossible to distinguish an aesthetic appraisal of the colours used from an artistic appreciation of the work. Again, poetry read aloud in a language one does not understand may strike one as aesthetically pleasing, even though an artistic appraisal of it is impossible. Nevertheless, even where one does understand a poem, the sound of it when read may be by no means irrelevant to an artistic appreciation of it – the works of Dylan Thomas and Verlaine are good examples, while Gerard Manley Hopkins actually marked the syllables he wanted accented.

In the case of music the distinction between the two concepts and the question of the relationship between them are more difficult. Nevertheless, there is a distinction similar to that in my example of Indian classical dance. It is quite possible to enjoy music aesthetically without understanding it at all. It could strike one as having a remarkable aesthetic quality, analogous to the call of a loon in a Canadian forest, or simply as a pleasing succession of sounds, analogous to the sound of the sea, or of the wind in the trees. For example, as an undergraduate I belonged to an Asian Music Circle in which many of us were introduced to previously unknown forms of music which we found immediately attractive. Yet in some cases if we had encountered these sounds in a different context they would probably have been unrecognizable to us as forms of *music*. This shows that our appreciation was purely aesthetic.

It should be added that it may often be necessary to take into account, at least implicitly, wider factors than what someone says on any one particular occasion in order to be able to judge whether his appraisal was aesthetic or artistic. For instance, his previous and/or subsequent behaviour and judgements may reveal that he lacks any understanding of the art form, and hence that his appreciation was aesthetic.

Problems

Architecture poses a problem for my characterization of art since, in perhaps the great majority of cases, buildings do not allow for the expression of a conception of life issues in the sense in which this is possible in literature, dance and painting. (There is, of course, a sense in which architecture, like almost every other aspect of life, could be said to be an expression of the spirit of the age, or of a particular society, but clearly that is a different sense from the one which interests me in the present context.) But I am inclined to think that to a large extent the reason for the difficulty is precisely the

reason for my doubting whether, in the majority of cases, we are concerned with works of *art* here, although they are undoubtedly central cases for aesthetic appraisal. It would strike one intuitively as odd to refer to the activity of designing and building the majority of houses, offices and factories, for instance, as *art*, and one does not hear it referred to in that way. Where architecture is normally and naturally designated as art, as, for instance, in the case of church architecture, this would accord with my account. For the architecture of churches can certainly, and characteristically *does*, give expression to a conception of life, as becomes particularly apparent when one visits the temples and mosques of very different cultures with very different religious beliefs.

It may seem that buildings such as ornate palaces, in which there is no such expression, are counter-examples to my account. It is no part of my case to deny that there may well be uncertain, borderline cases, but a further argument can be adduced to defend my suggestion here. I should be inclined to doubt whether such buildings are at least clear cases of art, for they are to a large extent functional, that is, there is a purpose for which they are constructed which can be specified independently of the manner of achieving it. By contrast there is no means/end distinction in the case of a work of art, since *what* the work could be said to be trying to achieve cannot be comprehensively characterized independently of the means by which it is achieved. The same consideration applies, for instance, to church architecture.

There is a parallel situation in dance, since one would not normally refer to some forms of dance as art, for example, social dance and much folk dance. But it is often impossible to draw a sharp distinction. In some cases there is a broad and hazy area between folk dance and dance as an art form.

A more difficult problem for my proposed account of art is posed by music. It has been said that all art aspires to the condition of music. What is meant by this remark is, I think, that in music, more than in other art forms, the inseparability of form and content is more often more immediately obvious. This is why it frequently sounds so odd to speak of the *meaning* of a piece of music (e.g. Bach's Fifth Brandenberg Concerto). Of course, this characteristic is equally, if less obviously, true of other art forms, which is why I prefer to use the formulation 'the expression of a conception of life issues' rather than, for instance, 'the embodiment of' or 'a comment upon' life issues. For these latter more readily imply that the 'meaning' could be adequately characterized independently of the medium. Yet it

The Aesthetic and the Artistic

makes no sense to suppose that, in the arts, *what* is expressed could be comprehensively characterized apart from the particular *way* in which it is expressed.

It will not do to attempt to overcome the problem of music in the way in which I dealt with architecture, since there are numerous pieces of music in which there is no expression of life issues, but which are *paradigm* cases of art, whereas this is not true of architecture. I could and perhaps I should rest my case on the fact that there is a vast amount of music which does give such expression, for instance opera, oratorio, religious music generally, songs generally, much of Debussy, some of Berlioz (e.g. the *Symphonie Fantastique*), Sibelius, Elgar and Beethoven (the Ninth Symphony) – and there are innumerable other examples. Strictly, that is sufficient for my characterization of an art *form*. Yet I confess that I am uneasy that there are also so many pieces of music which are unquestionably art but in which the suggestion that there may be some expression of a conception of life seems intolerably forced and absurd.

Conclusion

For this reason, of the two principal points I have tried to make in this chapter, I have rather more confidence in the first than the second. The first is that there is an important distinction between the aesthetic and the artistic which is largely overlooked, and that even where it is recognized its character has been misconstrued. That suffices, I think, to show that 'aesthetic' is not equivalent to 'artistic' and that therefore, *inter alia*, it is a serious misconception to slide from a consideration of the use of aesthetic descriptions to a generalization about artistic appreciation.

My second principal point is to offer a suggestion for an important distinguishing feature of the concept of art. That suggestion is not without its difficulties, but I think and hope that it is at least a step in the right direction. Some grounds for this qualified optimism are provided by the kinds of case we have considered. The salient feature of this account is clearly illustrated by the example of sport. As we have seen, as a consequence of eliding the aesthetic and the artistic it is often assumed that there is some support for the credentials of sporting activities as forms of art in that both characteristically attract terms of aesthetic appraisal. This kind of view, explicit in the passage from Ruth Saw cited above, is implicit in the following quotation from Lowe (1976), p. 167):

Among sculptors, R. Tait McKenzie has brought a fine sense of movement to his studies cast in bronze. There is no question about the aesthetic qualities of these art works: hence they provide intrinsic clues to our grasp of the elusive nature of beauty of sport.

Ironically, this kind of argument achieves the opposite of what its authors intend, in that in fact it can be seen to draw attention to the distinction between the aesthetic and the artistic, and to offer support for, and conveniently to summarize, my own account. For whereas sport can be the subject of art, art could not be the subject of sport. Indeed, however *aesthetically* attractive such activities may be, the very notion of a *subject* of sport makes no sense.

The same applies equally, *mutatis mutandis*, to the aesthetic appraisal of other phenomena, such as the beauties of nature.

It is the implicit reference to precisely this significant difference between the two concepts which, at least largely, gives the humorous point to Oscar Wilde's description of a sunset as only a second-rate Turner.

Summary

- (1) There is an important distinction between the concept of the aesthetic and the concept of the artistic.
- (2) The artistic cannot be defined in terms of that which is intentionally created for aesthetic effect.
- (3) An aspect of the distinction which is of crucial educational significance is that far wider understanding of life is required for artistic judgements. This is at least largely because a characteristic which is of central importance is that the arts can give expression to a conception of life issues.

Note to Chapter 11

1 I am, of course, aware that a phrase such as 'can give expression of a conception of life issues' gives only a vague indication of the characteristic I have in mind. It seems to me that such vagueness is unavoidable, since, as I am trying to emphasize, the arts can take as their subject matter almost, if not quite, *every* aspect of life. The question of the character of the relationship between art and life will be considered in Chapter 12.

Art and Life

Introduction

The previous chapter raises a fundamental question which is central to a consideration of the arts, and the arts in education, namely, that of the relationship, if any, between the arts and the life of society. There tends to be a polarization of views. Those at one pole rightly emphasize that artistic meaning is partly an expression of the life of society, and because they are especially impressed by the potential influence of the arts on life generally, they insist that the meaning and value of the arts are given by the purposes they serve. For instance, throughout history the arts have made powerful and incisive moral and social comments. It is a recognition of just how dangerous the arts can be in this respect which induces totalitarian regimes to censor and apply stringent restrictions on the arts. This purposive view offers a clear rationale for the important notion of education *through* the arts, in that there is a great deal, of enormous significance to life generally, which can be learned through the arts.

By contrast, those who hold the currently more prevalent view at the opposite pole rightly point out that to insist that the value of the arts resides in the purposes they serve is to deny their intrinsic value, for in that case the arts are merely means to ends. For example, since moral and social ends could be achieved by other, non-artistic, means it is difficult to see that the arts have any intrinsic value. Thus the present tendency is to insist that the arts are autonomous, in that their meaning and value are solely intrinsic and have no reference to the life of society.

The common assumption that the arts are to be characterized in terms of pleasure or entertainment is a version of autonomism. That notion

trivializes both the arts and society, and would incur the consequence that there could be no justification for the arts in education.

There is almost inevitably a confused sliding between the two poles of the purposive and autonomist conceptions of art, even by their advocates, since there is important truth in both.

The contention that it is irrational to be emotionally moved by fictional characters and situations is shown to be based upon a fundamental misunderstanding of the concept of art. The same misunderstanding underlies attempts to justify the rationality of response to the arts in terms of the supposition that, for instance, characters and situations in drama are imagined, illusory, pretended, or symbolic. On the contrary, the object of attention and response is real; the sense of that reality is given by the concept of art. It is a mark of the success of a work of art, and of one's understanding of it, that one responds not to a mere symbolic representation, but to a real character.

Purposive or Autonomous

Tolstoy (1930, p. 120) believed it to be a trivialization of art to equate it with beauty, since the value of art lies in 'the purpose it may serve in the life of man'. For Tolstoy the value of art resides in its moral purpose; thus a good work of art is one which expresses morally good feelings from which morally good lessons can be learned. By contrast, the autonomist contends that it is the purposive account which trivializes the arts by reducing them to mere 'message-carriers'. Since the 'message' could be conveyed in other ways, such as sermons, political speeches, or journalism, on the purposive account there appears to be no intrinsic value in the arts. Thus, in reaction against the purposive view, many regard the arts as self-contained activities. There are several examples of this prevalent autonomism. For example, Oscar Wilde (1966, p. 976) wrote:

As long as a thing is useful or necessary to us, or affects us in any way, either for pain or for pleasure, or appeals strongly to our sympathies, or is a vital part of the environment in which we live, it is outside the proper sphere of art. For to art's subject-matter we should be more or less indifferent.

He concluded from such considerations (pp. 5-6) that: 'All art is quite useless.' Hampshire (1954, p. 162) appears to have, or at least could naturally be construed as having, an autonomous conception of art when he writes:

Art and Life

The canons of success and failure... are in this sense internal to the work itself... In so far as the perfection of a work is assessed by some external criterion, it is not being assessed as a work of art, but rather as a technical achievement in the solution of some problem... Nothing but holding an object still in attention, by itself and for its own sake, would count as having an aesthetic interest in it. A great part of a critic's work, in any of the arts, is to place a frame upon the object and upon its parts and features, and to do this by an unnatural use of words in description.

Peter Brooke, the theatre director, has said: 'Culture has never done anyone any good whatsoever', and 'No work of art has ever made a better man'. A similar conception is expressed by Hirst (1980, p. 6) when, for instance, he says that 'the role of the arts in education is to aestheticize people', and it seems to underlie the comment of 'a distinguished educational pundit' who is quoted (*Observer*, 24 January 1982) as saying sharply: 'The arts are marvellous, but moral they are not.'

This is a classic example of the way in which philosophical conflict often arises. Each protagonist is so impressed by an important insight into an area of inquiry that he over-emphasizes it to the point of denying the equally important insight of the other, thus incurring an obvious mistake. This conflict is based on the shared presupposition that art is either autonomous or dependent on external purposes. Yet, on the one hand it is obviously mistaken to deny that the arts can express and illuminate life, since there are numerous works whose meaning is of this kind. On the other hand, it is obviously mistaken to insist that the arts have no meaning and value other than that of providing a vehicle for the expression of, for instance, moral and social questions.

The Arts as Autonomous

Roughly, I am arguing that art is, to use Wittgenstein's terminology, a language-game, by which I mean one set of practices and area of discourse among others, such as the sciences, mathematics, religion and morality, which together constitute a culture, or the form of life of a society. As we saw in Chapter 1, it is a fundamental error to believe that a language-game can be justified. For instance, induction cannot be justified externally. Particular inductive judgements can be justified only by the standards of induction. Those who argue a similar case for other language-games have been so impressed by this characteristic that they have sometimes failed to give an account of how each is related to the rest of life. For instance, in

the case of religious belief, some philosophers sometimes give the impression that the canons of meaning, validity and invalidity are exclusively internal to that language-game and thus no external criticism of it would make sense. Yet while it is true that religious discourse is different from other kinds of discourse, to insist that it is completely self-contained is to deny any relation to the rest of life. That fails to take account of one of its central characteristics, namely, the meaning it can give to a man's life.

If the autonomist thesis is taken to the extreme of denying that anything external is relevant to the meaning and evaluation of the work of art itself, on a narrow conception of what can count as the work itself, it can easily be shown to be incoherent. For example, it makes no sense to suggest that knowledge of French is irrelevant to critical appreciation of Verlaine's poetry, since without some grasp of the language one could not understand it even in the most obvious sense. This means that, at least in many cases, to understand and evaluate works of art requires some comprehension of the socio-historical context in which they were created. For example, to understand Chaucer's language requires some conception of the institutions of his period. His reference to the monk in the Prologue as a 'manly man to been an abbot able' could not be recognized as satirical without some notion of the context of religious life within which it was written. Similarly, the meanings of some of the terms used by Shakespeare have changed because of social changes. One has to learn their original meaning, given by that different social context, before one can begin to appreciate his plays. It is clear that a literary work could not be regarded as isolated from the rest of life. It is hardly an exaggeration to say, in contrast to the autonomist, that to understand a poem is to understand a form of life. That is, this point about language is of far greater significance than is often recognized, since to understand a language involves an understanding of social context. In brief, to understand a poem is to understand a language, which is to understand a culture.

Even if we ignore the most obvious connection with social context, and consider non-verbal arts, a work cannot be understood in isolation from the artistic context in which it was created. For example, it would be difficult to make sense of the notion that Stravinsky's music might have been written in the twelfth century. There is an important sense in which any work of art employs a vocabulary. A discord which might be characteristic of Bartok would be either very puzzling, or perhaps of immense significance, in Haydn. It is difficult to make sense of the suggestion that a whole Haydn symphony might consist of a series of such discords. It is evident, if one considers widely disparate historical periods or geographical

regions, that there is a characteristic vocabulary, mode of approach, or group of styles, peculiar to particular artistic traditions, some comprehension of which is necessary for understanding a work of art.

Artists are not, of course, restricted to the artistic context of their day. Some of Turner's later painting has similarities to and may be seen as a precursor of modern abstract expressionism. (Compare it with Constable, for instance.) And the remarkable progressions in some of Gesualdo's madrigals are in a form often used by much more modern composers. But the striking character of these cases derives its sense from the contemporary artistic context. To recognize the uniqueness of a work presupposes an implicit comparison with others.

The meaning of at least very many works of art depends upon relations with social and artistic context to such an extent that it becomes unintelligible to regard such contextual factors as 'external'. For example, Picasso frequently includes hints of bull fights, and the effect of surrealist painting, such as that of Magritte and Dali, relies upon the recognition of strident juxtaposition of objects in bizarre contexts, and upon disturbing perspectives and situations. Kinetic art occasionally employs illusion, and consequently surprises the spectator because of the expectations he brings to the situation. Some pieces of music incorporate allusions to others, or to birdsong, or to the noise of battle. In some jazz improvisations the soloist inserts snatches of melodies with certain associations – often for humorous effect. The humour obviously could not be understood by anyone unacquainted with the melodies.

Thus the difficulty even of formulating precisely what its thesis amounts to tells against autonomism, since it is by no means clear what is meant by the injunction that one should limit one's attention, in critical appreciation, to the work itself. It is as unclear, or incoherent, as the suggestion that one should consider the meaning of a sentence in isolation from the rest of language and life.

Response

It is, then, unintelligible to suppose that artistic meaning is independent of the rest of life. In many cases the criteria for the power or insight of a work depend upon its truth to life. Nevertheless, there is a problem here since, as we have seen, the possibility of artistic feelings depends upon an art form in which they can be formulated. Yet since the feelings can be identified only by reference to that formulation, how can such feelings have any

relation to life? The problem can be brought into focus by asking how it is that we can be moved by what happens to characters whom we know to be fictional. At first sight it may seem odd to be moved by characters who are artistic creations. Radford (1975, p. 75) proposes a solution:

being moved when reading a novel or watching a play is not exactly like being moved by what one believes happens in real life, and, indeed, it is very different. So there are two sorts of being moved and, perhaps, two senses of 'being moved'. There is being moved (Sense 1) in real life and 'being moved' (Sense 2) by what happens to fictional characters.

Yet one cannot intelligibly regard the artistic case as totally independent of life, since our being moved by situations in art depends on the fact that if these were real life situations they would be moving in the normal sense.

A source of the problem is the oversimple conception of a languagegame which has created intractable difficulties for other areas of philosophy. Several times in this book I have appealed to an analogy with chess in order to emphasize the importance of the medium. For, just as a checkmate experience depends upon a grasp of chess, so an artistic experience depends upon a grasp of an art form. But it is an analogy, and thus has limits. The concept of art differs from that of chess in that meaning in the arts is much more directly related to life outside the arts. It is, of course, true that even chess is not an isolated activity; its character and existence depend upon the fact that we are beings of a kind in whose lives there is a place for the notion of a game. Nevertheless, there is a relatively sharp boundary to chess, in that the validity of a move depends on the conventions of chess, whereas the validity and value of a work of art may depend on its truth to life. In this respect the arts are more like religion than chess in that a religion which loses touch with the concerns of people in a society degenerates into meaningless liturgical aridity. Yet although social questions cannot coherently be regarded as independent of religion, it is important to recognize the significant difference it makes to consider them from a religious point of view. The difference is unintelligible apart from the institution of religion, just as that institution would be meaningless if divorced from social concerns.

The purposive thesis, in effect, regards works of art as transparent windows through which we can see aspects of life. On this view there is no intrinsic significance or value in the arts since *what* one sees and responds to would be the same whether or not it were seen through the window.

The autonomist reacts to an opposite extreme, for he exaggerates their intrinsic value to the point of making the arts opaque to life, which again takes away the significance of art by isolating it from the concerns of society. The metaphor has some explanatory value if, instead, we regard art as translucent. To illustrate what I mean by this, consider Radford's sceptical conclusion (1975, p. 78): 'our being moved in certain ways by works of art, though very "natural" to us, and in that way only too intelligible, involves us in inconsistency and so incoherence.' If one had no grasp of the concept of drama the activities of actors would be unintelligible. Someone ignorant of the concept, watching a play, might well react in just the way Radford suggests: 'Why on earth is John calling himself ''Gloucester" tonight and pretending to be in pain? And why is Tom calling himself "Cornwall" and pretending to pluck one of John's eyes out? They did just the same thing last night so none of us will believe it.' That is, if someone responds to this situation as a life situation rather than one in drama, his response is inappropriate. (By a 'life situation' I mean a situation outside the arts. The reason why I use this term, rather than 'real situation', is that, as I shall argue, there is an important sense in which it is a fundamental misconception to contrast a situation in art with the real or, less obviously perhaps, with what occurs in life.) But, as we saw in Chapter 1, his inappropriate response would not reflect a failure of rationality. The work of art casts a translucent light on the situation, and that translucence is an ineliminable part of the appropriate emotional experience. To see the situation in that light requires and reveals a grasp of the concept of art. Similarly, in the example in Chapter 1 of people who have no concept of representational art, someone might say: 'How can it seriously be claimed that what is on this piece of paper is exactly like Mr Lowenberger? This is just a configuration of pencil lines on paper, he is a human being. How can they possibly be alike?'

Radford's striking conclusion, that our being moved by works of art is both '''natural'' and 'only too intelligible', and yet incoherent, arises from a failure to recognize the difference it makes that this is an *artistic* experience. For if someone were to be moved by actors, not realizing that they were actors, then his response would be based on a misunderstanding. But equally, it would be difficult to understand how someone could be moved if the dramatic situation bore no relation whatsoever to situations in life.

Part of the point I am trying to make can be brought out by considering the common use of the term 'illusion' in the arts. It is often said, for instance, that drama and dance are concerned with illusions, and in dance

the term 'illusory space' is sometimes used. But the term is misleading in the context of the arts, for whereas one may be deceived by an illusion, and take it for real, it is not intended that one should take the artistic situation for real in that sense. For instance, a mirage may give the illusion that there actually is an oasis in the distance, whereas in a dramatic production it is not normally intended that the audience should be deluded into believing that there is an actual murder taking place on the stage.

Similar difficulties arise with respect to the use of the term 'pretence' in an artistic context. For instance, in a perceptive paper on this topic, Mounce (1980, p. 183) writes of the actor and actress playing Othello and Desdemona that 'when Mr. Paul Robeson pretends to murder Miss Peggy Ashcroft, we are aware of the pretence and treat it merely *as if* it were real'. But whereas it is often, perhaps usually, the intention in a pretence to deceive someone into taking the situation for real, it is rarely if ever the intention to deceive in this way about a situation in a play. This is not merely a verbal quibble. It raises a matter which is central to the question of the relation of art to life, namely, the ineliminability of the concept of art. For it would involve a fundamental misconception about the character of the object towards which our response is directed, and which determines the character of that response, to think of it in terms of successful pretence.

Even the important qualification that we are *aware* of the pretence does not overcome the objection I am raising. It is true that if we are *aware* of the pretence there is no question of being deceived. But it is then difficult to understand why we should be moved. That is, if we are deceived, this might explain why we are moved, but deception is clearly not normally the intention in drama. On the other hand, if we are aware of the pretence, we are not deceived, but then this fails to explain why we are moved.

Our response is not a consequence of treating as if it were real Paul Robeson's pretence. Mounce writes later (p. 184): 'Mr. Robeson might have been pretending to murder Miss Ashcroft; the audience, however, was not *pretending* to be shocked and disturbed by what *he did*' (second italics mine). But we are not shocked and disturbed by what *he did*, that is, by Paul Robeson's *pretending* to murder Peggy Ashcroft; we are shocked and disturbed by Othello's *actually* murdering Desdemona.

It might seem at first sight that some substance is given to notions such as illusion and pretence by the fact that lighting, other stage effects and a high standard of acting are provided in order to make the situation as convincing as possible, so that the audience will respond as if to a life situation. But while it is true that in such a case the audience may respond in *some* respects as if to a life situation, it is equally important to recognize

that the intention in providing effective lighting, and so on, is certainly not that the audience should respond in *all* respects as if to a life situation. For instance, it is not intended that anyone should run to the stage to save Desdemona, or call the police, or shout a warning to Othello that Iago has deceived him about Desdemona's unfaithfulness.

It is because such situations can be so convincingly portrayed that Radford has to concede that it is 'natural' for us to be moved by works of art, even though he thinks that this involves us in incoherence. As Mounce puts it (1980, p. 188): 'It is evident that there are things in life that move us. This being so, why on earth is it surprising that we shall be moved by representations of such things? Would it not be more surprising if we were not so moved?' It is even less surprising that we respond in this way if the situation is convincingly portrayed. Mounce points out that it is important to recognize the distinction between the cause and the object of the response, for although the object towards which my emotional response is directed is an event in a play, what *causes* the response is the resemblance in certain respects of that situation to a similar situation in life.

More important, Radford's contention that it is *incoherent* to be moved by works of art arises from a failure to recognize the point emphasized in Chapter 1 that it is the natural response which is the *root* of the concept of art. The response is ultimate; thus to talk of what is and what is not rational or coherent at *that* level makes no sense. There is no rational principle which underlies and justifies the response; it is rather that reasons given in justification derive ultimately from the response. To assume that being moved by the fate of a fictional character is incoherent is itself as incoherent as averring that there is no justification for induction, or for deductive logic. One may justify particular responses within the arts, but the notion of justifying artistic responses in general, i.e. *externally*, makes as little sense as demanding a legal justification of laws.

The question can be approached by considering the use of the term 'imagination' and its cognates. As we saw in Chapter 7, Reid proposes a very tempting and widely assumed thesis:

How do perceived characters come to appear to possess, for aesthetic imagination, qualities which as bare perceived facts they do not possess?... Why should colours and shapes and patterns, sounds and harmonies and rhythms, come to mean so very much more than they are?... The embodiment of value in the aesthetic object is of such a nature that the value embodied in

the perceived object or body is not literally situated in the body . . . Our question is, How do the values get there? The only possible answer is that we put them there - in imagination.

But the common assumption that what distinguishes artistic experience from other kinds of experience is that in the case of the arts imagination is necessarily required in order to respond appropriately, is at least misleading and may be simply false. If the assumption means that the objects of our artistic responses are imaginary, then this is the same misconception as that involved in the cases of illusion and pretence considered above. For in this sense, to imagine something is to take to be happening what is not really happening. Yet one does not imagine that Othello murders Desdemona; Othello does murder Desdemona. Neither does one need imagination to understand that an actor is playing the part of Othello. If, on the other hand, the supposition is that even though the dramatic situation is not imaginary, imagination is required in order to respond appropriately to the arts, then (a) that is not always true, and (b) in any case this is not a distinguishing feature of the arts. For instance, given a high standard of acting, it requires no imagination to respond strongly and appropriately to the gouging out of Gloucester's eyes in King Lear - indeed, there would be something odd about anyone who did not so respond. In relation to (b). this is not in the least, of course, to deny that imagination is of considerable importance in the arts, for instance, in identifying with a character in a play and entering into his situation, in what I called in Chapter 9 the involved attitude. My point is that imagination may be equally necessary to understand and respond to certain people and situations in life. Imagination may be required to enter into King Lear's situation, to respond sensitively to the position of the character in the play, rather than simply observing what happens in a detached way. But, equally, imagination may be required to understand and respond adequately to an old man in a similar situation in life.

(If I am right about this, it raises, I suspect, fundamental problems for Scruton's thesis, in *Art and Imagination*, that the object of our attention in artistic appreciation is an *imagined* object. He writes, for instance (1974, p. 77), 'experience of a work of art involves a distinctive order of intentionality, derived from imagination, and divorced from belief and judgement'. But I have not the space to give detailed consideration to this matter.)

This misconception is related to the common assumption that creativity and imagination are the peculiar province of the arts. In fact, such

qualities are equally necessary, or at least highly desirable, in other areas of life such as the sciences, mathematics and personal relationships. In the particular case we are considering, the misconception is to think that the intelligibility of the artistic response can be justified by the fact that these are imaginative, pretended, or illusory situations. In fact, as we have seen, it is a fundamental mistake to assume that there can be a justification for artistic response.

Response to the Arts as an Analogue

It was said above that one responds in some respects to a situation in a play or novel as if it were a life situation. This may invite the objection: 'How can I respond as if to a life situation when I know that it is a situation in a play?' Part of the answer is that the situation is in some respects very similar to emotionally moving situations in life. But it may still be objected that nevertheless the differences are so great that it is difficult to understand how one can be moved. For example, the action takes place on a stage, no actor appeals to the audience for help or runs away through the auditorium; there may be hundreds of people watching even a supposedly intimate scene; the actors usually take care to face the audience; we know that these *are* actors, and sometimes the action or dialogue may be stylized in ways quite unlike situations in life.

Two questions arise here. First, although one responds in some respects as if to a life situation, because the dramatic portrayal is in some respects like life, at least at a sophisticated level the explanatory value, and perhaps even the sense, of the 'as if' depends upon the concept and conventions of drama. For instance, allegory may be quite unlike any life situation; one has frequently seen performances of plays where different sections of the stage represent different geographical locations containing people who are supposed to be ignorant of what is going on in the others. *Antony and Cleopatra*, with its very short scenes, is often performed in this way; asides and soliloquies, revealing secret thoughts of the characters, if they can be heard by the audience, could certainly be heard by the other characters – and there are many such examples. To respond appropriately to the murder of Desdemona *is* to reveal a grasp of the concept and conventions which give sense to the possibility of responding in some respects as if this were a situation in life.

This raises the second and more fundamental question which is that even if the 'as if' is given its sense by the concept, it is still, from a

certain point of view, a *remarkable* fact that we *do* respond in this way to a dramatic situation which we obviously do not take as a life situation. It is because the response is so remarkable, seen in this light, that some feel impelled to explain it in terms of delusion, in that they assume such a response is possible only as a result of confusedly taking the situation as a life situation. This brings us back to the foundation of the thesis of this book. For at this level all we can say is that such a response is immediate, primitive, natural. And in calling it natural or primitive, one is repudiating Radford's contention that it rests on confused thinking. It does not rest on incoherence or irrationality. Neither does it rest on coherence or rationality. It rests on nothing.

The same confusion is implicit in the temptation to assume that one can have the same response to a dramatic situation as to one in life to some extent. But it is misleading to suppose that through the arts we can have the same experiences as those in life to a limited degree on the same scale. Responses to art are not necessarily less intense, nor more intense, than responses to situations in life; they are just different. That is, responses to art are on a different scale, even though we are moved because of the relation with moving situations in life. The artistic response can be regarded as an analogue of the response to a situation in life. Yet to say that the response is analogous is not to say that it is any less powerful than responses in life.

Response, Reality and Symbolism

The central point can be brought out by considering an objection. This objection is that it is, indeed, irrational to be moved by characters whom we know to be fictional; our emotional response, if it be rational, is not to the fictional characters but to the real people whom they represent, or of whom they are symbolic. Thus, for instance, according to this objection it is irrational to be moved by the plight of the poor in Dickens's novels. Where one's response is rational it is directed to those who are poor in life in relevantly similar ways. The objection agrees that a work of art may produce a change in one's feelings towards the poor, but denies that it is one's emotional response *to* the work which produces the change.

Yet, on the contrary, if one responds not to the fictional character portrayed in the work but to the character or kind of character in life who is in some way symbolized or represented, then that is a failure either artistically

or in appreciation. This brings up the central thesis of Chapter 10. For in such a case substitution would in principle be possible, in that the object of the response would not be the particular character portrayed. Examples will illustrate the point. Athol Fugard's play *Statements Made After Arrest Under The Immorality Act*, as the title indicates, attempts to bring out the effects of an aspect of the apartheid laws in South Africa on the personal lives of ordinary people. Yet the play seems to me to be an artistic failure precisely because one responds not so much to the characters in it as to the people in life of whom they are symbols. To too great an extent one responds to those for whom they are surrogates rather than to the characters in the play. By contrast, Athol Fugard's *Sizwe Bansi is Dead* is, in my view, more successful artistically because one *does* respond to the situation of the particular characters in the play.

It is implausible to suggest that in a novel such as J. M. Coetzee's *Life* and *Times of Michael K* one's emotional response could be directed towards anyone other than the central character. One becomes immersed in the series of situations and difficulties he faces in his life, and one's response is highly particular in being identifiable only in terms of its direction on to that particular character who has lived through them in his own particular way. The notion of substitution, and thus the suggestion that the response, if it be rational, must be not to Michael K but to the kind of person he represents, makes no sense. Similarly, it is precisely a mark of the greatness of George Eliot's *Middlemarch* that one *does* respond, for instance, to Casaubon, Rosamund and Lydgate because of the perceptive particular detail with which they are drawn. We respond to *real* characters, not symbols.

Moreover, one may retain as vivid and detailed a memory of and feeling about such characters as one does in the case of people in life. It would reveal not a clear understanding that these *are* fictional characters, but a failure fully to appreciate, by involving oneself in, the novel, if one were to fail to respond to them in this way.

It is interesting in this respect to consider what counts as an appropriate response, and what counts as an inappropriate response, reflecting a failure of understanding. In one well-known British television series there is a popular character who suffered unhappy marriages. The actor playing the part of the husband who had recently married her, on a public appearance, was taken aside by a group of miners who, shaking clenched fists, warned him to be sure she was treated right this time. Humphrey Bogart, well known for playing film tough guys, was apparently several times accosted by aggressive men who demanded that he should prove how

tough he really was. This tendency to endow the actor with the attributes of the character or kind of character he plays was also illustrated by the dismay evinced by some women when his first wife revealed that an actor well known for playing James Bond spends a great deal of time admiring himself in the mirror.

Such cases reveal a failure of understanding, and to some extent a loss of touch with reality. But they connect significantly with a major concern of this chapter, namely, the sense in which what happens on stage, or in a novel or film, is real. This is brought out by the range of reactions which are regarded as appropriate. Brutus does not pretend to stab Caesar, nor does an actor pretend to stab an actor. Brutus *really does* stab Caesar. A response as to a pretence is inappropriate here precisely because of the sense in which what happens on stage is not pretence or illusion, but *real*.

To return to the objection raised above, it is of course true that one's response to a fictional character may produce a change of feeling about people in life. One's response to the fictional character Michael K may produce a new perception of and feeling for the numerous people in every country who are born into hopeless situations, who can only try to survive social contexts which are beyond their comprehension but of which they feel a dull, vague and immutable inability to be a part. This possibility of a change of feeling towards a general situation as a result of a particular experience is by no means limited to the arts. We saw in Chapter 10, and the point will be expanded in the next section, that a particular experience in life may bring about a profound change in one's feeling about war, the competitive spirit, or those who are disadvantaged or destitute. Indeed, contrary to the thesis of the objection, it is precisely because one is responding not to a mere symbol but to a particular character or dramatic situation that there can be such a real and meaningful change in one's attitude to people and situations in life.

This brings out in another way a misconception in theories which purport to explain artistic meaning in terms of symbolism. To take just one example from the many, a book on drama in education contends that the meaning of characters and situations in drama is given by their being symbolic of real people and situations in life. In fact, as we see, such a notion denigrates and emasculates the power of art. If a work is successful one responds not to a mere symbolic representation, but directly and fully to a *fictional* character who is *real*.

Learning through Feeling

Although the point is commonly overlooked, for instance in the prevalent tendency to assume that education is primarily a matter of being able to assert or assent to propositions, it is of the first importance to recognize that the most important lessons we learn in life are such that their significance to us cannot be characterized in terms of having acquired new facts. This notion is central to understanding the crucial contribution of the arts to education, in that it gives substance to the notion of education *through* the arts.

It is an obvious fact that war involves death and suffering, but a particular experience might bring home vividly, because of its emotional impact, what the fact *amounts* to. This applies not only to learning through the arts. One may learn from a particular experience, whether in life or in the arts, in ways which profoundly change one's general attitude, for instance, to war or other people.

King Lear, in mental torment, buffeted, cold and drenched while wandering without shelter in a violent storm on the heath, learns what he had never realized in his days of power:

> Poor naked wretches, whereso'er you are, That bide the pelting of this pitiless storm, How shall your houseless heads and unfed sides, Your looped and window'd raggedness, defend you From seasons such as these? O! I have ta'en Too little care of this. Take physic, Pomp; Expose thyself to feel what wretches feel, That thou mayst shake the superflux to them.

What does it amount to to say that Lear learned from his experience? Clearly it is not a matter of acquiring facts. In that sense he knew it all when he was king. He knew that the poor go hungry, have inadequate clothing and shelter, suffer various privations, and so on. These are mere truisms. His new understanding cannot be equated with the acquisition of facts. Thus he cries 'Take physic, Pomp; expose thyself to feel what wretches feel'. It is through *feeling* that Lear begins to understand the plight of the poor. That feeling arises from a particular experience, and it brings him to see what he had never before realized. It has to be brought home to him in his feeling for a particular situation. Through an involvement with a particular work of art, such as *King Lear*, we can achieve a similar

understanding. This is the peculiar power of the possibility of learning through the arts, and this is the principal reason for the central importance of the arts in education. If enough people learned to understand, in this sense, the plight of the unfortunate, we surely could not continue to have so many homeless while others have even several palatial homes; we could not continue to have so many wealthy people, while millions starve or suffer acute malnutrition. Our 'Pomp', our political leaders and dignitaries, already know the facts; their failure is a failure of feeling. In a different context Holland (1980, p. 63) makes the point: 'The kind of understanding open to us here is such that we can (and most often do) have it without being able to say what it is we understand.' Patrick White, in The Tree of Man, writes that revelations are never conveyed with brilliance as revealed. Wittgenstein (1967, \$158) says: 'If a theme, a phrase, suddenly means something to you, you don't have to be able to explain it. Just this gesture has been made accessible to you.'

This brings up again another point of such importance that it cannot be over-emphasized, especially in an educational context, which is that the learning involved here is essentially *personal*. It will not necessarily be accessible to everyone; it depends upon the understanding and sensitivity each individual brings to it. One learns only to the extent that the experience is a fully involved personal experience, given by one's own conception of the work, and one's own attitude to life. The principal criterion of one's having learned from it will be a change not of statable principle but in one's attitude.

This explains how it is that we can learn through an involvement with the arts, in ways which may affect our lives, without incurring the consequence, supposed by the autonomist, that this reduces the arts to mere message-carriers. In a particular case it may be impossible to imagine another, non-artistic, way of learning, for instance, such a powerful moral, social, or emotional lesson. This is largely because the arts can have such a profound emotional impact. Consider, for instance, how banal would be any attempt to make the same point by means of factual statements. The peculiar force of learning from a work of art consists in an emotional experience which casts a new light on a situation, revealing what the analogous life situation amounts to. There are numerous examples one could give. In each case the emotional experience is given by that particular artistic form of expression. As we have seen, the object of the emotion, that which *identifies* the emotion, cannot be characterized independently of one's *conception* of the situation. Because of this cognitive content of the

emotion, what one learns from it is internally related to the emotional response. And the emotional response is directed on to and identified by the *particular* work of art.

As we have seen, what is learned may affect one's life outside art, for instance in a changed attitude to other people. In *The Tree of Man* Patrick White writes: 'You do not know a thing until you have forgotten how that thing was learned.' After visiting an exhibition of Münch's paintings someone observed that he emerged from the gallery seeing everyone for days in terms of Münch's vision. People were seen as skeletons with dried skin drawn tightly across their bones. The vividness gradually faded, and the experience became absorbed into his general conception of life. One has had a similar experience with artists such as Francis Bacon, Edward Hopper and others.

In Chapter 1, I emphasized that the roots of art are to be found in immediate, natural responses, and that this immediacy of response should not be lost as one develops rational understanding and sophistication. In this respect, as I have said, it is seriously mistaken, though it may be common among those who over-intellectualize the arts, to suppose as Scruton does that it is a purpose of convention in art to overcome emotional involvement. It is to counter such a view that Mounce, in his perceptive paper (1980, p. 192) contends that an unsophisticate who sobs at sentimental Hollywood slush is closer to the spirit of art than an intellectual who regards his intellectualism as placing him in a position superior to and innoculated from emotional response. 'The unsophisticate responds to very bad art. But the response is at least genuine. The intellectual is deficient not perhaps in what he *thinks* good but in how he responds to it; he no longer feels its magic.'

Because of the possibility of emotional experience through involvement with the arts, one can achieve insights into and understanding of life which may be more powerful than any alternative. Through the arts one can come not only to understand a situation but, by involving oneself in analogous experience, to feel what it amounts to. Gloucester, in *King Lear*, after losing his eyes, learns so much that he exclaims that it was when he had his sight that he was blind, and it is only now, when blind, that he begins to see. Similarly, it takes insanity to make Lear sane. What their having learned these lessons amounts to could not be captured simply in their being able to assert or assent to facts or propositions which they could not have asserted or assented to previously. Stated propositionally, what they learned may appear to be mere truisms. Their new knowledge, if it is genuine, will be shown not in statable facts but in the way

they live. We can learn the same lessons through an emotional involvement with the play.

The Arts as Entertainment

There is a widespread assumption that the arts are forms of entertainment in that they are mere diversions from the serious concerns of life, from which nothing of any significance can be learned. It is remarkable that this trivializing conception of the arts should be furthered by many who are concerned with the arts in education. One source of this conception, as we have seen, is the misguided assumption that to accept that we can learn from the moral, social and other insights expressed in the arts implies the reduction of the arts to the status of mere message-carriers. Yet, contrary to what the autonomist believes, it denigrates the arts to deny that they can express incisive insights into a wide range of aspects of life. There is an important truth in Tolstoy's contention (1930, p. 120) that it trivializes the arts to equate them with beauty, and to value them in terms of the pleasure they may give rather than the purposes they may serve in the life of man. The conception Tolstoy was opposing is still prevalent. It stems partly from the conflation of the aesthetic and the artistic which was considered in Chapter 11. It is apparent in Hirst's (1980, p. 6) assertion that the role of the arts in education is to aestheticize people, and it is implicit in the confident assertion of the 'educational pundit' quoted earlier that 'the arts are marvellous, but moral they are not'. There is still wide scope for the application of George Eliot's characterization of the artistic ambitions and accomplishments of well-brought-up young ladies in her time as 'small tinklings and smearings'.

The seriousness of the arts consists partly but significantly in the fact that what is expressed in them feeds back into life, in the insights given into the human condition and other aspects of life. When the arts lose this seriousness they atrophy. This is particularly obvious in the literary arts, drama and film, and it clearly applies to at least some of the other arts. The point has frequently been recognized by artists. For example, the Dada group tried to revitalize art by making it face reality, by making reality into art, by sharply criticizing the artificiality of the contemporary conceptions of art which, they felt, vitiated its integrity. Their concern was a moral one, that artists should concern themselves with both the harsh and the banal in human experience. They would strongly have endorsed the aphorism that beauty is what the bourgeoisie pays the artist for. They

rejected the conception of art as a diversion having no direct bearing on the serious concerns of life because, by pandering to a desire for romantic escapism, it connived in the social immorality against which Dada was reacting. Art, in this sense, they believed to be an opium of the people. Yet they can also be seen as making the logical point that if art loses touch with reality it loses its meaning and becomes a substitute for life, and art experiences become merely vicarious. In this respect, as we mentioned above, the arts resemble religion, since when religious practices and doctrines become detached from a serious concern with social and moral matters they degenerate into irrelevant and vacuous liturgical autonomy.

This point that the vitality of the arts depends upon the integrity of their relation to life generally was made by Tennyson in 'The Palace of Art', which he wrote as a consequence of a remark made to him by a fellow undergraduate: 'Tennyson, we cannot live in art.' He imagines his having built 'a lordly pleasure-house, Wherein at ease for aye to dwell'. The choice of terms such as 'pleasure-house' and 'at ease' are already significant. He imagines it furnished with the finest art, tastefully decorated, and far removed from the squalor and harshness of reality – he sounds rather like many modern philosophers when he writes: 'I sit as God, holding no form of creed, But contemplating all'. Yet, the palace becomes a hollow prison and the enterprise self-defeating, since the value and meaning of art become drained of all substance and vitality. A cottage in the vale becomes far preferable.

Holland (1980, p. 108) points out that the arts, like scientific and nonscientific inquiries, are susceptible to debasement:

Enquiries trivialize themselves in subservience to exploitation, and the arts are commuted into instruments of gratification. The more they gratify the more they falsify and they proliferate with cancerous fecundity while in this state. So it is not their popularity but the presence or absence of anything absolutely good in them and the degree of attachment people have to whatever is absolutely good in them that makes the difference.

He goes on to make a point which I emphasized in Chapter 3 that this kind of involvement with the arts must be one which concerns *each individual separately*. In a similar vein, Shahn (1957, p. 106) writes:

It is not the degree of communicability that constitutes the value of art to the public. It is its basic intent and responsibility. A work of art in which powerful passion is innate, or which contains extraordinary revelations concerning form, or manifests brilliant thinking, however difficult its language, will

serve ultimately to dignify that society in which it exists. By the same argument, a work that is tawdry and calculating in intent is not made more worthy by being easily understood.

Meaning in Art and Life

A difficulty for the autonomist thesis which we have already mentioned is that of giving a coherent account of the meanings of terms used in discussion of the arts. As we saw above, Hampshire writes of the art critic's 'unnatural use of words in description'. But it is difficult to make sense of the supposition that the terms used in or of the arts have a meaning which bears no relation whatsoever to the meanings of those terms used in nonartistic contexts. For in that case the terms used in art criticism, although they appear to be the same as those in common use, would form a recondite technical vocabulary, understandable only by the cognoscenti. Of course, there are terms whose meaning is given by their use in the arts, such as 'chiaroscuro', 'iambic pentameter', 'modulation', and so on, but such terms do not form the majority, let alone the totality, of the vocabulary of critical discussion of the arts. More important, for my present point, it would make no sense to say that terms such as 'sad', 'being moved' and numerous others are totally unrelated to their use outside the arts. Most of us talk about novels, poetry, plays, and so on, quite freely and without having learned any highly specialized language. As we have said above, in general, and specifically in the case of emotion-terms. a principal criterion of one's understanding of a term used in an artistic context is one's ability to employ it in normal contexts.

However, this is certainly not to say that the meanings of terms used in an artistic context are merely parasitic on normal use. On the contrary, it is important to recognize that in this as in other aspects the arts feed back into life. Through a consideration of its use in discussion of the arts, one may achieve a richer understanding of a term whose principal use is in ordinary language. It is important to remember that the meaning of a term is not rigidly fixed. It may develop nuances as it is used in different contexts. For example, the use of the term 'sincere' and its cognates in critical discussion of the arts can endow it with richer meaning when it is used outside the arts. Or, one might say, it is possible to gain a deeper and more sensitive appreciation of its meaning by considering its use in the arts. To reflect on why a poem is sincere may give one a more perceptive grasp of the concept of sincerity in general.

A penetrating paper by Leavis (1952-3) entitled 'Reality and sincerity'

is a fine example. He considers three poems, *Barbara*, by Alexander Smith, *Cold in Earth* by Emily Bronte and *After a Journey* by Thomas Hardy. Leavis dismisses *Barbara* as a characteristic piece of Victorian sentimentality, which he has introduced simply as a heuristic foil for the other two poems. He does not consider it seriously, since it

has all the vices that are to be feared when his theme is proposed, the theme of irreparable loss. It doesn't merely surrender to temptation, it goes straight for a sentimental debauch, an emotional wallowing, the alleged situation being only the show of an excuse for the indulgence, which is, with a kind of innocent shamelessness, sought for its own sake. If one wants a justification for invoking the term 'insincerity', one can point to the fact that the poem clearly enjoys its pang... The cheapness of the sentimentality appears immediately in the movement, the clichés of phrase and attitude, and the vagueness and unrealities of situation...

By contrast, in Emily Bronte's poem

the emotional sweep of the movement, the declamatory plangency ... might seem to represent dangerous temptations; but in responding to the effect of passionate intensity we register what impresses us as a controlling strength.

Nevertheless, Leavis concludes that Hardy's poem is more sincere. Unlike the others it is not declamatory, and, although Emily Bronte's poem is striking,

when we go back to it from Hardy's the contrast precipitates the judgement that, in it, she is dramatizing herself in a situation such as she has clearly not known in actual experience: what she offers is betrayingly less real...Glancing back at Alexander Smith we can say that whereas in postulating the situation of *Barbara* (he can hardly be said to imagine it) he is seeking a licence for an emotional debauch, Emily Bronte conceives a situation in order to have the satisfaction of a disciplined imaginative exercise... The marks of the imaginative self-projection that is insufficiently informed by experience are there in the poem and (especially with the aid of the contrast with Hardy) a duly perceptive reader could discern and describe them, without knowing the biographical fact. They are in the noble... declamation, and in the accompanying generality, the absence of any convincing concreteness of a presented situation that speaks for itself. (pp. 93–4)

One may have reservations about the apparent implication that an artist would have to live through an experience in order to be able to

express it sincerely in his art. Yet there is undoubtedly something in the contention that the most profound works of art can be created only by a man with considerable experience of and sensitivity to life. Moreover, readers of the poems could not adequately appreciate them without similar experience.

Hardy offers 'a precise account of the highly specific situation defined by the poem' – 'precisions of concrete realization, specificities, complexities'. By contrast to the 'declamatory generality' of Emily Bronte's poem, Hardy offers a 'quiet presentment of specific fact and concrete circumstance'. Thus 'to say that Hardy's poem has an advantage in reality is to say... that it represents a profounder and completer sincerity'.

This is, of course, an inadequate sketch of Leavis's penetrating analysis, but I hope it is sufficient to illustrate how a deeper insight into a concept which is primarily grounded in ordinary language can be gained through reflecting on its application to the arts.

Learning to Experience Feelings

There are important implications for the education of emotional feelings. For, as the Leavis example shows, perceptive reasoning can give not just a richer understanding of feelings, but richer feelings. Without that rational understanding, one could not experience the feelings. One can come to recognize in a poem the criteria of sincere feelings, and one can involve oneself by imaginatively projecting oneself into the poet's situation. To involve oneself with his form of expression is, in that sense, to experience that feeling.

Writing of Hardy's poem, Leavis uses such phrases as 'the opposite of the rhetorical'; 'it is tenderly familiar and matter-of-fact'; 'No alchemy of idealization, no suggestion of the transcendental, no nobly imaginative self-deceiving attends on this devotion to the memory of a woman'; 'matter-of-fact precision and immediacy (there is no plangency about the resonance)'. These are the sorts of quality which we should recognize as criteria of integrity of feeling in a relevantly similar life situation – even the apparent clumsiness of Hardy's opening line: 'Hereto I come to view a voiceless ghost'. Sincerity in people in such circumstances consists in such clumsiness, control, playing-down and lack of extrovert emotionalism. Leavis points out the precise features of the poems which constitute the criteria for sincere feelings. This again brings out the complementary nature of feeling and reason. A clearer understanding of the poetic criteria

of feeling gives the possibility of deeper and more discriminating feelings. In this case, we may learn that certain forms of expression, and feelings, amount to the sentimentalism and self-dramatization which obscure and vitiate the capacity for genuine feeling – hence Leavis's insight that sincerity is inseparable from reality. For sentimentalism involves escape into the fantasy of self-indulgence, by contrast to the rigorous courage to recognize and respond to the truth.

The parallel between life and art is clear, as is the possibility of learning from emotional involvement in the arts in ways which can enrich our understanding and feelings in life. Simone Weil, castigating the romantic dishonesty of most literature writes (1968, p. 161):

But it is not only in literature that fiction generates immorality. It does so in life itself. For the substance of our life is composed of fiction. We fictionalize our future; and unless we are heroically devoted to truth, we fictionalize our past, refashioning it to our taste. We do not study other people; we invent what they are thinking, saying, and doing.

It is important to recognize the contrast between (a) 'fiction' in the sense of 'fantasy' or 'escapism', and (b) 'fiction' as opposed to 'fact' or 'history'. Simone Weil is exposing the immorality of fiction, in life and art, in the former sense, of escapist fantasy. Her comment underlines a principal theme of this chapter, which is concerned emphatically to *reject* the common assumption that the arts are fictional in *that* sense. Thus, for instance, *King Lear* is certainly *not* fiction in the sense that it is an escape from reality into fantasy, since, on the contrary, it brings home to us important *truths* about the human condition.

The situation against which Simone Weil was inveighing is now far worse, since television has turned fantasy into what many people take for reality, and other people become cliché images, passing by with background noise on a blurred screen.

Yet, to deepen integrity of feeling incurs the penalty of increasing vulnerability. Leavis sees the 'rare integrity' of Hardy's poem in its saying, in effect, that 'the *real* for me, the focus of my affirmation is the remembered realest thing, though to remember vividly is at the same time, inescapably, to embrace the utterness of loss' (p. 96).

Although the price is very great, it has to be paid for that depth and integrity of feeling, since 'Hardy, with the subtlest and completest integrity is intent on recapturing what *can* be recaptured of that which, with all his being, he judges to have been the supreme experience of life, the realest

thing, the centre of value and meaning'. By reflection on and involvement with such a poem one can learn more about what it is to experience profoundly sincere feelings in life.

The meaning and values which govern one's life are expressed not just in words but in how one lives. A work of art can reveal a *Weltanschauung*, a conception of life, in its details, perhaps in previously unrecognized or only partly recognized failures of integrity manifested in self-deception, self-indulgent sentimentalism. As Coleridge has put it: 'We know a man for a poet by the fact that he makes *us* poets.' Moreover, one of the criteria for the depth and sincerity of a person is the kind of art which engages him, and, perhaps, above all, the kind of *involvement* with the arts which he evinces. Involvement with the arts can give increasing depth and sensitivity to one's understanding of and experiences in life.

If faced with integrity, experiences in life are perplexingly heterogeneous, and serious involvement with the arts can help one to appreciate this. Criticizing the ordered artificiality of traditional novels, Virginia Woolf (1945, pp. 189–90) asks us to examine an ordinary mind on an ordinary day:

The mind receives a myriad impressions... Life is not a series of gig lamps symmetrically arranged... Let us record the atoms as they fall upon the mind in the order in which they fall, let us trace the pattern however disconnected and incoherent in appearance, which each sight or incident scores upon the consciousness. Let us not take it for granted that life exists more fully in what is commonly thought big than in what is commonly thought small.

Progressively an educated appreciation of the arts can help to remove the oversimple, misleading conceptual props of childhood and early youth. It can help to encourage the integrity and emotional sensitivity to explore the reality of the human condition. When we recognize that emotions are not just a matter of 'natural' instinctive responses, but that feelings can be indefinitely learned and refined, as one extends and deepens one's understanding, we can begin to recognize the important contribution which the arts can make to personality development.

Conclusion

It should, perhaps, be repeated that to emphasize the crucial importance of concepts and rational learning to the feelings involved in the arts is not

in the least to oppose spontaneous response. In Chapter 1 it was pointed out that the *roots* of the arts are to be found in immediate reactions. The ability to respond with feeling should not be lost as more sophisticated understanding is achieved. Not all feelings will be immediate, since it may require reflection to understand a work and thus to respond appropriately. But some feelings will be immediate – or if not, one has lost touch with the roots and spirit of the arts. My thesis is not primarily concerned with whether responses are or are not spontaneous, but with showing that conceptual grasp, and therefore rationality, are *necessary* for the kinds of feeling which are central to involvement with the arts. That is, without such conceptual grasp an individual would be *incapable* of such feelings, whether spontaneous or not.

This reveals the incoherence of purported psychological explanations of intentional action solely in terms of the stimulus-response causation model. As we saw in Chapter 8, an artistic intention cannot be characterized independently of the concept of art. Thus any account of such an intention in purely physical terms is inevitably deficient. A physical movement of limbs, unlike an intentional action, cannot express a moral view, or reveal a vision of life. Similarly, an exclusively psychoanalytic account of the artist's intention or the spectator's response, for instance, in terms of the working out of repression, would inevitably be inadequate since it would omit the *art* aspect of the emotion. It would ignore the institutional character of art, and thus would fail to distinguish artistic from non-artistic experiences. As we have seen, the feeling is inseparable from the possibility of its expression in the *arts*.

The point, which is a major theme of this chapter and of this book, can be illustrated by Wilfrid Owen's insistence about his own work that it was *not* that the pity was in the poetry, but that the poetry was in the pity. The poignant sense of pity which he felt for the appalling tragedies and agonies of the soldiers of the First World War was inseparable from the poetry in which *alone* he could express it. The pity could not otherwise be identified; without that poetry it could not exist. It was *that* pity – the pity of the poetry.

One's experience on reading such poetry can be a powerful analogue of the experience of those who were in the trenches. Through such an artistic experience one can come to understand in a sense which one did not understand before just what it feels like to have such an experience in life. Indeed, that is a serious understatement of the understanding which can be gained through the arts, for it is quite possible for someone actually to have been in the trenches yet never to have felt just what that situation

amounted to until he read the poem. Simone Weil (1978, p. 59) writes: 'It is due to feeling alone that a thing becomes freed from abstraction and becomes something individual and concrete.'

A work of art, and through it a perceptive teacher or critic, can reveal the character of sincere feelings, and give the possibility of deeper and more finely discriminated emotional experience. As Leavis puts it (1952-3, p. 92): 'the superiority can be *demonstrated*'. That is, perceptive reasons can demonstrate the character and calibre of the expression of feelings, and thus the character and calibre of feelings themselves. In this way reasoning in the arts can give a richer possibility of feeling, not only in the arts, but in life.

Summary

- (1) It makes no sense to suppose that the arts are autonomous, selfcontained activities. There is an inseparable interdependence between artistic meaning and the life of society.
- (2) The concept of art is fundamental and ineliminable in characterizing the response. The response may be in some respects as if to a life situation, but the 'as if' is given its sense, at least largely, by the concept of art.
- (3) Emotional response and understanding are not distinct, for to respond appropriately *reveals* one's understanding.
- (4) Feeling in response to the arts is an analogue of feeling in life situations, and it is because of the emotional impact of the arts that it is possible to learn from them in ways which would otherwise be impossible to achieve. The learning involved is not the acquisition of new facts, and it may not be precisely statable: it consists in a change of conception and feeling about aspects of life.
- (5) Through the arts one can learn not only to recognize but to experience feelings of greater integrity and depth in life.
- (6) Theories which purport to justify artistic response in terms of imagination, symbolism, or illusion involve a serious misconception and denigration of the power of the arts. If a work is successful, and if one understands it, one responds not to imagined or symbolic characters or situations, but to fictional characters who are real. The supposition that artistic meaning rests on and is justified by imagination or symbolism is fundamentally confused. The sense of reality given by the concept of art rests on nothing; it is a confusion to ask what justifies it.

References

- Anscombe, G. E. M. (1965), 'The intentionality of sensation', in R. Butler (ed.), Analytical Philosophy, Vol. II (London: OUP), pp. 158-80.
- Argyle, M. (1975), Bodily Communication (London: Methuen).
- Bambrough, J. R. (1973), 'To reason is to generalize', *The Listener*, vol. 89, no. 2285 (11 January), pp. 42-3.
- Bambrough, J. R. (1979), Moral Scepticism and Moral Knowledge (London: Routledge & Kegan Paul).
- Bambrough, J. R. (1984), 'The roots of moral reason', in Edward Regis, Jr (ed.), Gewirth's Ethical Rationalism (Chicago: Chicago University Press).
- Beardsley, M. C. (1979), 'In defense of aesthetic value', Presidential Address at the American Philosophical Association, *Proceedings*, vol. 52, no. 6, pp. 723-49.

Beardsmore, R. W. (1971), Art and Morality (London: Macmillan).

Beardsmore, R. W. (1973), 'Two trends in contemporary aesthetics', British Journal of Aesthetics vol. 12, no. 4, pp. 346-66.

- Beckett, S. (1963), Watt (London: Calder & Boyars).
- Bennett, J. F. (1964), Rationality (London: Routledge & Kegan Paul).
- Best, D. (1974), Expression in Movement and the Arts (London: Lepus).
- Best, D. (1978), Philosophy and Human Movement (London: Allen & Unwin).
- Bondi, H. (1972), 'The achievements of Karl Popper', *The Listener*, vol. 88, no. 2265, pp. 225-9.
- Bosanquet, B. (1915), Three Lectures on Aesthetic (London: Macmillan).
- Britton, K. (1972-3), 'Concepts of action and concepts of approach', Proceedings of the Aristotelian Society, pp. 105-18.
- Bronowski, J. (1973), 'Knowledge and certainty', *The Listener* (19 July), pp. 79-83.
- Carritt, E. F. (1953), 'Croce and his aesthetic', Mind, vol. 1, no. 1.
- Collingwood, R. (1938), The Principles of Art (Oxford: Clarendon).
- Ducasse, C. J. (1929), The Philosophy of Art (New York: Oskar Piest).
- Eisner, E. (1981), 'The role of the arts in cognition and curriculum', Report of INSEA World Congress, Rotterdam (Amsterdam: De Trommel), pp. 17-23.
- Goodman, N. (1969), Languages of Art (London: OUP).
- Hampshire, S. (1954), 'Logic and appreciation', in W. R. Elton (ed.), Aesthetics and Language (Oxford: Blackwell), pp. 161-9.
- Hart-Davies, R. (1962), The Letters of Oscar Wilde (London: Hart-Davies).
- Hepburn, R. W. (1965), Emotions and emotional qualities', in C. Barrett (ed.), Collected Papers on Aesthetics (Oxford: Blackwell), pp. 185-198.

- Hepburn, R. W. (1966), 'Contemporary aesthetics and the neglect of natural beauty', in B. A. O. Williams and A. Montefiore (eds), *British Analytic Philosophy* (London: Routledge & Kegan Paul).
- Hirst, P. H. (1974), *Knowledge and the Curriculum* (London: Routledge & Kegan Paul).
- Hirst, P. H. (1980), Transcript of a symposium 'Education with the arts in mind', Bretton Hall.
- Holland, R. F. (1980), Against Empiricism (Oxford: Blackwell).
- Kant, I. (1929), Critique of Pure Reason, trans. N. Kemp Smith (London: Macmillan).
- Kneale, W., and Prior, A. N. (1968), 'Intentionality and intensionality', Proceedings of the Aristotelian Society, suppl. vol. 42, pp. 74-106.
- Kuhn, T. S. (1975), The Structure of Scientific Revolutions (Chicago: University of Chicago Press).
- Langer, S. (1957), Problems of Art (London: Routledge & Kegan Paul).
- Lawrence, D. H. (1936), *Phoenix: The Posthumous Papers*, ed. E. D. McDonald (London: Heinemann).
- Leavis, F. R. (1952-3), 'Reality and sincerity', *Scrutiny*, vol. 19, no. 2, pp. 90-8.
- Lowe, B. (1976), 'Toward scientific analysis of the beauty of sport', British Journal of Physical Education, vol. 7, no. 4 (July).
- MacDonald, M. (1952-3), 'Art and imagination', Proceedings of the Aristotelian Society, pp. 205-26.
- MacIntyre, A. (ed.) (1965), Hume's Ethical Writings (New York: Macmillan).
- MacIntyre, A. (1967), Secularization and Moral Change (London: OUP).
- Meager, R. (1965), 'The uniqueness of a work of art', in C. Barrett (ed.), Collected Papers on Aesthetics (Oxford: Blackwell).
- Mounce, H. O. (1980), 'Art and real life', *Philosophy*, vol. 55 (April, pp. 183-92.
- Perry, R. B. (1926), General Theory of Value (New York: Longman).
- Phenix, P. (1964), Realms of Meaning (New York: McGraw-Hill).
- Phillips, D. Z. (1970), Death and Immortality (London: Macmillan).
- Radford, C. (1975), 'How can we be moved by the fate of Anna Karenina?', Proceedings of the Aristotelian Society, suppl. vol. 49 (July), pp. 67-80.
- Reid, L. A. (1931), A Study in Aesthetics (New York: Macmillan).
- Reid, L. A. (1969), Meaning in the Arts (London: Allen & Unwin).
- Reid, L. A. (1970), 'Sport, the aesthetic and art', British Journal of Educational Studies vol. 18, no. 3.
- Rhees, R. (1969), Without Answers (London: Routledge & Kegan Paul).
- Robinson, I. (1973), The Survival of English (Cambridge: CUP).

Saw, R. (1972), 'What is a work of art?', in her Aesthetics: An Introduction (London: Macmillan); first published in Philosophy, vol. 36 (1961).

Scruton, R. (1974), Art and Imagination (London: Methuen).

References

- Shahn, B. (1957), *The Shape of Content* (Cambridge, Mass.: Harvard University Press).
- Sibley, F. N., and Tanner, M. (1968), 'Objectivity and aesthetics', *Proceedings of the Aristotelian Society*, suppl. vol. 42, pp. 31-72.
- Stanislavsky, K. (1961), Chekov and the Theatre, originally from My Life in Art (Moscow).
- Spencer, L., and White, W. (1972), 'Empirical examination of dance', British Journal of Physical Education, vol. 3, no. 1, pp. 4-5.
- Strawson, P. F. (1968), 'Freedom and resentment', in P. F. Strawson (ed.), Studies in the Philosophy of Thought and Action (London: OUP).
- Tolstoy, L. (1930), What is Art? trans. A. Maude (London: OUP).
- Urmson, J. O. (1957), 'What makes a situation aesthetic?', Proceedings of the Aristotelian Society, suppl. vol. pp. 75-99.
- Weil, S. (1951), Waiting on God (London: Routledge & Kegan Paul).
- Weil, S. (1952), Gravity and Grace (London: Routledge & Kegan Paul).
- Weil, S. (1962), Selected Essays 1934-43, chosen and trans. Richard Rees (London: OUP).
- Weil, S. (1968), On Science, Necessity, and the Love of God, ed. Richard Rees (London: OUP).
- Weil, S. (1978), Lectures on Philosophy, trans. H. Price (Cambridge: CUP).
- Wilson, R. (1967), 'The aerial view of Parnassus', Oxford Review of Education, vol. 3, no. 2, pp. 123-34.
- Wimsatt, W. K., and Beardsley, M. (1960), 'The affective fallacy', in W. K. Wimsatt (ed.), *The Verbal Icon* (New York: Noonday Press), pp. 21-39.
- Wimsatt, W. K., and Beardsley, M. (1962), 'The intentional fallacy', in J. Margolis (ed.), *Philosophy Looks at the Arts* (New York: Scribner), pp. 91-105.
- Winch, P. (1958), The Idea of a Social Science (London: Routledge & Kegan Paul).
- Winch, P. (1972), Ethics and Action (London: Routledge & Kegan Paul).
- Wisdom, J. (1952), Other Minds (Oxford: Blackwell).
- Witkin, R. (1980), 'Art in mind reflections on *The Intelligence of Feeling*', in J. Condous, J. Howlett and J. Skull (eds), *Arts in Cultural Diversity* (Sydney: Holt, Rinehart & Winston), pp. 89–95.
- Wittgenstein, L. (1958), *Philosophical Investigations*, 2nd edn (Oxford: Black-well).
- Wittgenstein, L. (1967), Zettel (Oxford: Blackwell).
- Wittgenstein, L. (1969), On Certainty, (Oxford: Blackwell).
- Wollheim, R. (1970), Art and its Objects (Harmondsworth: Penguin).
- Woolf, V. (1945), 'Modern fiction', in *The Common Reader*, 5th edn (London: The Hogarth Press), pp. 184-95.

Index

Absolute truth 57 Aesthetic descriptions 161-3 Affective fallacy 125-8 Agreement 60 Anscombe G. E. M. 147 Architecture 165-6 Argyle, M. 68-9, 102-3 Arts: in education passim; as entertainment 185; purposive or autonomous 170-3; roots of 1-11; and science 15-33 passim, 39-41 Assessment 65-6; and quantification 17 - 18Asymmetrical logic of psychological statements 96-7 Austen, Jane 28 Authoritarianism 46-7 Bach, J. S. 132, 166 Bacon, Francis (painter) 29, 185 Bambrough, J. R. 36, 45-6, 62-3, 114-15 Beardsley, M. 154, 158-9; see also Wimsatt Beardsmore, R. 140, 142-4, 155-6 Beauty 38, 109, 186 Beckett, Samuel 29, 49, 63, 137 Behaviourism 94-7 Berlioz 28, 127, 167 Bond, Edward 84, 105 Bondi, H. 26 Bosanquet, B. 90, 109 Brahms 136 Brain hemispheres 114 Britton, K. 155 Bronte, Emily 189 Brooke, Peter 171 Brooke, Rupert 85 Browning, Robert 112-13 Carritt, E. F. 155

Chaucer, G. 172 Chekhov, A. 29 Code, *see* Language Coetzee, J. M. 181–2 Collingwood, R. 119-22 Communication 99-104 Concepts see Meaning Conditioned response 5 Courage, different concepts of 85-6 Criteria 50; for creativity 75-89 passim; public or private 81 Dada 186-7 Dali 173

Dali 175 Death, and the meaning of life 104–6 Detached attitude 131–8 passim Dickens 180 Disagreement 60–2 Distancing from feeling, 116, 131–8 passim Donne, John 93 Dualism and behaviourism 95–7

Education through the arts *passim*, especially 168-94 Eisner, E. 98-104 Elgar, E. 76 Eliot, George 181, 186 Existentialism 71-2 Expecting 92

Fauvism 51 Fiction 177-82 passim, 91 Foundations 1-11 passim Fugard, Athol 160, 181

Gesualdo 173 Gillespie, Dizzie 88 Given 104, 110 Goodman, N. 155 Graham, Martha 27, 50-1, 84

Hampshire, S. 170-1, 188 Hardy, Thomas 189-92 Haydn 77, 172 Hepburn, R. W. 144, 155 Hirst, P. 30-1, 171, 186 Holland, R. 36, 150, 184, 187 Hopkins, Gerard Manley 93, 165

Index

Hopper, Edward 185 Hume, D. 16

Illusion 175-6 Images, see Meaning Imagination 100, 178-9; and the truth 84-6 Impressionism 51 Individuality 45-8, 64-75 passim, 114-15, 149-51, 187-8 Intention 52; of the artist 122-5, 127-8 Intentionality of emotions 139-52 passim Interpretation and conceptualization 24-7 Involved attitude 131-8 passim

Judgement 43; evaluative, see Value

Kant, I. 64, 73-4, 134 Keats 85-6 Kipling, Rudyard 85, 88 Klee, Paul 133 Kuhn, T. S. 25-6, 60-1

Langer, S. 107 Language: as a code 1023; in art criticism 188–90; game 2, 171–2; and man 104; religious 106–7 Lawrence, D. H. 66, 136 Leavis, F. R. 188–94 passim Limits of reason 32–3 Locke, J. 108 Lowe, B. 167–8

MacIntyre, A. 104-5

Magritte 173

Material object 147-9

McDonald, M. 155

Meager, R. 145, 150

Meaning: and concepts derived from the senses 100-1; as imagery 99-100; of life, *see* Death; at base linguistic 104; as private concepts 101-4Mounce, H. O. 176-7Moratt W. A. 76, 77, 140

Mozart, W. A. 76, 77, 142

Natural response 1–11 Non-verbal reasons 28–30, 113

Orwell, G. 142–4 Owen, Wilfrid 30, 84–6, 193

Phenix, P. 107 Phillips, D. 68 Picasso 42, 76, 80, 84, 121, 133, 159, 173 Pretence 176–7 Process, creative 78, 82–4, 86 Product, creative 78, 82–4 Proof 59 Propositional knowledge 30–1

Radford, C. 174–7 Reactive attitude 8–10 Reading meaning in 41–3 Reality, in the arts 188–94 Reid, L. A. 17, 42, 108–9, 154, 158–60, 177–8 Relativism 49–60; and realism 21–4 Robinson, I. 106–7, 136

Saw, R. 157-8, 160, 167 Schoenberg 132-3 Scientism and subjectivism 15-18 Scruton, R. 134, 178 Secondary qualities 108 Sentimentality 135-7 Shahn, B. 187-8 Shakespeare 159, 161, 172; Antony and Cleopatra 179; Coriolanus 85; Julius Caesar 182; King Lear 20, 126, 175, 183-4, 185; Measure for Measure 162; Othello 117, 134, 135, 176-9; Twelfth Night 41 Sibley, F. 54-6, 161-4 Sincerity 188-94 Spectator's response 125-8 Sports: as art 157-60, 167-8; purposive and aesthetic 157-60 Stravinsky 172 Strawson, P. 8 Swift 32, 115 Symbolism 8, 69, 180-2 Tanner, M. 54-7, 161, 164 Tennyson, A. 187 Thomas, Dylan 165 Tolstoy, L. 118, 170, 186

Truth 41, 54, 56, 59; see also Absolute,

Typical artistic judgements 163

Imagination

Turner 168, 173 Twelve tone music 133

Urmson, 155

Value 35-7

199

WESIMAR COLLEGE LIBRARY

Feeling and Reason in the Arts

Verlaine, P. 165, 172

War poets 84-6 Weil, S. 18, 53, 93, 139, 191, 193 White, Patrick 150, 184-5 Wilde, O. 72, 136, 168, 170 Wimsatt, W.K. and Beardsley, M. 122, 125 Winch, P. 73, 146
Wisdom, J. 96
Witkin, R. 31, 80
Wittgenstein, L. 2, 5, 51, 58, 62, 71, 92, 184
Wollheim, R. 134, 155
Woolf, Virginia 192

BH 39 .B42 1985 Best, David. (106251) Feeling and reason in the arts